THE **MIDDLE** OF **SOMEWHERE**

		Lb.
canary		4–6
dow fescue		8–10
Red fescue		4–6
Kentucky bluegrass		6–10
top		6–10
rennial rye		3–5
ermuda		
Bahia		4–6
Carpet		4–6
Dallis		6–8

winter and spring. Therefore winter
er and yellow trefoil must be enc
o ded, or grown in a supplementa
kudza the summer.

Temp **ry pastures** are more o
legumes than perennials. Sometimes
(hayfield) is gra for one or two me
wheat, rye and oa re pastured a
early spring followed b lespedeza. Ve
excellent early spring p re, and
beans are useful in summer herev
asture. Dr. W. Fream caused a botanica examina
of several of the most celebrated past res of Eng
ntrary to expectation, found that the chief con
ordinary perennial ryegrass and w ite clover
rasses and legumes were present, bu these two
verwhelming proportion of the plants.

usage the term grass, pasturage, hay, etc., includes
of clover and other members of the natural
osae (q.v.) as well as other "herbs of the field,"
not strictly "grasses," are always found in a grass
included in mixtures of seeds for pasture and
following is a list of the most desirable or valu
ral grasses and clovers, which are either actually
case of old pastures, encouraged to grow by drain-
nuring and so on:—

Grasses

pratensis	Meadow foxtail.
um odoratum	Sweet vernal grass.
m avenaceum	Tall oatgrass.
ristatus	Crested dogstail.
merata	Cocksfoot.
riuscula	Hard fescue.
tior	Tall fescue.
ina	Sheep's fescue.
praten	Meadow fescue.
talior	Italian ryegrass.
prat	Timothy or catstail.
ratensi	Smooth meadow-grass.
rivialis	Rough meadow-grass.

Clovers, etc.

Medicago lupu	Trefoil or "Nonsuch."
Medicago sativ	Lucerne (Alfalfa).
Trifolium hybr	Alsike clover.
" prate	Broad red clover.
" prate	Perennial clover.
" incarn	Crimson clover or "Trifolium."
" procu	Yellow Hop-trefoil.
" repens	White or Dutch clover.
Achillea millefoliu	Yarrow or Milfoil.
Anthyllis vulnerar	Kidney vetch.
Lotus major	Greater Birdsfoot Trefoil.
tus corniculatus	Lesser " "
Ca um petroselinum	Field parsley.
Plan go lanceolata	Plantain.
Cichor um intybus	Chicory.
Poteriu officinale	Burnet.

The predo inance ny particular species is largely
termined by c matic mstances, the nature of the soil an
the treatment in receive in Great ritain in limestone area

THE **MIDDLE** OF **SOMEWHERE**

An Artist Explores the Nature of Virginia

Suzanne Stryk

Trinity University Press

San Antonio, Texas

What you are doing is exploring. You are undertaking the first experience, not of the place, but of yourself in that place.

— Wendell Berry, *The Unforeseen Wilderness*

For all the native creatures of
our life-rich Commonwealth
and for Dan

Contents

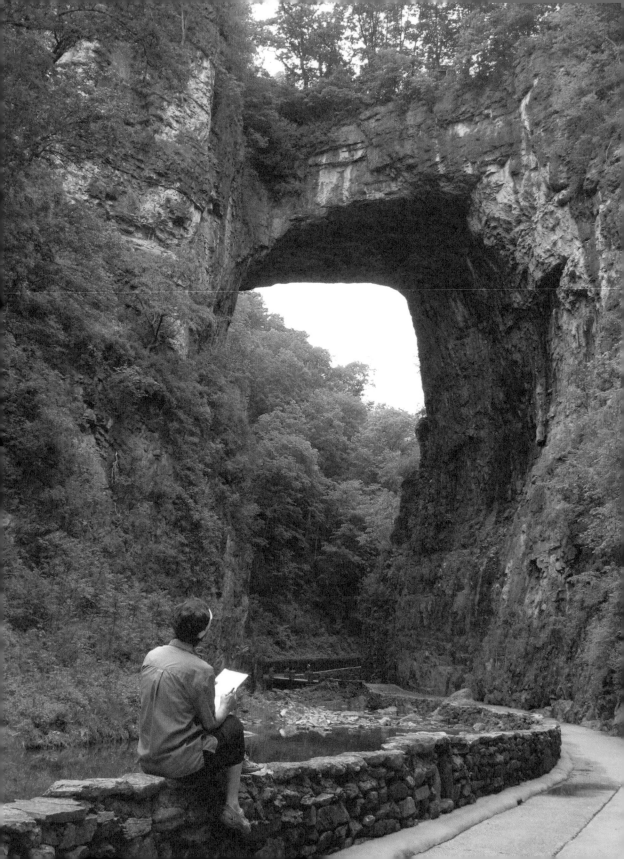

Preface

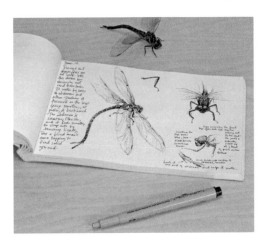

There's no such thing as the middle of nowhere. Every place is the middle of somewhere for some living being. That was my mantra as I journeyed throughout my home state of Virginia. Kayaking pristine swamps in river country, strolling Alexandria's cobblestone streets, or hiking rocky trails crisscrossing the Appalachians, I encountered frogs, millipedes, ravens, dragonflies, people, sparrows, turtles, and so many others claiming a particular place as home. All of these "somewheres" and their inhabitants are characters in this book.

My fascination with place began when I was a skinny little girl crouched in tall grasses pretending to be Meriwether Lewis

exploring the vast prairie. These imaginary expeditions were staged in the weedy honeysuckle-tangled edge of my Chicago-area backyard. The inspiration? A love of being outdoors coupled with my fourth-grade social studies book's description of Lewis and Clark's adventures. Orbiting that text were oval portraits of Thomas Jefferson and the duo he dispatched west, over which a cursive *Corps of Discovery* printed in sepia created an authentic quill-pen flair. On the opposite page, Lewis's roughly drawn fish swam in a river of his scrawled observations. This image merged in my mind with a different book, *Wonders in Your Own Backyard*, a birthday gift from my grandmother when I turned nine. The message kindled by that fish and that book of wonders would resonate all of my life.

In 1991, years after moving from Illinois to Virginia, I read Thomas Jefferson's *Notes on the State of Virginia*. This classic book surveying the state's natural and cultural history would then collect dust on the shelf for decades until 2010, when it became the springboard for an art project, an exhibition, and ultimately this collection of place-based essays describing my venture. When asked to revise his book decades after writing the original, Jefferson wrote:

> *I consider . . . the idea of preparing a new copy of . . .* [Notes on the State of Virginia] *as no more to be entertained. The work itself indeed is nothing more than the measure of a shadow, never stationary, but lengthening as the sun advances, and to be taken anew from hour to hour. It must remain, therefore, for some other hand to sketch its appearance at another epoch.*

I took his word "sketch" as a prophecy. So, there I was: a woman, an artist, and a transplant from the Midwest to boot, but I'd give it a shot. I'd try to measure the shadow of a place as my own sun advanced.

In 2011, I received a fellowship from the Virginia Commission for the Arts to pursue my version of *Notes on the State of Virginia*. Before embarking on any journey, I dug into Jefferson's book again with the fresh eye of someone on a mission. It's formally written, as you might expect from a natural philosopher and statesman living the late 1700s, and packed with lists and descriptions of topography and geology, flora and fauna, weather and climate. One chapter covers religious freedom, while others detail the Commonwealth's practical side, its commerce and laws.

Unfortunately, though, amid this impressively wide-ranging catalog of place, one can't ignore Jefferson's negative characterizations of the African American. Sure, he was a man of his times—I understand that. And sure, my project taps into his *Notes* as a point of departure. But still I had hoped to find more insight from the man who'd inserted the abolition of slavery into the Declaration of Independence (a passage sadly removed by his peers). Yes, I expected better from the man who grasped the ecological value of the natural world—wise for any time.

With that conflict in Jefferson's own nature in mind, I knew I also had to face some present-day conflicts while I explored the nature of Virginia. I could not pass judgment on the past without considering how the future might judge our own age. For instance, when describing those glimmering riffles on the Shenandoah River, I also express my dismay for its mercury contamination. And I acknowledge my own complicity in the use of fossil fuels extracted from mountaintop removal in the chapter titled "Coal Tattoo."

As I continued to shape my own approach to this Virginia project, I would aim to freely interpret land and life from a contemporary,

personal perspective, create a tapestry of place from an artist's point of view. My ideas about where to go and what to see were sketchy: an endangered species, a Civil War battlefield, a pristine wetland, a mountain peak, along with some of Jefferson's old haunts to create a historical arc ... *How to begin?*

I TACKED A HUGE laminated map of Virginia on my studio wall to study the five geological regions of the state: (1) Coastal Plain (Tidewater), (2) Piedmont, (3) Blue Ridge, (4) Valley and Ridge, and (5) Appalachian Plateau. After brushing up on how to read topographic maps, I searched for special people with expertise on some aspect of Virginia (many of whom you'll meet in these pages). They added to the list of places already piquing my interest, and then I winnowed possible sites down to those with particular resonance or locality in the state. I say that like it was easy. It wasn't. For example, the endangered species: Would it be the giant carrion beetle, the red-cockaded woodpecker, or the bog turtle? All fascinated me. I finally chose the woodpecker, for seeking it would take me to southeastern Virginia, where I'd

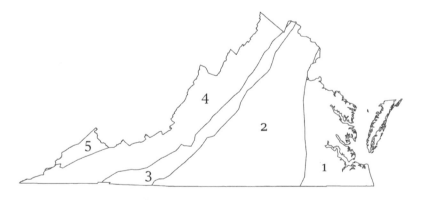

find fields of cotton and peanuts, a region I'd only seen through the windshield of a car. Another reason was the bird's curious life cycle, which, if lucky, I might glimpse (you'll find out in the chapter titled "Gaining Ground").

I confess that no matter how much planning I did, I usually strayed off course once at the site. I did—or rather I *do*—get sidetracked by design. When actually face-to-face with an orange-headed skink (before it dashes off), or after intently listening to an expert guide, I follow the thrall of the moment, which may mean physical wandering or may mean following my internal meditations. In other words, I daydream.

That said, the distinction between ordinary daydreaming and what I call "focused daydreaming" is crucial. I know it's an oxymoron. But I claim focused daydreaming is the secret to traveling: be present yet also allow associations or imaginative flights to flow. Say I'm rocking in a motorboat off the Eastern Shore, and marine biologist Barry Truitt has just finished describing the island before us when my mind conjures a scene—no, really a whole life—on that little plot of seabound land. Sure, I miss a few particulars, but in the focused daydream I enter my surroundings more viscerally. I knit fact with feeling. And it connects me more intimately with a patch of earth and thus becomes more memorable.

AFTER EACH EXPEDITION, I'd return home with a car chock-full of collections. Once these "treasures" were hauled into the studio, I spread them on two makeshift tables—4-by-8-foot sheets of plywood propped on sawhorses. So had you walked in my studio in 2012, you might have found Ziploc bags filled with sand or clay splayed alongside Labtek

cases of dead bugs, piles of tourist pamphlets, road maps, and pressed leaves. You would have noticed chunks of rock nudging animal bones. You might have seen a bottle of swamp water leaking on handwritten directions, staining paper onionskin yellow with inky swirls. From this clutter I plucked what might be valuable in an artwork about the site, continually arranging and rearranging, gluing or casting off.

Each assemblage began with a US Geological Survey (USGS) topographic map. I love these maps. I know, Google Earth is mind-boggling. But I prefer a good old topo map. Maybe it's because it doesn't make me feel like I've been to a place; it makes me imagine going. And those beautiful rusty red and green contour lines—they're like art: suggestive, abstract. These maps recall a living animal: undulating lines like the

swellings and hollows of a body, blue rivers and red roads like veins. Yet topographic maps also have matter-of-factness. This merger of the factual with the evocative plucks a chord deep inside me. Over the map foundation, I layered found materials, sketchbook drawings (often printed on clear Mylar), and paintings. Sometimes I glued, sewed, or painted so much stuff on the surface that only a small section of the map remained visible.

I think of myself as a kind of cartographer — not someone who draws geographically accurate maps, but an artist who maps *responses* to a particular place. I document other lives in other places as I've experienced them, so I often refer to these assemblages not as art but as "documents."

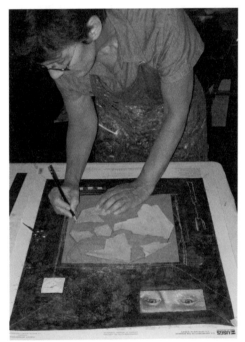

Occasionally the studio influenced the final piece. For instance, every morning when I flicked on the light of the studio, the first thing I'd see was the Chesapeake Bay on the big Virginia map hovering over my worktable. It reminded me of a dragon or huge root, so I combined that thorny animated shape with sketches of washed-up horseshoe crabs collected in the bay. Over the map, I mounted text printed on clear Mylar from an article, "Climate Change and the Chesapeake Bay," offering yet another layer to the work titled *How the Past Returns*.

Each piece, like an archaeological dig, reveals the strata of what I excavated at the site. The phrase "glimpse the layers" kept surfacing in my mind as I worked. For in the end, all we can really do is glimpse the lives, past and present, that pass through a place.

After nearly two years, I had twenty-six assemblages: fourteen on full-sized 27-by-21-inch USGS topographic maps and twelve 12-by-12-inch works on maps or stacked mirrors. It was only after the artwork lined the walls of the Taubman Museum of Art in Roanoke that I set out to describe my Virginia adventures in writing.

What began as vague ideas evolved into full-blown narratives as I sat each morning scribbling memories across a yellow legal pad, periodically jabbing my pencil in the sharpener as I searched for words. To sharpen my memory, it helped to prop up the site-related assemblage that I'd planned for the opening image of each chapter I was writing. I then flipped through sketchbooks for related notes jotted on location. And guiding me throughout was my recurring mantra "I'm always in the middle of somewhere."

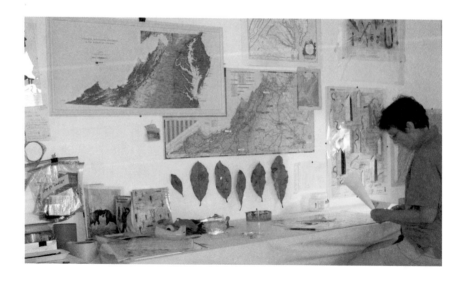

Now as I face a blue laptop screen scattered with words, my painting of a blue vortex swirls with feathers behind me. I'm aware I sit between two worlds—image and word. Each tugs for my attention. I'm a visual artist drawn to writing.

For the artwork in this series, I focused on whatever resonated with me after my site visit, whatever had an afterlife. And the goal of writing? To capture my eclectic experience of a place, one that blurred the lines between art and nature, past and present. On site visits, I often felt like a character in a Ken Burns documentary, minus Ken and the camera crew. Driving away, as the place itself shrunk in my rearview mirror, it expanded in my thoughts. The people I'd met, and the animals and plants I'd witnessed, rolled film-like through my mind.

The painter Milton Avery said, "Why talk when you can paint?" So why do I write when I can make visual art? Because I can express different things with each. Nothing compares with the visceral, intuitive act of smearing viscous paint or arranging some rusty metal with ripped paper to create a suggestive object. Yet nothing compares with chiseling an experience into words. I sit here now tapping on the keys because of the rush I get making a short thought into a long one. Because of the way habitats and characters—human or nonhuman—might be resurrected.

Writing pushes me to grapple with my own sundry thoughts as I birth them onto the page, the way a gooey larva becomes a fully formed honeybee. And like that honeybee, perhaps both my art and writing about place form a kind of waggle dance. I'm here in the hive saying, "Look—here's the nectar I found. Now go out in the world and find your own."

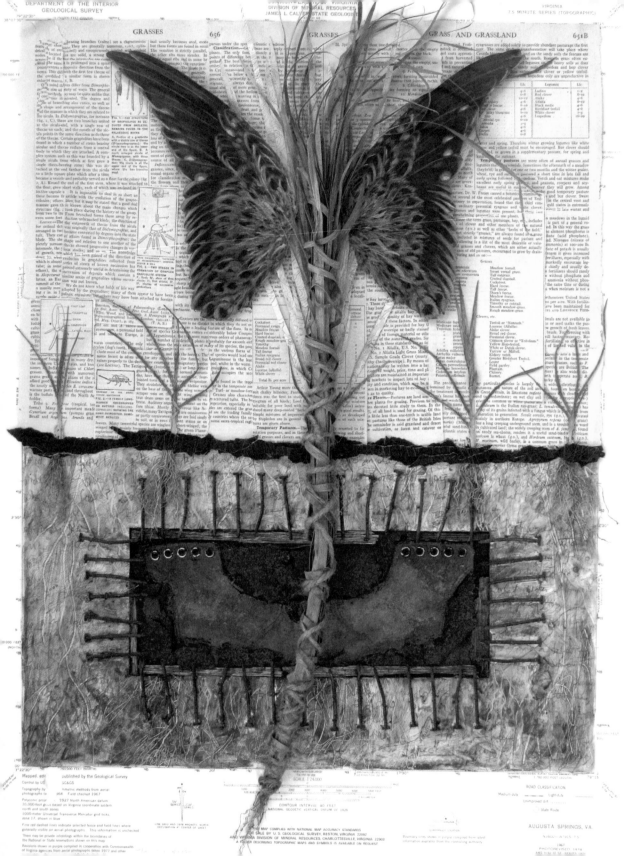

The Green Fuse

SHENANDOAH VALLEY

> *If we were not here . . . the show would play to an empty*
> *house, as do all those falling stars which fall in the daytime.*
> *That is why I take walks: to keep an eye on things.*
> — Annie Dillard, *Teaching a Stone to Talk*

IMAGINE AN ART studio in the hayloft of a barn. A Carolina wren hops through a crack in the rough planks. Clasping fine grasses in its tweezers-like beak, the bird flies up to perch on an easel's paint-splotched crossbar. From there it flutters among jars of worn brushes to a shelf where it weaves the grass into a nest already brimming with moss, long strands of horsehair, and sticks splayed left and right. All the while grunts of cattle along with a musty aroma of dung waft in from the open window. A lone bat hangs torpid from the rafters, napping until dark when it'll fly off to forage.

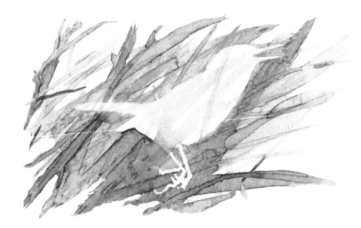

Now imagine a covey of artists in this unconventional workspace: they perch on stools, lean over paintings, brushes in hand. All are completely okay with the wren and the bat, the fecund pasture smells, and a barn cat plunking down on their sketches. Jennifer arranges a stag beetle—a new kind of painter's model for her—on the table. Sean hums a Talking Heads tune as he layers glazes on his cicada picture; Rebecca's long purple hair matches her painted heart, valves and all. Deanna stands back from her easel, tilts her head as she checks her composition. Srikanth takes a break from teaching yoga to bow over a painting of a red flame within a hand.

This is a scene from artist-teacher Elizabeth Sproul Ross's Shenandoah Valley farm, where she invites artists and art students to share her rustic studio for weeklong retreats. Her roots here reach back to the 1700s, when Scots-Irish ancestors settled this land. Now paintbrushes replace plows, as it's become a getaway from city life for those seeking new skills.

And with each group, this spry seventy-plus-year-old still climbs the hill behind the barn, funky knee and all, camera strapped around her neck, to fulfill the ritual of visiting an ancient apple tree. I, too, have now hiked to that windswept tree. Because in 2011, after seeing

my images of flying feathers tangled with strands of double helixes, she invited me to demonstrate painting at this farm where ideas are seeds, art the harvest.

WEEK OVER, I STOOD alone on the farmhouse porch watching the mid-May sunrise. On that unseasonably chilly morning, I clasped a hot mug of tea with both hands, touching its heat to my cold cheek. In the meadow before me, Black Angus nibbled shoots of fresh grass. I thought: *Right now, in each blade of grass, some tiny green disc snatches a ray of sun, a spot of water, a molecule of CO_2 from the air, and—presto!—the plant makes its own food. In the process, the leaf tosses out useless oxygen, ironically providing life-giving breath to animals.*

"Photosynthesis" sounded too studied for such magic, so I searched for something better when a line from a Dylan Thomas poem sprang to mind. Still leaning on the porch rail, I whispered: *The force that . . . through the green fuse . . . Um . . . drives the flower . . . drives my green age*

I inhaled, conscious of breathing a living equation: Sun + Water + CO_2 = Sugar and Oxygen. Breath and Life. *The green fuse.*

Whack!—the screen door slapped behind me. I turned to see John Sproul, Elizabeth's brother. It's his habit to swing by for some morning coffee and fresh-baked bread.

"What'ya looking at?" he asked, his big eyes twinkling.

"Oh . . . just watching the sunrise," I murmured.

We stood in silence, gazing toward John's farm about a half mile away, nestled in hilly meadows now hidden in morning mist.

"Bee-*u*-ti-ful." John's calloused thumb and index finger clasped the delicate handle of a porcelain coffee cup. As we continued to gaze past

the old springhouse, we spotted Elizabeth crouching low, her camera's long lens fused to her silhouette, reminding me of a long-beaked bird. She crouched to get her "rabbit's-view" perspective. I could have guessed she'd return to the redwing blackbirds' nest we'd discovered the day before. And that she'd rise early to capture it while fleeting drops of dew hung from each grassy leaf.

After breakfast—home-baked bread with scrambled eggs fresh from the neighbor's free-range chickens (school-bus-yellow yolks)—I knew what I wanted to do first: draw.

"Matthew found a dead kestrel. He saved it for you," Elizabeth had told me earlier. Matthew's a college student with a big heart and a keen eye. The little hawk was floating in a watering trough. Did it drown trying to capture a swallow swooping for a gulp? We'd never know. Its death was just one drama among billions every day on this farm alone that would, in Annie Dillard's words, "play to an empty house."

I picked up my sketchbook from the smokehouse-turned-cabin for visiting artists and walked to the barn-turned-painting studio. After the week's hubbub (everyone gone home now), the quiet was palpable. I fetched the kestrel from the barn fridge. Unwrapping cold sheaths of plastic released a death smell like sour cookie dough. Pulling on latex gloves to spread the bird on a Styrofoam meat tray, I pinned its wings as if stretched out in flight. Feathers quivered as a gust of wind blew through the hayloft. Except for its sunken eye, the bird looked ready to escape with a few rapid wingbeats.

As I drew, I noticed that each feather's black spot formed a stripe as it aligned with the adjoining feather's spot. For what purpose? At

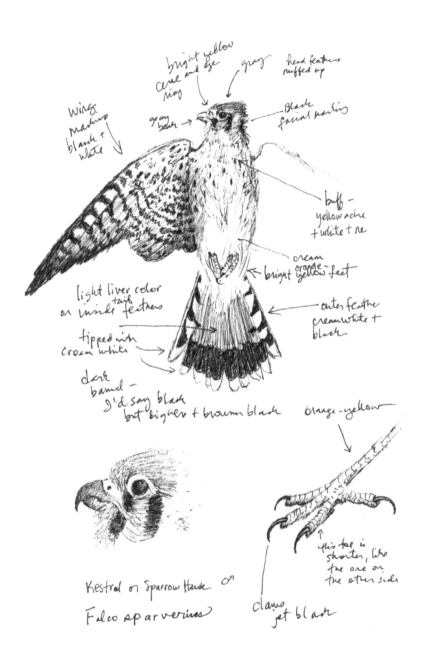

bright yellow cere and eye ring

gray

head feathers ruffed up

Wings. marking black + white

grey beak →

Black facial marking

buff – yellow ochre + white + re.

cream orange yellow feet

bright

light liver color on inside tail feathers

outer feather cream white + black

tipped with cream white

dark barred – I'd say black but higher + brown black

orange-yellow

this toe is shorter, like the one on the other side

Kestral or Sparrow Hawk or Falco sparverius

claws jet black

that, moment it seemed designed to dazzle my eye alone. But no, I suspect this intricate pattern evolved so a vole hunched in grass, nibbling seed, might not notice doom hovering overhead. Evolution is the greatest artist of all.

LATE THAT AFTERNOON A gentle rain fell, so I pulled on my new rubber wellies from Southern States. With a neon-orange poncho over my head, I trudged across land owned by the Sproul clan. But kestrels, voles, and black snakes also own the land. This turf belongs to the yellowthroat warblers who've been asking *wichita wichita wichita?* down by the creek for centuries, long before Scots-Irish settlers staked their claim. A meadowlark declared its ownership broadcasting *de de da dedaleeeee* atop a snag in the emerald pasture. Same for grasshopper nymphs snap-hopping away as I brushed through soggy leaves of grass. Spittlebugs cowered in their foamy cover-up busy sucking plant juices with their straw-like mouths—they, too, hold a deed in their DNA.

All of these lives plug into the green fuse.

Drizzle turned to downpour. I ducked into a dilapidated pigsty that hadn't heard oinking for decades. While rain hammered the rusty metal roof, I stood scanning the dirt floor in dim light. Mementos of human lives scattered on the dusty hard-packed earth like a canvas of found objects: an old leather shoe with metal eyelets, a dirt-encrusted cell phone ("Got to finish fixing the fence. I'll be late for supper"), square nails, corroded chains, a red plastic comb with missing tines, and rusty remains of farm implements.

I knelt down to gather these artifacts, hearing John's dream: "Someday I'm going to make a museum in the barn with all sorts of old

farm equipment." If anyone could do it, he could. Because John could identify the smallest corroded fragment of a reaper, plow, or harness. Holding a piece of tarnished buckle (from a draft horse's halter?), I thought: *All of these implements were fashioned to harvest the green world.*

To jot that down, I reached in my jeans pocket for pencil and paper but found only a crumpled dollar bill. A "greenback"—funny. Not "ha-ha" funny, but funny in the sense of how weird it is to think of money as "green." Perhaps the greatest human illusion—for sure the one leading to environmental catastrophe—is that life depends not on plants but on money. What a different world it would be if the truth were wired into us early. Planted in our brains at the ripe age of five or six should be the understanding that our lives depend on chlorophyll's alchemical green magic. And that the same is true for the grasshopper and meadowlark, the Black Angus and deer, the hawk and panicking vole running for its life under a tuft of grass. The spittlebug and I have so much in common.

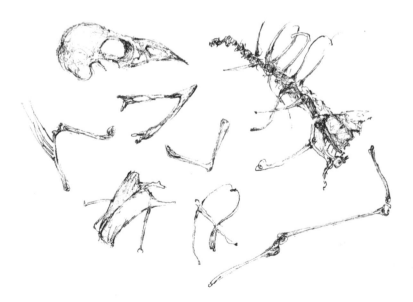

As I knelt on the earthen floor examining a constellation of small ivory bones, the sun broke through the clouds, sending a shaft of light through the wall, illuminating my discovery. Shards of brilliant green pasture glowed through gaps in the wood planks, like a stained-glass window in a cathedral honoring the living world.

When the rain let up, two chirping barn swallows swooped in, flying to their mud-caked nest fastened to a rafter. How did I not notice it? Spotting me, they plunged toward my head, chattering worry. Air currents from their beating wings fanned my face — would they really peck my head? It seemed so! One frantically circled the dirt floor, so I walked over to see why. There in the corner, a fallen nestling with purplish bumpy skin stuck with tiny quills struggled to hold up its wobbly head to peep. Its enraged parents dive-bombed *me* again. How to explain I didn't steal their baby from the safety of its nest?

I scooped the helpless chick from the dirt, clambered up some old stacked boards, and placed it back into the nest to join its siblings still inside their eggs. A whorl of striped down feathers lined the cup, which I recognized from my morning's drawing: the kestrel. Imagine, a predator's feathers softening the nest of prey.

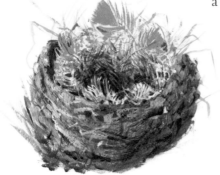

Squall over, time to leave, but not before stuffing my backpack with the leather shoe, as many hand-forged nails I could gather, and a few select shards of rust, all crumbling in the slow process of decay. Yet so

much couldn't be stuffed into a pack: the thrum of rain, the dizzying green light through broken slats, the chattering distress of bird parents.

"Okay, you'll be happy to know I'm going now," I told the swallows perched on a beam overhead, their flat little heads twitching this way and that, nervously waiting for this intruder to scram. I emerged into the sunlight, and the sweet scent of rain made me heady as I waded through wet grass back to the farmhouse.

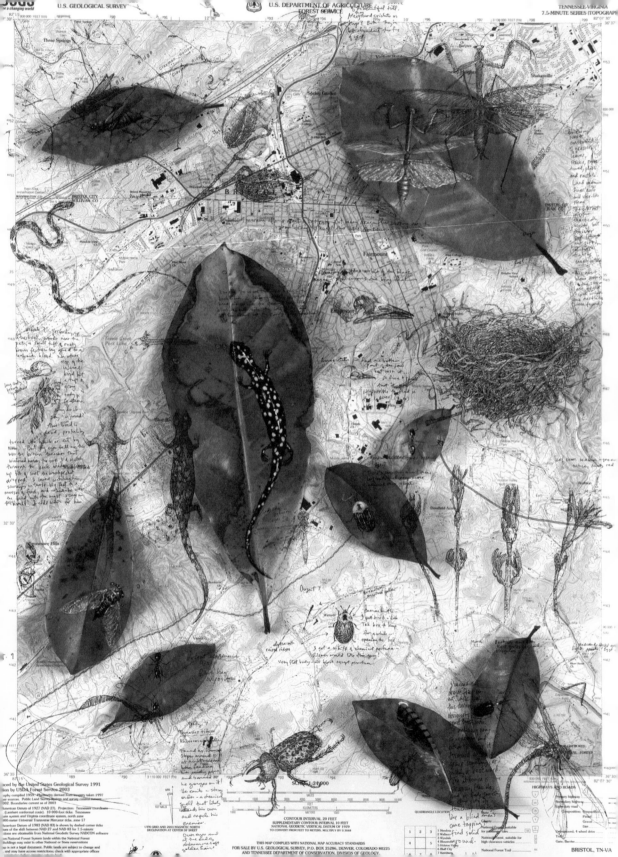

Daily Observations

BRISTOL

"TWO BEAUTIES!" DAN called from the porch. My husband of forty years had pulled on his old sneakers to wade out in soggy morning grass to gather a few magnolia leaves in the front yard. The leaves fall year-round, but because they're leathery thick, they age but don't curl up dry and brittle. The pattern on each one, once it falls from the mother tree, is unique. Glossy green ages in russet or chestnut-brown patches, shifting to shades of dun or silvery gray before gradually crumbling into earth. A study in senescence.

"No dimwit today," Dan muttered, referring to his self-made litmus test of mental sharpness. His daily leaf-collecting ritual creates an arc between the old magnolia tree ("Maggie" as we call her), his leaf-selecting process, and finally, me.

As he placed his discoveries on the kitchen table, I watched a small spider scramble from the heap to hide under the saltshaker. One

leaf was splotched with coppery dots over glossy chestnut brown—a dappled horse's rump. Another was burnt sienna, green flaming from its central stem that branched to a point on every vein.

In his black small-billed cap, Dan reminded me of a Chinese worker as he carefully arranged one weathered leaf on the sill of the dining room window. I watched it flutter to the floor as his hand, shaking from essential tremor, lost its grip. He carefully placed it back. My attention shifted from the leaf to his eager face. I remembered that face tanned and smooth, wisped with blondish curls. Now, crow's feet gather around his still-spry eyes and gray stubble bristles over his slightly drooping cheek.

So I live with a curator of leaves, our house bursting with them: on tables with paisley cloths, on oak shelves, but mostly on windowsills where they glow in morning sun. We speak of how they fade, or don't. Chemical mysteries! Sometimes they fall, break, are replaced.

Dan can get even more obsessive, scissoring and slicing a broken but beautifully patterned leaf into a tapered shape.

"So, you think you can improve nature, luv?" I ask, really hinting that he might empty the garbage, not while away yet another hour shaping an old broken leaf to his dream of perfection.

I empty the garbage. Not that he notices.

"Look at this one." He holds up a leaf with a spot of butterscotch brown on green.

"That spot needs something…an ant?"

"Can't wait to see it!" Dan obliges me to live up to my whim.

EVERY MORNING, GLOOMY OR BRIGHT (before any painting begins), I climb up to the woods that shadow our house, dry leaves crunching along the path I've lined with fallen branches and sticks. Beginning a few feet from the kitchen door, the trail enters a hillside of grasses, tall ironweed, and goldenrod, and then it passes through a border of sapling sassafras, redbud, and thorny brambles. Above that, it makes a big circle through a stand of tall sugar maple, tulip poplar, oak, and shagbark hickory.

> *June 14th, 8:30 a.m. I'm strolling around the loop of the path for the umpteenth time. But no walk is ever the same walk, says a poet whose name isn't coming to me now. A fern frond bows, as if to say, "Look at this," pointing to a lichen-encrusted rock. I squat to draw those patina-colored concentric circles on the stone. I paint it in my mind: cerulean blue with a pinch of yellow ocher and a dab of titanium white.*
>
> *A glossy black-and-yellow millipede ambles by on his slow way to some-where, casually coordinating all those threadlike legs across last year's leafy rot.*

*Beginning near the head, its legs move in waves, undu-
lating "down all ten segments of his sleek armor — since
my two legs wobble climbing this hill, I must bow to this
creature's genius.*

*Farther up, I kneel on a log, try to decipher the erratic lines etched on
its surface — squirrel scamper? — then scrape the tough green skin of
a fallen hickory nut with my thumbnail, sniff. Wow! — the scent
whacks my nostrils like Vicks VapoRub. I sketch the husks arching
over a nutty heart.*

That walk was as good as it gets.

I confess that sometimes I hardly get halfway around the path when my mind wanders to the shopping list on the fridge or embarks on a planning session for an exhibit. Or perhaps a nagging duty lingering within my inbox eclipses nuthatches and millipedes or the entire hillside. Worse yet, some thorny personal problem or petty offense echoes in my mind. That's when I make myself trudge back down to begin the loop over. Not paying attention draws the card "Go Back to Start."

THE NEXT DAY, I made it happen. A black ant gleamed in the brown spot on Dan's prize leaf. The morning after he'd found it, I'd watched an ant tugging futilely on a dead caterpillar, so I scooped it up. Once in my studio, I covered the critter with a bell jar, squeezed out acrylic colors on my palette, and pleaded with the ant to hold still as I painted.

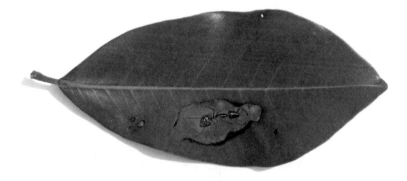

It was the beginning of a new ritual: leaf painting. Soon a smaller leaf made a leather-brown canvas for a grasshopper I'd found leaping in midsummer's heat. Not long after, on a broad coppery leaf, I painted

a praying mantis—she'd hung out on the morning glory vines all summer. I brushed a spotted salamander on another. And in late October, my chosen models were slugs mating in a yin-yang embrace, coupling motionless when I brought them in my studio (I'm no species snob and am a tad voyeuristic).

Just yesterday, I peered through the magnifier lamp at a carrion beetle. The leaf chosen for that one was bladelike, edged with a squiggly black line. Smack in the center of the beetle's hard yellow thorax was a black spot filigreed with tiny veins when seen up close. Eyes shifted to my grubby cuticles—a manicurist's nightmare! I should use Intensive Care lotion on my hands, rough from decades of scrubbing brushes, but can't be bothered. And the line between my squinting eyes grooves deeper every year from constant gazing at small things, such as this tiny insect spread before me.

Magnolia leaves. They clutter our house. Some bear my paintings; some move Dan to arrange and rearrange. Now he even writes a poem in the voice of a magnolia artist:

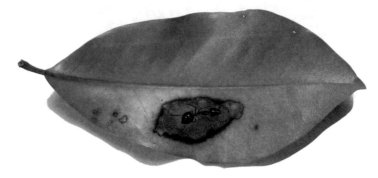

No longer needing
"brush or pen,"
only my *winter-weathered eye*
which reawakens every Spring

 to gleaming copper circlets

overlapped like oval
scales upon those fallen
leathery canvases

SOMETIMES IN A SUMMER breeze, or when we stir the air walking briskly by, brittle leaves float from windowsills, clatter on the oak floor. It doesn't matter. Shards are swept up, thrown in the compost. Dan gathers more leaves from Maggie.

We witness leaves lose all trace of green, chestnut brown dulling into umber. And we watch the painted images change, like tattoos on aging skin, as their leaf-canvases fade.

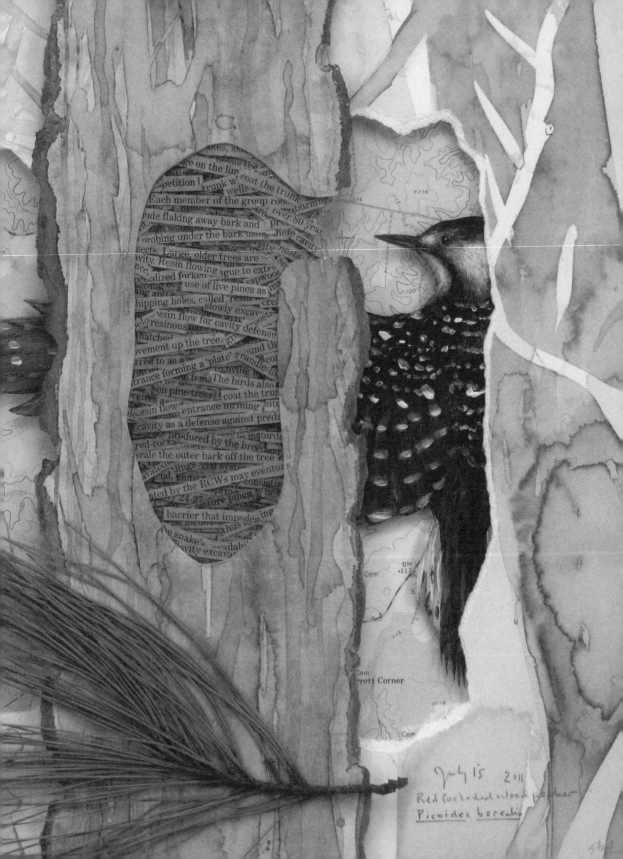

July 15 2011
Red Cockaded Wood pecker
Picoides borealis

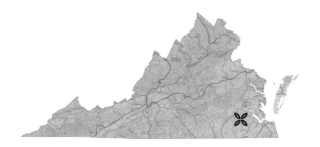

Gaining Ground

PINEY GROVE PRESERVE, SUSSEX COUNTY

BEEP...BEEP BEEP...BEEP BEEP BEEP...I peeked from my shelter of sheets, the room still shadowy, toward the clock's digital glow. 4:30 a.m. Time to rise, time to seek an endangered species, the red-cockaded woodpecker, which is gaining ground in a hostile world because a few good spirits guard it. And I was about to meet one of those spirits.

Throwing off the blanket, I swung my legs over the bed, punched the alarm off, and stumbled to the bathroom. My unfussy lodging was a small room at a 4-H camp. As I peered into the mirror, toothpaste foaming from my mouth, I anticipated seeing the rare black-and-white-checkered bird. What banal rituals we conduct every morning! Yet wait, surely birds, too, have ordinary rituals on waking? After dragging a brush through my hair, I slipped on cargo pants and a stiff camp

shirt, gulped some lukewarm coffee from a thermos. Banana stuck to the roof of my mouth as I grabbed my keys, backpack, and binoculars.

I was in southeastern Virginia, land of cotton and peanut fields, swamps and pine groves—same latitude as my home in the mountains, yet worlds apart. More like the Deep South of Georgia, where Janisse Ray's *Ecology of a Cracker Childhood* is set, a book that first stirred my fascination with the red-cockaded woodpecker. Truth is, I was surprised these birds, so dependent on old-growth pines, were in Virginia at all. When I discovered they were, the RCW—what the devotees of the bird call it—became a quest.

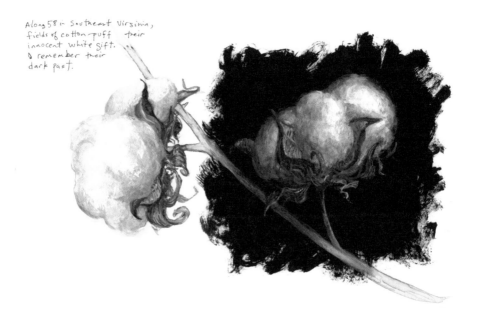

Along 58 in Southeast Virginia,
fields of cotton puff their
innocent white gift.
I remember their
dark past.

And that fancy word "cockade" in its name? It refers to a little dash of red feathers on the side of the male's head (named by an ornithologist long ago when cockades of colored ribbons decorated hats). The red streak—small as it is—surely evolved to dazzle the eye of the female woodpecker. She must be a subtle type.

That morning I'd arranged to meet Bobby Clontz, the Nature Conservancy steward of Piney Grove Preserve, where all of Virginia's breeding red-cockadeds live. "The surest way to see the birds is to be in the grove at sunrise when they first emerge from their cavities," Bobby had emailed the week before.

By 5:10 a.m., my hands clutching the wheel, I steered down a deserted country road, headlights on bright. The thrum of tires on sand and stone ceased as I turned onto pavement, Highway 460. Bobby told me to be at the Adams Country Store by 5:30. When I pulled in the lot lit by one security light, I knew the lone white truck had to be his.

Bobby reached from the rolled-down window to shake my hand. "Good morning, Suzanne," he said with a smile.

"Thanks for getting up so early!" I held back a yawn.

"No problem—it's the norm for me. Besides, it's great you want to see these birds. Get on in." In the predawn light, Bobby cruised along carefully, using his blinker though there wasn't a car in sight.

"My dad was a wildlife artist," he told me. "Painted mostly waterfowl—ducks, geese." Bobby himself is an accomplished photographer, snapping pictures of his beloved birds, but also frogs and flowers, even some city scenes. As we chatted about art on the way to the Piney Grove, all the while I kept my doubts to myself: *I came all this way. Will I actually spot the woodpecker?*

We arrived at the preserve around 5:45 a.m. Though the first blush of dawn illumined the sky, it remained shadowy under the towering pines. An old log provided our perch as we began the wait, clutching binoculars should a bird appear. Bobby's Nature Conservancy hat was cocked back; his eager expression made him seem so youthful despite his over-forty years.

"I paint white stripes on trees with an RCW cavity," he said, which I noted in my sketchbook. The way he said "RCW" reminded me of how folks call friends by initials—you know, "JR" or "BJ"—instilling mere letters with affection.

Robins declared morning with their melodious *cheerily, cheer up, cheer up, cheerily*, as if the opening act for the main event. The sharp scent of pines filled our nostrils, and while I hadn't spotted an RCW yet, I would find out the next day that legions of chiggers had found me. Itchy bumps around my waist were a small price to pay to see an avian marvel in the wild.

As we waited, I thought about why I was out there. I mean, I could always paint from a photograph—would anyone even know? Maybe not, but I prefer witnessing creatures in the habitat where their own life dramas take place. It keeps me grounded. It keeps art-making connected to living, breathing animals that then crawl or fly or swim into my images.

At 6:14 a.m. Bobby whispered, "Hear that?"

"You mean that squeaky chirp?"

"Yep. That's it up there." Bobby pointed to a hole high in one of the pines marked with rings. A sharp beak jutted out. A head poked out, in, out, in, out—each time making a high-pitched *chirip!* Then another

bird joined from its cavity in a tree nearby: *Chirip!* Then another. And another. My eyes ricocheted from bird to bird high in the pines as they greeted one another.

It was as if the lights had risen on a stage—the Piney Grove theater. Sunlight glazed pines golden green as the entire cadre of red-cockad-eds emerged from their roosting trees. Soon they scattered into the canopy, unseen but for one bird that swooped down to a nearby trunk in a blur of black-and-white speckles. For the moment it clung to rough bark, I made out the white cheek patch, black cap, and long black line running down the neck, reminding me of long sideburns. Then, as if to say, "You've had your look," it zipped off.

ONCE ALL THE BIRDS had disappeared to forage for the day, Bobby and I walked deeper into the grove across the springy duff of pine needles.

"RCW family groups are called clusters," he explained. "A mating male and female nest with their unmated male offspring as 'helpers.' The female offspring leave to join other clusters."

"Wow, that's strange for woodpeckers, or any bird for that matter."

"Yep. And RCWs are the only woodpeckers that actually *live* in their cavity year-round—they don't just use it for nesting."

"Each bird has its *own* cavity?"

"That's right. And they only use living pines, seventy years old or more. Old enough to have red heart fungus, which softens the heart-wood so the woodpecker can drill into it. These are old loblollies." He swept his hand around.

"I read they only like longleaf pine?"

"Not strictly longleaf, though that might be their first choice. They'll accept loblolly or shortleaf pine if they have to."

Leaning back, I craned my neck to check out one of the cavities.

"See all that sap dripping from the hole?" he asked.

"Yeah—reminds me of a candle dripping wax."

"Well, when the cavity's bored out and the woodpecker takes up residence, it drills small wells around the entry hole so sap runs down the trunk. That keeps snakes from entering the cavity."

"Snakes climb *that* high?" The hole was at least forty feet from the ground.

"Black rat snakes can slither vertically up the trunk. But they won't cross the gooey sap. No sap flow means the cavity isn't occupied."

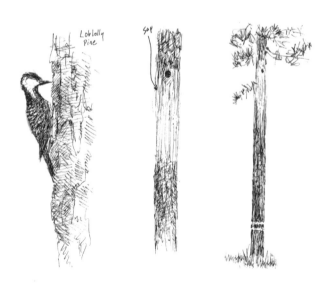

Loblolly Pine

sap

BY 8 A.M., SHAFTS of sun dappled the ground, like a slow-motion light show on a mat of rusty needles. Not a red-cockaded in sight, only a faint tapping on a trunk now and then. Bobby showed me swaths of black-charred pines his crew—his "fire family," as he called them—burned to keep the undergrowth down, all for the birds. Too much undergrowth means fewer insects to feed on.

"Why are these birds endangered?"

"Remember, they need *old* pines? Well, people don't let pines mature long enough before logging. Back when European settlers first came to Virginia, there were huge stands of old-growth longleaf—about a million acres. They tapped them for pitch and tar and logged them for ship masts. Or clearcut for farms. The pines and the RCWs were common in Jefferson's day, but they were on the decline even then. Clear the old pines and the birds have no way to hollow out a cavity."

"There you go—take one species out of the picture and it affects so many others."

"That's right."

It was a beautiful woodpecker-and-pines morning. What a magical place, Piney Grove. A refuge where, after centuries of decline, the red-cockaded woodpecker is making a comeback.

Before we parted, Bobby handed me a pamphlet about the bird's life cycle. About the mission to keep this precious species alive. One day I'd take a scissor to these printed words, layer sentences within a nest cavity of my own making for an assemblage titled *Gaining Ground*.

RETURNING TO THE BUSY highway, by myself now, I felt as if I'd just emerged from the spell of a dark movie theater into the glaring light of day. Near Wakefield a little stand boasted "Fresh Peanuts"—no way to resist nuts rooted in this very place. But I did resist the urge to tell the gruff old guy at the register about the woodpeckers. Out in the parking lot I cracked a crisp shell, popped a roasted nut in my mouth.

What the Mockingbird Told Me

MONTICELLO

I FELT A PRESENCE. A stone's throw from Thomas Jefferson's grave, someone stirred behind me. The leaves crackled slightly — surely only a squirrel? Then I heard breathing. I kept my pen moving as I sat cross-legged on the forest floor, drawing. A throat cleared, followed by a camera's rapid *cha-chick.* Slowly, I turned my head.

"Mind if I look at your drawing?" a husky voice asked. Looking up, all I could see was a towering figure silhouetted by the sun. All, that is, but Monticello written in white script on a cap.

"Um, sure," I replied as he stooped to look.

"I can't draw a straight line with a ruler," he grinned, then paused a moment. I imagined he was wondering why I wasn't sketching the tomb nearby, the polished granite obelisk carved with the epitaph Jefferson wrote himself that famously leaves out having been president:

HERE WAS BURIED

THOMAS JEFFERSON

AUTHOR OF THE DECLARATION OF AMERICAN INDEPENDENCE

OF THE STATUTE OF VIRGINIA FOR RELIGIOUS FREEDOM

AND FATHER OF THE UNIVERSITY OF VIRGINIA

"I'm from Iowa," he continued. "Just visiting Charlottesville—here to get a little dose of American history. What is that you're drawing?"

"A patent leather beetle," I answered. It flashed through my mind to tell him I'd been searching for twinleaf, *Jeffersonia diphylla*, in the Grove, the woods surrounding the family graveyard on the grounds of Monticello. But then I'd have to explain that the little flower is named after Jefferson because it blooms in April around his birthday. And I'd have to confess that I knew it was really too late in the season to find it. Besides, the flower in the wild is rare. If all that had spilled out of my mouth, I'd likely have waxed philosophical about how I thought twinleaf related to Jefferson's dichotomous nature, a man who was happier singing on horseback observing the natural world than planning policy in the White House. So I remained silent.

"Are you from Virginia?" the stranger asked.

"Yep."

"Mind if I take your photo?"

"Not at all," I answered, amused he didn't see me as a tourist but as part of the ambiance of the place, as if I were a prop. Somewhere in Iowa, deep within a computer file, lurks my quaint image—a *real* Virginian?—sitting cross-legged near Jefferson's tomb, sketching a beetle.

Decades ago, I visited Monticello with my husband and young son Ted—a history lesson for our fourth grader. I remembered the Neoclassical house, a take-off on Andrea Palladio's sixteenth-century architectural drawings (themselves inspired by ancient Roman temples), seen by Jefferson during his stint as ambassador to France. I also vividly remembered the entrance hall teeming with trophy heads—a shaggy bison, an elk's huge rack—and an American Indian pictograph painting on buffalo skin. Not your typical eighteenth-century decor.

But this time I was alone. This time I was equipped with sketchbook and pen (no "Oh, Mom, do you *have* to draw?"). This time my task was to gather ideas for an assemblage based on my experience, one I'd mount on a Charlottesville West US Geological Survey topographic map. So far, so good. But if you really want to know, my profound reaction on arriving at Monticello was this: *Jeez, what was I thinking?*

How could I make art in my own voice based on a national monument? A piece that was personal and fresh? I had no clue. As I packed my day's gear in the parking lot—nauseated by the fumes from a looming tour bus (why do they have to keep their motors running?)—I thought: *It's one thing to create a work on a historical figure, yet another to respond to a UNESCO World Heritage Site and a celebrated tourist hub. How could I intimately connect to the restored Monticello, with its swarms of camera-toting tourists, numerous guides, posh gift shop, and vast parking lots humming with shuttle buses?*

I coaxed myself: *Don't think too much. Just spend some time here.* Just stroll around, squat to make a sketch of some little creature that might have landed on Jefferson's horse, hear the birds squawk or whistle, inhale the mountain air, examine some detritus on the ground, and perhaps discover some idiosyncrasy about the architect of this house and garden.

I forked over the $24 entry fee, then shuttled up the gentle hill Jefferson named Monticello, which translates "little mountain." To forget the buses and to hear the voice in my head, I marched off to the Grove, where I began this tale. There I had avoided the tourists, until the Iowan with his camera came along.

ON TO THE HOUSE tour. Surely some snippet of the tour guide's script might spark an idea. Still tucked in the clear plastic pocket of sketchbook #34, the ticket reads:

<div align="center">

ON MOUNTAINTOP

ENTER LINE AT 11:20 AM MAY 25, 2011

ADULT

TRX#: 1992760

MONTICELLO

</div>

Under those words stretches a signature, as if sanctifying the tour by the man himself:

<div align="center">

TH JEFFERSON

</div>

The tour group gathered around the front steps of Monticello's octagonal shrine, like pilgrims about to embark on a mission. Nearly hidden but for its stunning blue tail, a five-lined skink spied us warily before dashing up the rough rouge bricks.

"Hi, my name's Andrew. Please come join me," said our guide, wearing a stylish black sports coat with a thin orange tie and black shades. He herded us in the door as a flycatcher sang *pee-weeeeeeee* over the portico. I wondered what the group would do if the tour began, *Welcome to Monticello!*

Hear that bird? That same species would have swooped over Mr. Jefferson when he checked his rain gauge. We know this because, consummate record-keeper that he was, he jotted "Little brown flycatcher" on a bird list—what we now call the eastern wood pewee.

What our guide actually said: "Over here is a copy Mr. Jefferson made of his father Peter's original map of this region." As he continued, I stealthily crept over the creaky floorboards. Fumbling my sketchbook open, I jotted some notes next to a quick sketch of the elk antlers sent to Jefferson by Lewis and Clark, along with so many other specimens, furry and not. A white marble bust of a smirking Voltaire perched on a shelf amid Native American shields, headdresses, spears, and painted skins depicting battles, as if the philosopher were amused to find himself among this anomalous collection.

We continued to the bedroom/study, two rooms split by a bed within a niche smack in the middle. I wondered on which side Jefferson's bare feet hit the cold floorboards.

A tourist near the bedside wearing an embroidered US flag on her denim shirt pocket whispered something in her husband's ear; he blushed, murmuring something as he shifted his white Reeboks. When we crammed into the study, a slight man with a pointed beard put on reading glasses for a closer look at titles on the revolving bookstand. Beside a tall grandfather clock, a teenager's shaggy head bobbed to an inaudible beat heard only in his earbuds. If Jefferson suddenly stepped in the room, I'd bet the iPod would be the first thing to pique his curiosity.

Next Andrew pointed out architectural features designed by the former POTUS, including a skylight in the ceiling, and the primitive copy machine that attached a second pen onto his pen, enabling replication

of his twenty thousand letters. Then he casually mentioned Jefferson's love of mockingbirds: "As the legend goes, while the president mulled over the nation's problems, his pet mockingbird, Dick, perched on his shoulder. Often Jefferson would put bread between his lips so the bird might pluck it from his mouth." Now that's intimacy!

Andrew continued, "He carried his pet from Monticello to DC during both his terms as commander in chief. When President Jefferson played his violin, Dick poured out his own melodies."

Shame there's no recording of that duet, the first "Live at the White House" concert of sheer joyful noise.

AFTER THE HOUSE TOUR, I wandered through the gardens. It pleased me to see clover in the turf—what would the Founding Gardener have thought if ChemLawn destroyed all the nitrogen-fixing legumes on the mountaintop? As a flock of cedar waxwings whistled *zeeeeee!* overhead, a hoverfly sipped salty sweat from my leg with its suction cup of a tongue.

All the while a mockingbird sang, its aerial antics in full swing. The bird leapt up, flashed white wing patches, then landed on Monticello's front pediment, long tail pumping like a lever as it hopped right, then left, still piping its tune. I identified the birds he imitated.

Tweedle tweedle tweedle: Carolina wren. *Drink your tea!*: eastern towhee (were any real towhees ever fooled?). *Eh-eh-eh-eh-eh-e*: red-bellied woodpecker. *Itchi-tah itchi-tah ooo*: What the heck was *that* bird? I was stumped. Either I didn't know the bird imitated, or the mockingbird's imitation so altered the original as to become something new. Which got me thinking: *Wasn't the mockingbird's appropriation of other birds'*

erson's own appropriations—and improvements—of others' work?
on of Independence was a take-off on George Mason's Virginia Bill
ever remember Mason's line about life, liberty, and "the means of
ing and protecting property and pursuing and obtaining happiness and
skill was not to conceive it, but to streamline it into "Life, liberty,
happiness." Sometimes creating something original isn't as important
xisting thing memorable.

N to the vegetable garden, where perfect rectangles of
loamy compost abounded with peas, coarse artichoke plants, the feath-
ery tops of carrots, and beans vining up teepees of lashed saplings.
A woman—I'd say fortyish—in a blue shirt festooned with white
flowers bent over as she tugged purslane from the asparagus bed. She

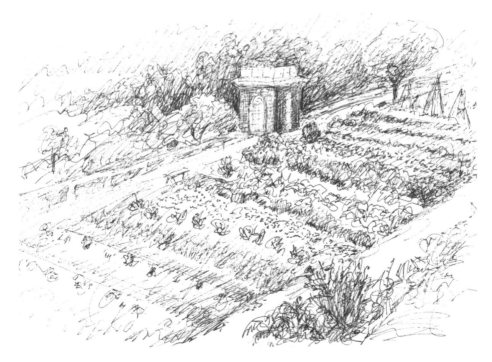

obviously worked there, but little did I know she was Pat Brodowski, head gardener at Monticello.

"Excuse me," I said haltingly, pointing to a heap of plants in a wheelbarrow. "Could I have a few of these nasturtium flowers to draw? I'm an artist working on a project called 'Notes on the State of Virginia.' I'm here gathering ideas for a piece on Monticello and...."

Before I could finish she brushed the dirt off her hands, adjusting her round glasses as she squinted up at me, and began a personal tour of the gardens. "My name's Pat. Jefferson loved nasturtium," she told me as she plucked one of the orange flowers. "He admired plants that satisfied both his eye and his palate. Did you know both the flowers and leaves are edible?"

"Really?" Although I did know, I opted for not sounding like a know-it-all, since there was so much I wanted to learn from her hands-on green expertise.

"He loved plants that were both aesthetically pleasing *and* practical," Pat continued, giving her long ash-blond braid a tug. "Beauty for the eye, pleasure for the palate, and good health." She smiled. She must have been following his advice herself, I thought, judging from her robust complexion.

She snapped off a couple of huge bristly artichoke leaves. "Here, take these." By now she'd already offered me so many specimens. These were too big to fold in my pack, already crammed with pea pods on the vine, variously colored carrots, and nasturtium. So I clutched them like a bouquet in my grubby hands.

"All the plants grown here now could've been found in Jefferson's garden over two hundred years ago," she told me.

I pointed to a purple cabbage. "What a gorgeous color! I wonder if it would make a purplish-blue dye?" I'd experimented with natural pigments—coffee, walnut, poke—but was surprised to find Pat an expert on the subject.

"No, the cabbage color fades," she said. "Jefferson purchased the indigo plant—*Indigofera indigo*—to get a blue dye. You boil it with a mordant to fix the color—come to my July workshop on natural dyes, and I'll show you."

"I'll be back!" I promised. And in July I did return to Monticello's Tufton Farm to watch Pat demonstrate her brews of natural dyes to a class. Four pages of my sketchbook are brushed with various colored washes and descriptions such as "Coreopsis: pour boiling water over flowers / place in sun for 2–4 hours." Or plant names labeling dye swatches, such as "Tansy" under bright yellow and "Cutch" under rusty red.

But now, within the gardens of Monticello, Pat and I talked veggies. Before leaving for home, she wrote on the back of my sketchbook: "Suzanne Stryk can collect what she needs from Jefferson's garden. Pat Brodowski." I felt like royalty (with apologies to antiroyalist Jefferson).

MY DAY WAS WINDING UP. After sketching a rogue plant bug crawling up a bean stem, I hopped on a shuttle back to the parking lot. Sprays of pea plants burst out of my backpack as I hugged Pat's gift of artichoke fronds. I did get some odd looks. Eager to whip out my special note from Pat, I felt like a schoolgirl proud of her hall pass to leave before the bell, but no one on the bus questioned my botanical booty.

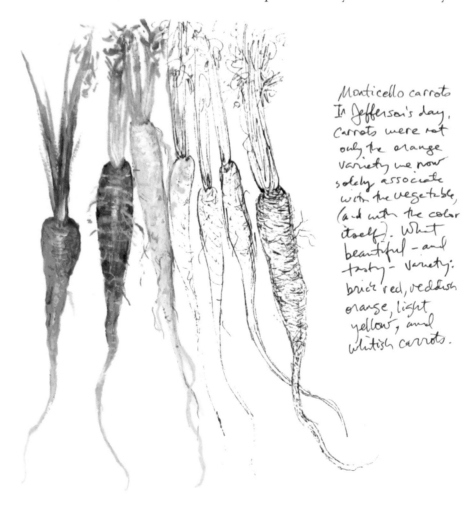

Monticello carrots
In Jefferson's day, carrots were not only the orange variety we now solely associate with the vegetable, (and with the color itself). What beautiful — and tasty — variety: brick red, reddish orange, light yellow, and whitish carrots.

I rinsed dirt off the carrots in a cast-iron drinking fountain. The first thing to do back at the car was get the pea and nasturtium leaves in the plant press. And though zapped from cramming so much into one day, I used my last ounce of energy to get out pens, brushes, and watercolor. In the distance, a mockingbird strung phrases of other birds' songs together like beads on a necklace.

Leaning over a palette set up on the hood of my Subaru, I painted the carrots' subtle shades of brick red and pale yellow. I took one last look at the carrots before eating them. They were still crisp and so sweet.

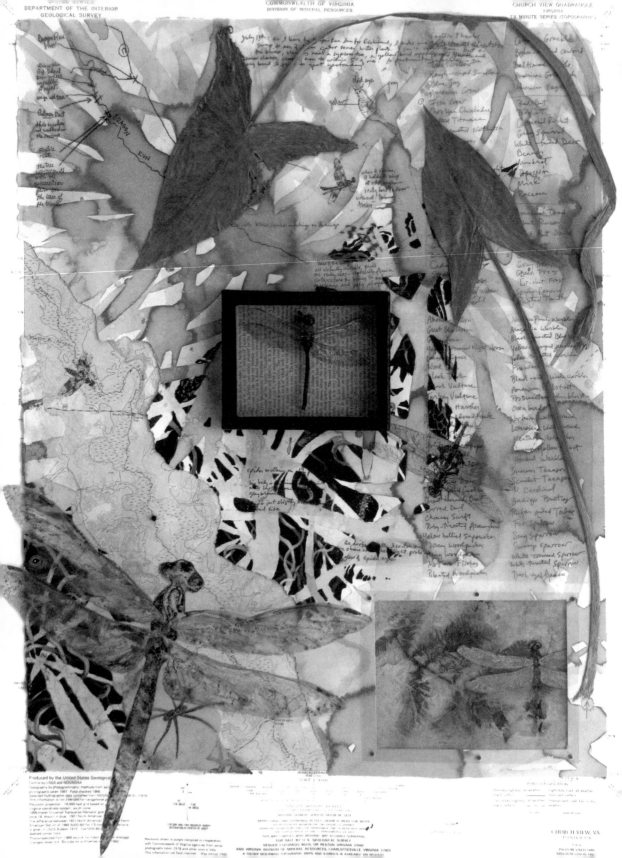

The Dragon

DRAGON RUN SWAMP

Knee-deep in the Dragon, I lean in
to feel the wilderness.
　　　　　　—Carolyn Kreiter-Foronda,
　　　　　　　　"Dragon Run"

ID-JULY AFTERNOON, MY car wheels crunched the gravel driveway of the Dragon Run Inn, a big old farmhouse turned country-style bed-and-breakfast. I'd come to kayak the pristine swamp at the headwaters of the Piankatank, a river overshadowed by its larger cousins—the Rappahannock, York, and Potomac—meandering through the "River Country" region of Virginia.

After hours behind the wheel, I couldn't wait to wander under the broad lawn's sprawling black tupelos. I quickly checked into my quaint room with its ruffled lemon-yellow curtains and matching bear-claw

quilt. With the afternoon to myself before a guided excursion later that night, I stuffed sketchbook and pens into my vest pocket and took a stroll.

Darting over a do-it-yourself koi pond (the kind lined with thick black plastic rigged with a trickling little fountain), a large dragonfly alternately appeared iridescent green and pure black, depending on how it caught (or didn't) the sunlight. The living drone cared nothing about the artificial decor, only about its prey that bright afternoon. Dashing through a cloud of midges, it snared one in its spiky front legs, then buzzed over to perch on the head of a blue ceramic boy holding a watering can to munch on its victim. Meanwhile, the cadre of midges continued to bounce up and down like gyrating electrons, seeming not to notice one of their comrades had gone missing.

Nor did the dragonfly seem to notice my presence. Ever so slowly I opened my sketchbook, slower yet removed the cap of my pen with my teeth and began scribbling head-thorax-banded abdomen crossed with those delicately netted wings.

All the while unaware that I myself was being watched.

"I didn't know anyone did *that* anymore!" Ivan, the innkeeper, shouted from the wraparound porch as he watered hanging ferns.

Startled, I dropped my sketchbook in the grass, surprising the dragonfly, which veered off to another perch.

"Do *what?*" I called back.

Removing his ballcap, Ivan scratched his gray hair and stroked his beard, then slapped his hat back on, as if needing a moment to ponder his response.

"Oh, you know…draw stuff when you could take a picture."

"Guess I just like drawing." I knew better than to explain my love for this low-tech practice, something most folks think old-fashioned, and certainly not to shout it at the top of my lungs from thirty feet away.

Grabbing my sketch from the grass, I smoothed the creased paper with my fingertips and then folded the book into a deep pocket. As I moseyed over to check out some citron-yellow mushrooms gleaming from an old stump, Ivan's words echoed in my head. My response? Draw something else, something equally primal — fungus. It occurred to me then that this anachronistic preference for drawing held the very reason I was at Dragon Run: to witness the world filtered through my own eye and hand alone.

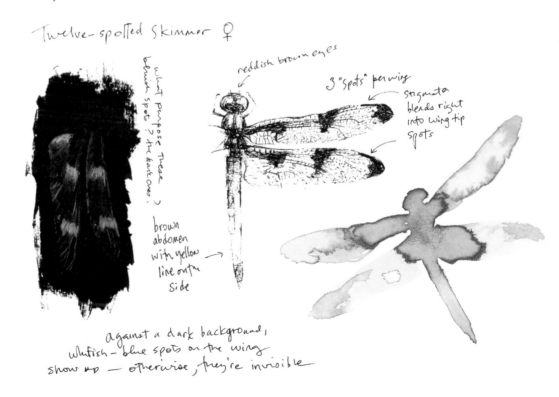

Twelve-spotted Skimmer ♀

what purpose these brown spots? the dark ones

reddish brown eyes

3 "spots" per wing

stigmata blends right into wing tip spots

brown abdomen with yellow line on the side

against a dark background, whitish-blue spots on the wing show up — otherwise, they're invisible

"IF YOU REALLY WANT to experience the Dragon, you have to go out at night," paddlemaster Teta Kain had emailed me in May when I was planning the trip. Described as "everything Dragon Run," all-around naturalist Teta would be my guide into this secluded cypress swamp. She assured me, "I know all of the bridge crossings — all of the ways to access the launching points. And make sure you have binoculars, a water bottle, and some mosquito repellent."

The email stirred my excitement about kayaking one of the most unspoiled wetlands in the eastern United States, with the undauntable Teta and newly befriended poet Carolyn Kreiter-Foronda. In fact, Carolyn's poem "Dragon Run" had first drawn me to this unspoiled swamp, and I'd written her as much. When she expressed eagerness to join our paddling adventure, well, that was icing on the cake.

But both of us were a little perplexed when Teta later insisted on keeping a secret about something special we'd see only at night, promising a unique vision a poet and an artist would surely love.

After 7 p.m., when sunlight began to wane, we three Dragon Ladies met at the bed-and-breakfast lot. Carolyn and I pushed aside piles of field guides to squeeze into the cab of Teta's Ford pickup. We jostled shoulder-to-shoulder as the truck bumped along wheel ruts in grassy roads. When we reached the Friends of Dragon Run wilderness, I hopped out to unlock the gate.

We parked in a clearing near the dark water's edge. A small bird squeaked — *pee-eat-seik! pee-eat-seik!* — from a towering sweetgum.

"Acadian flycatcher," Teta pointed.

"I don't see it." Carolyn looked overhead, surveying the treetops as she shielded her eyes from the sun.

"Those little guys are easier to hear than see." Teta's bright eyes flashed, her mouth tightening into a grin. She gazed up to the trees as if she were talking to the bird itself: "Acadians love moist hardwood forests, so even blindfolded I'd know the habitat just by hearing one."

The end-of-the-day drone of swamp cicadas and the *errr-errr-errr-errr-rrrrrrrrr* of their organ-grinder kin began, mingling with the flycatcher's own staccato song. In sync with that soundtrack, Teta started dragging kayaks out of the truck bed.

"Here, let me help you." I scrambled over.

"Oh, no! Since my hip and shoulder replacements, I've got to stay active to do these river trips," she playfully scolded. "All I had to quit is skydiving." She raked her fingers through close-cropped hair, then heaved the blue boat out onto the ground. Carolyn and I exchanged glances with raised eyebrows. *Wow, what a seventy-two-year-old!*

Our swamp poet laureate, Carolyn (who'd worn that Virginia laurel from 2008 to 2010), climbed into a kayak first. Her freshly applied lipstick and flowing dark hair combined with her knee-high wellies told me so much about her one-foot-in-the-ballroom, one-foot-in-the-wild spirit.

Because I was new to kayaking, Teta patiently demonstrated the basics: how to sit snug in the cockpit, how to grip the paddle, how to stroke—forward, backward, draw, and sweep. How to launch. Pushing off awkwardly into the tea-colored water, I bashed into a cypress tree. But after that graceful debut, I quickly got the hang of it.

"So where are all the mosquitoes?" I grumbled. After all my fretting, the little pests never showed. Mysteries abound!

We paddled single-file through dense arrow-shaped leaves of pickerelweed out into open water. Before me, Carolyn's hair swirled over

an orange life preserver as she carefully dipped her oar right, then left, right, left. Teta backed our excursion, stabbing the water with sharp firm strokes, huffing slightly.

With lights strapped to headbands and to the prows of our kayaks, we floated down the current. As darkness spread, the bird-cicada concerto transitioned to a frog-katydid crescendo. Teta continued to identify calls: cricket frogs like hundreds of snapping fingers, bullfrogs' deep bassoon, the high-pitched trill of gray tree frogs. This night music was backed by the mellow percussion of a *katydid-katydidn't-katydid-katydidn't* chorus overhead in the leafy gloom.

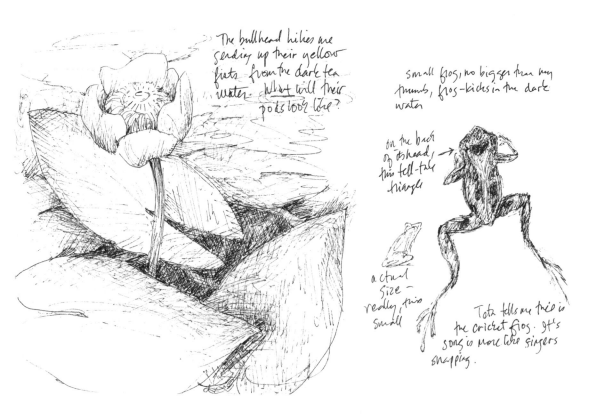

The bullhead lilies are sending up their yellow fists from the dark tea water. What will their pods look like?

small frogs, no bigger than my thumb, frog-kicks in the dark water

on the back of its head, this tell-tale triangle

actual size — really, this small

Teta tells me this is the cricket frog. Its song is more like fingers snapping.

"Stop!" Teta suddenly whispered. She pointed her paddle toward a tiny cricket frog, hardly bigger than a nickel, crouched on a slick lily pads. Edging closer, I could make out a green Y on its gleaming beige back. Our kayaks knocked together as we drifted closer, yet it didn't frighten the frog a wink. Every so often he pleaded for love by bloating his throat skin into what swelled like a bubblegum bubble without the pop.

"Now see those little lights glowing at the edge of the water?" Teta aimed her beam toward the shadowy shore. Carolyn and I followed, pointing our headlamps by lowering chins.

After a moment I blurted, "What *is* that?"

"Fishing spider eyes." Teta slowly swept her headlamp along, spotlighting the edge of the swamp. The dark bank sparkled with small gleaming beads — countless arachnids (with their multiple eyes) lying in wait to ambush dinner. Pinpricks of light glittering like a miniature city at night.

There, circling the swamp's rim, Teta's secret revealed.

THE NEXT DAY, MY swamp mates joined me at the Dragon Run Inn for one of owner Sue's splendid breakfasts. Our forks and spoons clinked against china as we indulged in fresh waffles dripping with real maple syrup, topped with local strawberries bursting with sweetness. (I never claimed I was roughing it.)

"Our goal today is to paddle down to the eagle's nest," Teta began. "I've been keeping an eye on the birds since early spring." Carolyn and I were psyched — bald eagles, in a nest no less. With full bellies, we readied ourselves for another day on the Dragon's dark tannic water.

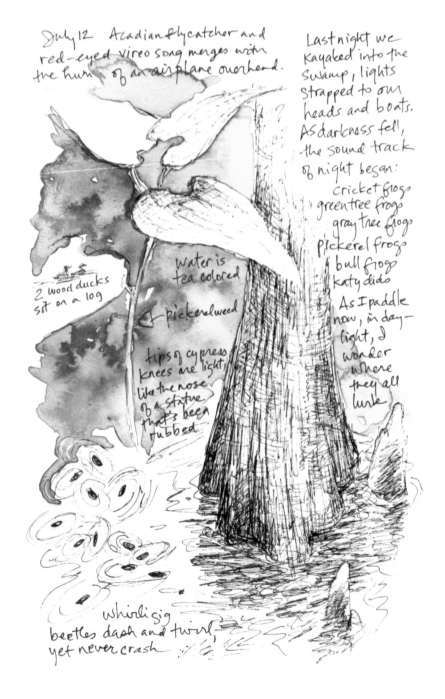

July 12 Acadian flycatcher and red-eyed vireo song merges with the hum of an airplane overhead.

Last night we kayaked into the swamp, lights strapped to our heads and boats. As darkness fell, the sound track of night began:
 cricket frogs
 green tree frogs
 gray tree frogs
 pickerel frogs
 bull frog
 katydids
As I paddle now, in day-light, I wonder where they all lurk

2 wood ducks sit on a log

water is tea colored

pickerelweed

tips of cypress knees are light, like the nose of a statue that's been rubbed

whirligig beetles dash and twirl, yet never crash

By now I was getting the hang of kayaking, leaning back in the cockpit with my legs relaxed, casually gripping the paddle. I even managed to steer clear of the yellow bullhead lilies whose floral fists thrust above their glistening floating leaves.

As my fellow voyagers caught up, Teta pointed out a fishing spider as it scampered over a lily pad. The hairy hunched creature hardly seemed the source of that luminous vision the night before.

A little farther downstream, a golden prothonotary warbler clung to a cypress limb. Looking down, I caught its reflected gold head and black eye in the still water, almost as clear as the jewel-like denizen of the swamp itself. Refocusing my eyes, I peered beneath the surface where a dragonfly nymph scooted. As I drifted aimlessly in the kayak, one of my favorite lines in Carolyn's poem came to mind: "I breathe in these wetlands like wild iris."

"You all right?" Teta chimed, paddling past me.

"Yeah, I'm fine, I'll catch up." I was as all right as I could possibly be, what with dragonflies of every shape and color orbiting in air trails around me. Darners big as sparrows, skimmers glinting on the arrow plant, and tiny amber wings looping in a taut love embrace. Even a rare saddlebag whizzed by my rig.

I bungled a sketch of one in flight. The next fell short, too, as my pen dried out after beginning the wingspread of a blue-eyed swamp darner perched on a cypress knee. Yet I was okay with only a few scratchy doodles on my page. That was part of the day, too.

Which launched me into a reverie—well, really more of a delayed response to Ivan's comment the day before, "I didn't know anyone did

that anymore." I thought: *It's hard to explain why experiencing the world quietly, slowly, unplugged, satisfies me. Or to express the thrill of feeling my hand trace the fine bristles of a dragonfly's leg. Or to put into words how the unhurried process of drawing connects me more viscerally to a place. And could I ever truly describe the spark between a wild animal and myself when eye-to-eye, whether it's a familiar species or exotic, right outside my studio door or in this wild wetland?*

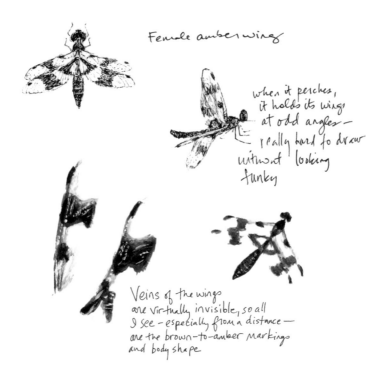

Female amberwing

when it perches, it holds its wings at odd angles — really hard to draw without looking funky

Veins of the wings are virtually invisible, so all I see — especially from a distance — are the brown-to-amber markings and body shape

When I caught up, Teta was ardently showing Carolyn the pickerelweed's cobalt-blue flower spikes poking over pointy leaves, all thrusting skyward.

"Wonder if I could plant these in our wetland garden?" Carolyn asked.

We continued paddling on our journey's last leg to that special nest site Teta saved for the finale of our swamp excursion. Sharp blades of arrow arum leaves whistled and squeaked as they brushed our kayaks' hulls. Although we saw no eagles, it was hardly a disappointment. The vision of a huge mass of sticks balanced, uncannily, on the very top of an ancient cypress, its own feathery needles trembling in the breeze, was more than enough.

Teta craned her neck up. "Bald eagles often reuse their nests. You two will have to come back to see them next spring."

Would there be a next time? I didn't know. But I did know that it's a natural impulse to assume there will always be a next time—another spring, another eagle, another dashing dragonfly. Do the eagles also think about a next spring? They must. What is a nest but hope for the next spring, even if it's for another feathered life?

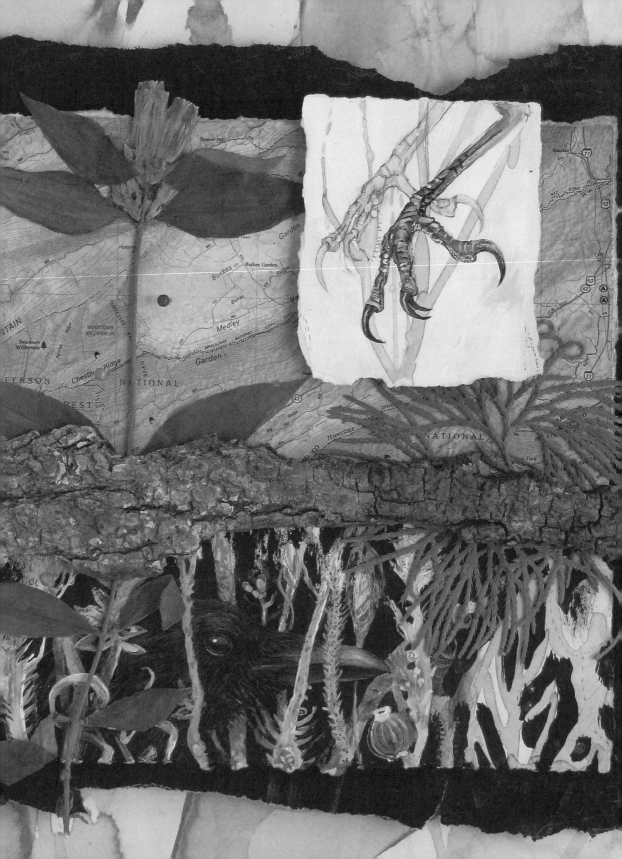

Back to the Garden

BURKE'S GARDEN

IN THE SKY over the two-lane wheeled big black wings. I buzzed the car window down to get a better look, and listen: *Cruk...cruk...cruuuuk.* A raven. Then another appeared, *cruk...cra cra cra.* Male and female? I wasn't sure. But I shivered: *Damn, it's cold up here!*

Grabbing my windbreaker from the back seat, I zipped it up to my chin. I'd driven only a couple hours west to Burke's Garden, but the high elevation meant cooler air, even in mid-August.

Walking along the gravel shoulder, I assumed I'd scare these shy cousins of the crow. *Au contraire.* The ravens swooped closer—so close I could see those heads more beak than skull. So close I could see soot-black feathers scalloped over their shoulders.

Their conversation continued. *Ca ca ca ca ca ca ca ca* rattled the first. *Cruk...Cruk...ca ca ca ca ca* grunted the other. I once described the

call of a raven to young birdwatchers as "a crow with a cold. In my experience, more often heard than seen. And if seen, rarely up close."

But here I was, and there they were. Close. They seemed to be conferring about something. *Me?* I didn't think so—I was probably just a mild annoyance. One bird pointed its beak in my direction, staring me straight in the eye, as if sizing up a threat. A myriad guttural clicks, croaks, and whispered grumbles passed between the two in ravenspeak, all wonderfully indecipherable. A few minutes later, they flapped into the bright overcast sky, their silhouettes getting smaller and smaller until they vanished into a copse of trees.

They had raven things to do.

It figures these birds would like Burke's Garden, since they generally avoid hobnobbing with people. Only about three hundred of our species live up on the highest meadow in Virginia, surrounded by the vast Jefferson National Forest. Weeks before my trip, I learned the name "Burke's Garden" was not because James Burke, leader of a surveying party up there in 1748, planted a garden in the fertile soil. Not because it's Eden-like either. No. Truth is he buried some potato skins in the brush while cooking over a campfire; the following year a copious crop of spuds sprouted on that spot. So the idyllic name sprang from Burke's crew razzing him about it—a joke that stuck.

But fascination with the place is no joke. I'd come because a naturalist-friend urged me to: "No place quite like it. Geologically so

unique." At 3,074 feet, Burke's Garden forms the bottom of a bowl. The top rim is Garden Mountain. Tazewell Beartown, at 4,711 feet, is the highest peak on that rim.

One would think it a meteor crater looking at an aerial photo—but no celestial object ever struck. The oval mountain valley formed when underground limestone caverns collapsed. Its elliptical shape inspired another name: "God's Thumbprint." On my USGS topo map, the concentric lines added to the thumbprint notion. I wondered how the ravens see it, from a real bird's-eye view.

And the human community? It's like entering a portal to the past. Reaching the edge of town, I saw white slatted signs pointing the way to each landowner and giving their distance in mileage: "MARVIN MEEK 1.7 >," "KENNY & HEDDA ST. CLAIR .8 >," "DUNFORD FARM 4.37 >," and so on. Twenty-one families in all. It wouldn't be easy to be anonymous here. Some of the townspeople's ancestors were so fiercely proud that they refused to sell land to George Vanderbilt in the 1880s, so instead the millionaire set his sights on Asheville for his regal Biltmore Estate.

I circled the 8.5-mile road around the valley—a basin of spinach green ringed with smoky blue. At one point, I got out of the car, leaned on a fence to watch the cattle and camels nibble and rip and chew the green hide of the earth. Grass grows lush here, since the meadow is a virtual compost bin of well-rotted organic matter.

Wait…*camels?* I waved to a farmer sputtering down the road on a tractor, someone I could ask about these oddly incongruous herbivores.

"Them's the Doc's camels over at Lost World Ranch. Nice guy. Moved here from New Jersey." Deeply grooved lines on his face reminded me of lines on the map I held in my hand. For him, a lifelong resident of Burke's Garden, harking from New Jersey was exotic enough to explain why someone kept two-humped Bactrian camels as pets.

Later I learned that one Dr. Jurgelski retired in Burke's Garden to raise Mongolian camels and llamas. He felt them both "lost" species suited to what he called the lost world of this meadow. Another way of thinking about restoring lost species to Burke's Garden—okay, *my* way—would be to reintroduce woodland bison and elk, animals that once roamed wild there.

"Anywhere to walk around here? Any trails?" I asked, itching to ditch the car.

"Old CCC road up thar." His arthritic finger crooked toward the east. "Hit'll take you to the Appalachian Trail." Clutching my Bic with a gnarled fist, he sketched a map in my spiral notebook. As he drew, I studied his leathery cracked hands, hands that had worked this land for decades. Though the soil's fertile, the high altitude at Burke's means the growing season's shorter. Farming up here's no piece of cake.

Still looking up at him on the tractor seat, I spotted a black bird winging overhead.

"That there's a raven," he pointed, having followed my eyes. "Tail's a wedge, not straight like them crows."

"Oh yeah, I can see that." I took the map as he handed it down. "Thanks for the directions."

He nodded, said "Ma'am," and rumbled away.

I took off around the meadow. Light glinted on rusty metal-roofed barns. Ocher hay rolls dotted green fields. Not a single billboard, fast food joint, or plastic modular sign in sight, although a few satellite dishes cupped their ears toward the sky, listening for news of another world.

SUCH A PEACEFUL VALLEY—but it wasn't always this way. James Burke returned to farm here in 1754 and built a log cabin for his family—home for three years. But others laid claim to the land, too.

The Shawnee. This was their ancestral hunting ground, so who could blame them for trying to push the German, English, and Scots-Irish settlers back east? I write "push," but that's a euphemism, for what they really did was tomahawk the invaders. In 1756, Burke fled his mountain home during a Shawnee raid. He joined others in "Burke's Choice," an offensive—shotguns versus axes—of settlers against Shawnee enclaves closer to the Ohio River, where the Native people held prisoners, mostly women and children.

Serene now, God's Thumbprint once saw war.

For a moment as I circled the valley, I viewed it like a photo of someone you know who has gone through hell yet smiles for a snapshot.

I'd brought a sack lunch but stopped at Burke's Garden General Store for something to drink. Its rustic wood siding and quaint sign seemed touristy, though I couldn't imagine enough tourists to keep the place going. Unless local farmers are keen on Campbell's soup, they must get groceries in nearby Tazewell. Walking out, I clutched a quart of local honey and a bottle of apple juice.

My all-wheel drive geared up the potholed Forest Service road to a small parking lot bordered by massive bracken ferns. No sooner did I start up the Appalachian Trail toward the Chestnut Ridge Shelter than a raven flew overhead. I swear it tilted its head, looking in my direction.

At every other site I'd visited, I was the watcher, the animals the watched. Or so it seemed, for who knows how many animals spy us as we bumble through the wild? But at Burke's Garden, I felt I was the watched.

Again, a raven flapped overhead when I stopped to chat with a member of an Appalachian Trail hiking club as he buzz-sawed a tree fallen over the path ("Wife can't figure out why I like to do this on my days off"). I heard ravens grumbling in the distance as I stepped into the Chestnut Ridge shelter to read AT hikers' names scrawled in the guest book. I thought I heard the raspy *cruk* mingle with the *ank ank ank* of a nuthatch while collecting crumbling bits of bark.

But the biggest surprise came as I hunkered down in the leaf litter sketching mushrooms sprouting from a decayed log. I felt uneasy, as if someone were present. Peering over my shoulder, there sat a dark bird hunched on a branch overhead.

"Am I near your nest?" I asked.

Raven:

I realized my question was a stupid one—it was way past nesting season. The raven peered down its beak in my direction, reminding me of the way people look over their reading glasses. Perhaps it was just keeping an eye on me. *You flatter yourself, Suzanne.* Its eye turned white with the blink of a nictitating membrane, that gauzy bird version of an eyelid.

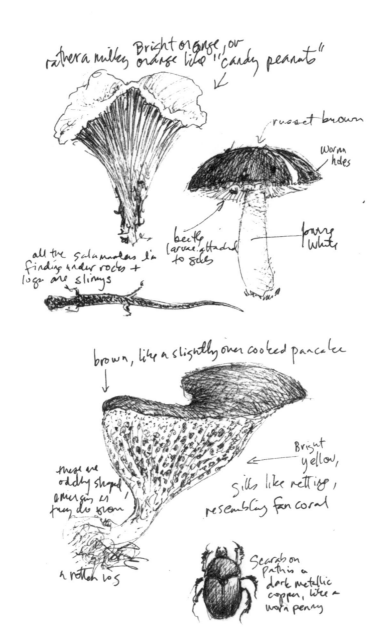

rather a milky Bright orange, or
orange like "candy peanuts"

russet brown

Worm
hdes

beetle
larvae attached
to gills

furry
white

all the salamanders I'm
finding under rocks +
logs are slimy

brown, like a slightly over cooked pancake

these are
oddly shaped
emerging as
they do from

a rotten log

Bright
yellow,

gills like netting,
resembling fan coral

Scarab on
path is a
dark metallic
copper, like a
worn penny

Me: "Could you grant me one wish? Could I be inside your head for just one minute?"

Raven:

The bird cocked its head checking out something overhead. As if to give the impression of nonchalance, it preened its right wing feathers with that anvil of a beak. Did I see some downy whitish feathers around its breast? Slowly bringing my binoculars up to my eyes, I detected a remnant of golden gape, flanges around the beak that would disappear once the bird reached adulthood. So this was a youngster.

Me: "What do you find to eat out here?"

Raven:

Maybe that question was too practical, like asking an artist how many hours it took her to do a painting. I changed my tactic.

Me: "Something I've always wanted to know. What is it ravens are saying with all those cruks, clicks, and grunts?"

Raven:

Another blink. Peering around to make sure no one—no *human*—had crept up on me, I carried on my one-sided interview. Or perhaps the bird's answers were very Zen: maybe no answer was an answer.

Me: "What are you thinking?"

Raven:

How would I translate ravenspeak anyway?—I asked myself, feeling silly and exhilarated at once. *Could the bird possibly be wondering what I was thinking?* I thought not. No matter how brainy ravens are, and how absurd humans may be, I feel pretty sure we're the only animal who imagines what it's like to be another animal.

Crauk-ca-ca ca-ca ca—a call came from a nearby oak. The young raven eyed the leafy canopy beyond the clearing, stooped, sprang up, and with gnarly feet dangling gave a few sturdy flaps before vanishing into the green overstory. And I, expelled from the raven's garden, would return to mine.

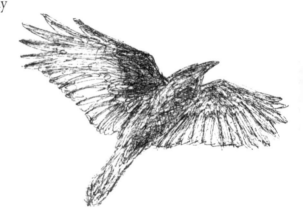

UNITED STATES
DEPARTMENT OF THE
GEOLOGICAL SURVEY

STATE OF VIRGINIA
DIVISION OF MINERAL RESOURCES
JAMES L. CALVER, STATE GEOLOGIST

VIRGINIA—ROCKBRIDGE CO
7.5 MINUTE SERIES (TOPOGRAPHIC)

Mapped, edited, and published by the Geological Survey

Control by USGS and USC&GS

Topography by photogrammetric methods from aerial
photographs taken 1960. Field checked 1961

Polyconic projection. 1927 North American datum
10,000-foot grid based on Virginia coordinate system, south zone
1000-meter Universal Transverse Mercator grid ticks,
zone 37, shown in blue

Fine red dashed lines indicate selected fence and field lines where
generally visible on aerial photographs. This information is unchecked

There may be private inholdings within the boundaries of
the National or State reservations shown on this map

Revisions shown in purple compiled in cooperation with Commonwealth
of Virginia agencies from aerial photographs taken 1977 and other
source data. This information not field checked. Map edited 1979

SCALE 1:24 000

CONTOUR INTERVAL 40 FEET
NATIONAL GEODETIC VERTICAL DATUM OF 1929

THIS MAP COMPLIES WITH NATIONAL MAP ACCURACY STANDARDS
FOR SALE BY U.S. GEOLOGICAL SURVEY
DENVER, COLORADO 80225, OR RESTON, VIRGINIA 22092
AND VIRGINIA DIVISION OF MINERAL RESOURCES, CHARLOTTESVILLE, VIRGINIA 22903
A FOLDER DESCRIBING TOPOGRAPHIC MAPS AND SYMBOLS IS AVAILABLE ON REQUEST

The Dinosaur and the Bridge

ROCKBRIDGE COUNTY

"WHAT'S A *Tyrannosaurus rex* doing here?" I muttered to no one as I swerved off Interstate 81 at Exit 175. At the end of the ramp, the gigantic head popped over a billboard, its toothy grin enticing visitors to Dinosaur Kingdom. In smaller letters, Natural Bridge—my destination—seemed but a footnote.

For more than twenty years I drove from Bristol, Virginia, to the cultural treasures of Washington, DC, whizzing right past Natural Bridge. Never stopped once. Not that I didn't want to. Just that I always had an excuse: *not enough time, too cold, looks like rain.* The real reason? My knee-jerk aversion to tourist traps.

Now, though, with my "Notes" project, no more excuses. I had to visit because at one time the Virginia site was considered one of the Seven Wonders of the World, right up there with Niagara Falls. I had

to because Thomas Jefferson purchased Natural Bridge from King George III for the whopping sum of twenty shillings—a little less than a dollar. In the 1700s, Jefferson wrote ecstatically in *Notes on the State of Virginia*, "So beautiful an arch, so elevated, so light and springing, as it were, up to heaven." But in all honesty, the first time this landmark registered on *my* radar I was eight years old watching the *Andy Griffith Show*. If I remember right, Barney Fife squeaked to Thelma Lou, "Maybe we could go somewhere *really* special, like Natural Bridge." That sounded downright exotic to a kid from the Midwest.

Now I wound around tree-lined Route 11 to the famed bridge, at one point crossing over it, though I've no idea where. I arrived at a cluster of large colonial brick buildings—an imposing hotel among other columned edifices—nestled within lush green hills. Lovely, yes, but what instantly snagged my eye was a fiberglass dinosaur bucking a cowboy, rodeo style, outside the visitor center.

"What does a dinosaur-riding cowboy have to do with a rock bridge?" I asked a gardener clipping boxwoods nearby.

"Beats me." He paused, scratching the back of his gritty neck as he stood staring at the anomaly with me. "Guess the kids like it." Wiping sweat off his brow with the edge of his Rockbridge Wildcats T-shirt, he resumed snipping branches, blades cutting like giant prehistoric teeth. He had a point; I confess those fiberglass dinosaurs that roamed the touristy Wisconsin Dells in the 1950s once thrilled me as much as the pristine birches of the Northwoods.

SEARCHING FOR THE TICKET counter, I found myself in the gift shop adrift in a sea of kitsch. Among hundreds of Founding Father trinkets,

there sat a faux-gold Thomas Jefferson bank with a slot in the back of his skull. *Jefferson could have used one of these,* I smiled, remembering that his heirs were forced to sell Natural Bridge to pay his debts. (It remained a private for-profit attraction until after my visit; in 2016 it became a state park.) I strolled down more rows of tourist baubles: polished rocks and replica arrowheads, Indian headdresses stuck with turkey feathers dyed fire engine red and canary yellow, Daniel Boone caps dangling fake raccoon tails with their female counterpart, pioneer bonnets in calico prints. Revolutionary War hats mixed with plastic Civil War muskets. A mash-up of Americana. More shelves offered the Natural Bridge arch etched on coffee mugs, T-shirts, greeting cards — you name it.

Which finally brought me to the ticket counter.

"That'll be $18 for one adult," the cashier said, a tricornered Paul Revere hat jauntily askew over her multiple earrings. "With this ticket you get in the Toy Museum, the Monacan Indian Village, *and* the Wax Museum!"

"But I've only come to see the rock bridge."

"It's *still* eighteen bucks."

Ticket in hand, I headed down a flight of stairs, studying vintage black-and-white photos of Natural Bridge on my way. I passed the Toy Museum's sign: "WE PROUDLY PRESENT: AMERICAN HISTORY TOLD WITH TOYS." Red, white, and blue buntings draped around plastic GI Joe figures costumed like early American patriots posed in the window. From the doorway, the band Journey belted out "Don't Stop Believin'." Maybe it was the soundtrack for the museum, or maybe just the lone staffer's entertainment.

But my own believing had one more test.

Outside the door, smack in the center of an abandoned minigolf course, reared a larger-than-life fiberglass palomino, its tarnished golden hide cracked with age. The horse's hind legs sank into crusty-green Astroturf sprouting chest-high stalks of wooly mullein and a tangle of pink-stemmed poke. An archaeologist excavating this ruin might speculate the steed once served as some kind of deity—an icon of leisure?

THAT STRING OF ODDBALL attractions ended at the trailhead, for a few strides away stood the remains of an ancient cedar. The 1,600-year-old tree set a world record for the oldest and largest of its species before it died in the 1980s. For two millennia, the shady microclimate sheltered a grove of arborvitae, which translates "tree of life." I paused to draw the twisted trunk, bulging with sinews sheathed in peeling bark. It seemed more alive than the leafy maples encircling it.

Sunlight filtering through the canopy spotlit a daddy longlegs tiptoeing over the cinder path with its eight threadlike legs. I wandered down some rough-cut stone stairs, careful not to slip on mounds of soggy moss. Following the curve of Cedar Creek, there it was, the legendary bridge, like a giant keyhole in stratified limestone, dwarfing me as it arched two hundred feet overhead, graceful and powerful at once. I loved the way the ancient jagged rock cupped fresh green ferns in its craggy crevices.

Standing in the cool shade below the bridge, I watched a swallow's sharp wings beat rapidly, then glide. It twirled, then darted into a stone cranny only to quickly swoop out again—a master of the air. The drone of gurgling water merged with the magic fluting of a wood thrush: *De de de da de-a-lee…de de de de-a-loo.* No surprise that the Monacans—the Native tribe that once called this turf home—considered this a sacred site.

Suddenly someone behind me called out in a loud whisper: "See the snake down there?" Startled, I turned to find a young woman pointing to some smooth boulders by the creek.

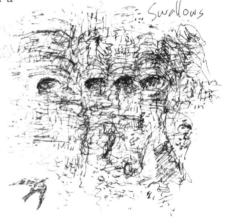

She swept her long hair away from her nametag—"JENNY NATURAL BRIDGE GUIDE"—pinned to her olive-green shirt.

"Where?" I asked.

"Look a little to the right of the huge reddish rock," she said, shyly aware she'd blurted her enthusiasm for what some folks might fear was a copperhead.

Below, half in shadow, basked a two-foot water snake, its brown-on-tan splotches matte from coiling in the sun.

"Beautiful! It looks so calm." I lifted my eyes again to the bird swooping overhead. "What kind of swallow is that?"

"Sorry, like this is my summer job—I'm a business major at JMU," Jenny said, and apologetically giggled. "Um…I don't really know birds, but I call those rock swallows."

"Hmmm, *rock* swallow." It seemed a better name than rough-winged swallow, my own shaky identification. I couldn't help but think that for a business major she had a better sense of naming a bird than the ornithologist who did.

"See the 'GW' carved into the stone?" She pointed to a place on the bridge wall about twenty feet over the creek, not far from the bird's cavity.

"George Washington's initials—I read about those. How'd he get up that high to graffiti the rock?"

This time she recited a script: "Centuries ago access to the rock bridge was only from the top. You had to be lowered down with a rope to get to where we stand. George Washington was the first to survey Natural Bridge in 1750. The white rectangle around his initials was added later to designate the spot."

Her voice softly echoed as she continued. "Natural Bridge was carved from limestone by the force of Cedar Creek, a tributary of the James River. It's 215 feet tall and spans 90 feet at its widest. It was once the roof of a cave."

So what seemed a gentle rill had exerted a heck of a lot of force over millions of years, shaping the gorge from soft deposits of sedimentary rock. But this thick, stubborn section of the limestone remained intact, creating the massive archway above me. Water, with eons of time, has a gift for sculpting.

AFTER MY UNPLANNED TOUR, I headed far enough away to get a good view of the bridge. The wide stone wall bordering the creek would make a perfect spot to spread out my drawing stuff.

Atop the bridge was dense green foliage, making it even harder to believe a steady stream of cars—even diesel rigs—barreled over it every day. Its role as an actual byway goes way back. Herds of bison, now extinct in Virginia, once hoofed across it. The Monacans believed it had saved them from an enemy tribe: Fleeing an attack, they fell to their knees praying to the Great Spirit for help. When they lifted their heads, a massive stone bridge spanned the gorge, over which they scrambled to safety.

Natural Bridge was later part of the Great Wagon Road, a passage for settlers along with their cattle. But to cover it with *asphalt*? How stupid. Yet if the chattering swallows and basking snake didn't pay it any mind, I'd put it out of mine too, for the time being.

As I arranged pencils, pens, sharpener, and eraser on the stone, I thought about the legions of artists who had sketched at this very site. And I realized: *This may be as close as I'll ever come to being part of an artistic tradition.*

For more than two hundred years the bridge symbolized Wild America, inspiring grand, inspirational landscapes, or souvenir prints for sightseers. I'd once seen an entire exhibition of drawings, etchings, and dramatic paintings of Natural Bridge—and that was only a sliver of images depicting this landmark. Folk artist Edward Hicks even brushed it into the background of a few of his *Peaceable Kingdom* paintings. In the 1850s, Frederic Church worked up preliminary drawings of the bridge on site before returning to his upstate New York studio, where he rendered the scene in oil. In his Romantic version of the site, the radiant monument dwarfs two figures in the foreground.

As I drew, clouds curtained the sun, turning the limestone cool with streaks of muted browns and grays. But when the sun reappeared, it

was as if a golden varnish were brushed over the stone—raw umber turned to burnt umber, yellow ocher now mixed with rich warm grays. During this light show, swallows gracefully lunged from the arch; it occurred to me then that Native Americans, early settlers, and Jefferson himself would have witnessed the same bird. I mean, genetically related to these before me now.

That notion was a seed idea, one that would expand later in my Bristol studio. There I would find *Stelgidopteryx serripennis*—the Latin name of this bird—on the website of the National Center for Biotechnology, print out strings of nucleotides (represented by the letters ATGC) making up its genome, and snip them into long, thin strips of paper. From these DNA sequences, I'd construct my Natural Bridge.

If that seems far from other Natural Bridge interpretations, good. That's the advantage of an artistic tradition: the viewer's aware of the point of departure. I've often envied those Renaissance artists commissioned to paint the Crucifixion, because when a subject is well-known, its subtle and not-so-subtle differences are clearer: Rubens's muscular Jesus, Memling's delicate savior, Grünewald's tortured spirit.

So *my* bridge would connect art and science. Not really so far-fetched, for after all, their origins are intertwined. Think about it: the first people who drew on cave walls created images to pay homage to the animals that filled their dreams and their stomachs, to honor them but also have control over them. The beginnings of art, of science.

But now, here at Natural Bridge, I put some final flecks on my ink sketch of the arch. And before packing up, I scraped some fine granules of pigment from fallen rocks with my Swiss army knife, separating their colors into different vials. Those earthy ocher, rust, and grayish brown particles I'd later grind into powder, mix with watered-down matte medium, and layer over a topographic map.

I walked back to stand alone under the bridge. This time a phoebe perched on a branch overhead, pumped its tail, and declared itself: *FrreeeBEE...frreeeBEE!* I remembered John James Audubon once

astonished his hiking companion by predicting where Natural Bridge would be long before it became visible: a phoebe's song tipped him off, since he knew the species nests on rock ledges.

Jenny, noticing me walking away, called out, "Come back tonight to see the *Drama of Creation* show. At sunset they beam colored lights on the rock and play special symphony music from loud speakers. It's a-*maz*-ing!"

"Maybe next time," I called back, though I was really wondering why birdsong and sunlight weren't drama enough to amaze. Yet it got me thinking: *Is there another culture in the world that mixes the natural and the entertaining, the sacred and the banal, the way we Americans do?* This mishmash coils in my own cultural DNA—the dinosaur *and* the bridge.

Before leaving, I lingered before the wacky cowboy on his prehistoric mount and considered making a sketch of it, but didn't.

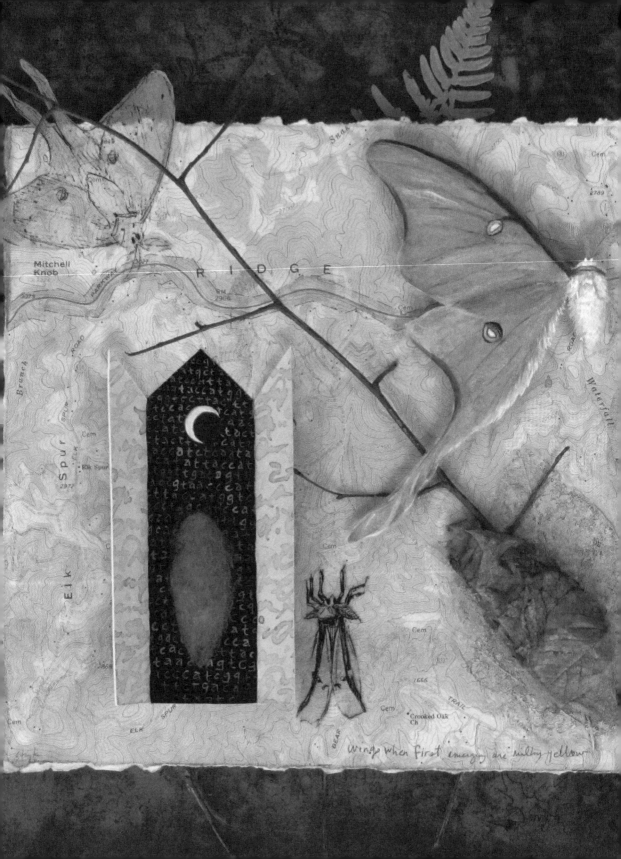

Wings when first emerging are milky yellow

Life Cycle

DRY RIDGE

GENTLE RAIN TICKING on a metal roof: could there be a more soothing sound? That chilly evening in late May, I was snug in a rental cabin, my woodland retreat a few miles off the Blue Ridge Parkway. As I stared at the wooden rafters, swaddled in the caul of a quilt, the white noise of drizzle lulled me to sleep.

Minutes after midnight, I woke to the hard thrum of rain, pine branches swiping the roof like a drummer's brush stick, low thunder rumbling in the distance. This jazz trio morphed into a boisterous Big Band. Loud thunder cracked. Now a full-fledged storm, a third movement began as Metallica crashed the concert: noisy, pounding, thrashing.

Bang!—a tree limb on the roof?—I leapt up, threw the covers off, cringed as my feet hit cold floorboards. I felt like a small animal that hadn't burrowed deep enough. Vulnerable.

Even so, I craved a closer look at the storm. By one feeble nightlight, I negotiated the unfamiliar dark cabin, like walking within a mezzotint: soft edges of furniture, grainy walls, blurry rectangles of windows. As I opened the door—*creak*—and crept out barefoot onto the porch, I was greeted by a sweet rain-on-earth aroma. As the downpour let up a screech owl shivered soprano scales overhead. Maybe it sang with relief that the storm was ebbing, or maybe it was singing all along but I hadn't heard it for the din.

When I finally crawled back to bed, an anxious dream played in my night theater, a rerun that pops up every few years: I'm heading home from Kipling grade school—nine or ten years old—skipping down the cracked concrete sidewalk in my Keds. Turning the corner, I stop short. *My* house has vanished. Only an empty lot with a few shagbark hickories and a towering red oak that once shaded the back deck. On either side, neighbors' shades are pulled down tight like closed eyelids. In the dream, I'm a hybrid of my girlhood and my present self. Utterly alone without a clue where to go....

Around 2 a.m. I woke, edgy. For a moment, I wondered where I was. I shook off the dream. I'm in a cabin, Virginia, not Illinois, not childhood. Now.

Thunderstorms don't usually make me anxious, but who knows if this one hadn't plucked some subconscious chord, some atavistic fear buried in my crocodile brain? Thunder always sent my gray longhaired cat bolting under the bed; I'd shine a flashlight to see his paws drawn up

under his little chin, eyes squeezed shut but not sleeping. I was pretty sure he'd never been hurt by lightning or thunder, so the instinct to hide must have been deeply rooted in his primitive panic mode.

I tiptoed out to the porch yet again, goose bumps signaling my slight fear. But what I found was far from frightening. For under the timber posts a celadon phantom had found shelter from the squall: a luna moth clung to the eave. Its paper-thin wings spanned the length of my hand, the milky green rippling like silk into long, twisting tails. On each wing, a sleepy faux eye blinked a droopy "lid" over a metallic silver circle, edged with pink and ocher, all rimmed with pencil-thin black.

I considered drawing then and there but worried I wouldn't have the energy to hike the next day. I gambled the moth wouldn't fly away. So back to bed, taking one last glance into the gloom of the surrounding woods.

This time—before getting under the covers *again*—I jammed a ladder-back chair under the doorknob. A different kind of darkness had come over me.

Oh, yeah, like that'll keep someone from breaking in, I teased myself. Childish, yet I knew it would help me sleep more soundly. I don't fear copperheads coiled in leaves, or the fierce stare of wolves, or big hairy spiders, or the tiny teeth of bats. Or any other animal for that matter, but for one: a man with a sad boyhood, raging hormones, and a cold heart. I considered making a long digression here about being a woman alone in the woods. About how the threat of assault lurks in the back of her mind, always. But that would wrench me away from the moth, the

magic of the rain, the sweet smell of earth, even the intimate dream of lost place.

But I must say this: a woman must conquer a double jeopardy if she wants to enjoy being alone in the natural world — *actual* physical attack, of course, but also that gnawing awareness of its threat, which, if the imagination starts to run, eclipses the wonder-filled present. Decades before I had escaped a ski-masked man who held a hunting knife to my chest. Alone in an isolated woods, a rustling rabbit scared the attacker off, giving me time to bolt. But though unscathed *physically*, for years I peered over my shoulder, jumped at every snap of a twig. I'd devise intricate plans to bluff with a toy pistol, or continually pat my back pocket for the pepper spray. Or take a path where I saw other people rather than the one where I might find more birdlife. Meanwhile — and here's the tragedy — I was diverted from the living world pulsing around me.

MORNING. DAZZLING SUN SLANTED through the cabin window, warming my face, as if delivering news that I'd have a clear day for exploring. While the teakettle boiled, I pulled the chair from the doorknob, dashing out to see the moth.

It hadn't budged!

What seemed a ghostly vision the night before made me smile now, for it tucked its head down, as if slightly embarrassed to be a lump of white fur wearing green fairy wings. As I nudged my index finger against its head, it scuttled on, then froze in an "I'm a leaf" pose as it rode my finger to the wooden kitchen table—turned—drawing board.

A *super*-fine pen line felt thick and clumsy limning those fragile wings. Maybe only paint could do their translucence and soft celadon hairs justice. The moth's large yellowish antennae told me it was a male, for those ferny receptors must be long to detect a female's pheromone from miles away. I'd need a pen point the size of an eyelash for those.

While I scrawled little golden-furred legs, it occurred to me that every molecule in the moth's body came from *this very place.* The crumbling lime-rich soil, the trickling mountain water, and the walnut leaves his larval self once gobbled—all these for a brief time now shape-shifted into *Actias luna*, a member of the saturniids, or giant silkworm moths.

And my own body? Molecules that make up "me" may hail from Virginia, but just as likely from half a world away. I've guzzled apple juice from China and coffee from Kenya. Gobbled peaches from Georgia, bananas from Central America, and oranges from Florida. Lettuce (and God knows what else) grown in California renews my cells. My mind might be in the Blue Ridge Mountains, but my body is global.

The moth shivered, stilled, shivered again.

"What to do?" I spoke to him. "Should I place you in the freezer, let the cold carry you off slowly, so that I might pin a perfect specimen? Or should I release you to fulfill your life cycle?"

I needn't have asked, since I knew what I'd do. His antennae twitching, he seemed eager for his night moves. Did a female's scent already waft on a forest breeze through the screen door? How could I ever rob him of that winged delight?

I gently placed the moth back under the porch eaves while I'd explore the ridge. He'd be rested for his expedition after sunset.

NOW FOR MINE. Along the trail, I collected crusty brown seedpods, beetle husks, and a small bit of bone gnawed by squirrels. Fence lizards fled my clomping hiking boots, dashing up rocks or tree trunks. From the tip of a sapling, a chipping sparrow threw back its rusty-capped head: *Chip-chip-chip-chip-chip-chip-chip-chip.*

I remembered the red-haired cashier at the nearby Marathon station, slouching between rows of rental videos, despairing to his buddy that he had "nothing to do," that this place was "the middle of nowhere." *Are you kidding?* I thought but said nothing, swiping my debit card for gas and coffee. Not his fault. We're taught to think that way. What a privilege it is to be astonished by the living world so that every place becomes the middle of somewhere.

Farther along the ridge, layers of steely-blue mountains stretched before me. I wished to have delicate antennae so I, too, could sense chemical signals drifting in the breeze. Think of what I miss. But heck, that sensory overload might knock me out.

Looping back toward the cabin, I discovered a pouch of grayish wrinkled leaves hugging a dried stem close to the ground. A luna moth cocoon? I scooped it up, carefully placed it in my pack. It would

be a small piece of the ridge I'd take home, where months later I'd document—yes—a luna's miraculous emergence in my sketchbook. Later I'd stitch that empty cocoon into a pointed niche incised into a map.

Back on the cabin's porch. As night fell, my moth companion quivered his wings, warming them up for flight while circling jerkily along a beam. Then off he flew, flapping due west as if pulled by an invisible scent-string, drawn by an airborne message of fertility. One only he could decipher.

UNITED STATES
DEPARTMENT OF THE INTERIOR
GEOLOGICAL SURVEY

COMMONWEALTH OF VIRGINIA
DIVISION OF MINERAL RESOURCES

VIRGINIA
7.5 MINUTE SERIES (TOPOGRAPHIC)

GEORGE WASHINGTON NATIONAL FOREST

Mapped, edited, and published by the Geological Survey
Control by USGS and NOS/NOAA
Topography by photogrammetric methods from aerial photographs
taken 1963. Field checked 1966.
Polyconic projection. 1000-meter Universal Transverse Mercator grid,
zone 17, shown in blue. 1927 North American Datum

THIS MAP COMPLIES WITH NATIONAL MAP ACCURACY STANDARDS
FOR SALE BY U.S. GEOLOGICAL SURVEY, DENVER, COLORADO 80225,
OR RESTON, VIRGINIA 22092
AND VIRGINIA DIVISION OF MINERAL RESOURCES, CHARLOTTESVILLE, VIRGINIA 22903
A FOLDER DESCRIBING TOPOGRAPHIC MAPS AND SYMBOLS IS AVAILABLE ON REQUEST

Field Notes

ALLEGHENIES

I DON'T BELIEVE IN time machines. I mean the kind where you step into a contraption, slam the door, ramp up a motor, and zoom off, the surrounding landscape flashing through the past like a flipbook. But Goshen Pass in the Alleghenies convinced me there are very real time *warps*.

In early June, I cruised up Route 39 on my way to Douthat State Park. Lush green hills grew steeper and steeper as I headed west. At the overlook, I pulled off the road. Above, rocky escarpments jutted from forested bluffs, where a lone dead pine snagged the sky. Below, the Maury River roared through a wild gorge—no surprise that "Devil's Kitchen" is the name of this cauldron of whitewater. Water rushed, rolled, and crashed over rocks, drowning out a truck's grinding roar from the highway. Had I not been leaning against the metal hood of

my Subaru at that very moment, I might have doubted the very reality of trucks and cars.

I felt as if I'd stepped into an early nineteenth-century painting of the American wilderness. Two bald eagles swept into the chasm like omens in a Romantic drama, one swooping over the rapids toward me, head and tail so white as if dipped in paint. It seemed an artist straight out of that age—*Thomas Cole himself*—might stride into the scene, attired in black waistcoat and broad-brimmed hat, stabbing his walking stick into the rocky path with each step.

How would the conversation go if I crossed his path? That is, if he were willing to converse with a woman wearing dungarees, her hair chopped short. Would he ask if American artists still connect the "landscape with the sacred"? Or maybe he'd declare: "The grandeur of wilderness in our young country replaces the time-honored cathedrals of Europe."

I might be tempted to reply, "Yes, wildness still turns the God gene on, Mr. Cole." But wait, folks in the early 1800s had no inkling of genetics. And if I did drag God into our conversation, this Romantic artist might drift into lofty transcendentalism, waving his hand toward the majestic blue yonder, proclaiming, "*This land* is my sanctuary. What's God, anyway, but the inner sensation there is something larger, *much* larger, than one's own puny life!"

And standing there imagining that implausible chat with the past, it occurred to me that my own art belongs to that long American tradition of the veneration of place.

I DROVE DEEPER INTO the heart of the Alleghenies, sharply veering right, left, right, left (shoulders both aching) along a serpentine section of

byway. Now on Douthat State Park Road, a blur of green flanking either side, a truck up ahead suddenly swerved, knocking something roundish that skidded down the road like a hockey puck

A turtle? If so, could it still be alive? I pulled over to find out.

By the time I reached the—yes—turtle, its nose pointed blissfully toward the blue sky, as if nothing had happened. Yellow spots on each side of its head with parallel yellow lines crossing its carapace identified it as an eastern painted turtle, a log-basker of ponds and small lakes. Where was its water hole?

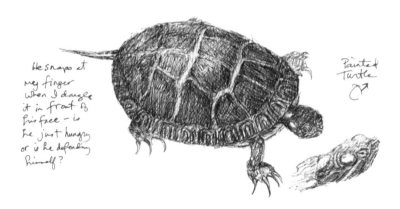

He snaps at my finger when I dangle it in front of his face – is he just hungry or is he defending himself?

Painted Turtle

"Are you okay?" I cringed to hear my falsetto lilt as if speaking to a toddler (*how foolish, since I respect turtle-knowledge as much as my own*). It sucked its head in as I leaned closer, now lowering my voice: "Well, we gotta get you outta here." But where? Glancing up the banks on either side of the road, neither direction seemed safe. No sight of a pond, either. Just then, a van came barreling down the lane toward us.

"Let's make sure you don't end up roadkill." I clutched the smooth shell in my hand, its pin-like claws scratching me as I dashed to my car door. Once inside, I checked for injuries: all seemed fine but for small scrapes on a couple olive-green scutes.

Minutes later "we" were nearing Douthat State Park, which I knew to be home of a man-made lake. And while my aloof passenger pulled head, legs, and tail into its shell, I chattered on.

"I know you might be put out by this move, but it's better than being fossilized on the asphalt." But no nod from my hitchhiker. The reptile was into its own turtle mode that had proved successful for millennia: patiently wait out a threat within your shell—a surefire strategy. Before modern roads with their speeding cars, that is.

Continuing down a narrow lane edged with white pines, I arrived at the park's visitor station: a simple frame structure built in the 1930s by the Civilian Conservation Corps (CCC), as were the park's log cabins where I'd planned to bed down for the night. Browsing the gift shop, I found a laminated folding guide to the park's flora and fauna. My eyes zeroed in on an orange-headed reptile.

I blurted, "Wow! I've got to see one of these!"

A woman in a drab state park uniform overhearing my delight smiled mildly, shrugging and tilting her head as if to say, "Whatever floats your boat." I handed her some bills for the pamphlet.

"Good luck, honey," she called to me as I headed out.

"Thanks! I might need it." I glanced around to see her nose already back in the local Covington *Virginian Review*.

The species I was now resolved to see—and draw, if lucky—was one oddly named "broad-headed skink." Walking back to the car, I shook

my head in disbelief: *How could a scientist name a reptile with a bright orange head "broad-headed?"* But I supposed it was better than something like "Hertzenbaum's skink," or an arbitrary honor to someone with no connection to the living creature. Who said that the beginning of wisdom is calling things by their right name? I couldn't remember. Anyway, the "right name" for animals would always come down to personal opinion, often having little to do with the creature's actual nature.

Skink-naming thoughts had whisked away turtle-saving thoughts. In the meantime, my captive guest had morphed from introvert to extrovert, an edge of yellow plastron glowing against the navy-blue floor rug as he scrambled about the car, raking the vinyl walls with his sharp nails ("his" now because by then I recalled that males have the long claws).

"Don't worry. Freedom's a few minutes away," I assured him, driving the last leg of my journey toward the dam at Douthat Lake. The turtle paused, gazing at me sleepily from one keyhole of an eye.

From the parking lot, I heard the soothing sound of lapping water. A brief walk took me to a rocky shoreline of the lake's sparkling eye among the bluish-green hills. Clutching the turtle, I took one final look at the vibrant red zigzags edging his carapace before tossing him tenderly into the water.

"Okay, get on with your life."

Floating for a moment, his thick head curved upward on a skinny neck like a hitchhiker's thumb. Then — *whoosh!* — all four legs flailed wildly as he paddled away.

For a few minutes, I leaned over the water looking for a sign of turtleness. A bluegill glided by, kissing my reflection on the cheek as

it gulped a drowning crane fly. Whirligig beetles looped round like bumper cars but never collided. Still no turtle. Then my gaze fastened on a zone between the lake's surface and its leafy bottom where a red-spotted newt floated, legs dangling limp. I envied what seemed to be its utter relaxation—how often I wished to feel that calm.

At last, I reeled in my wandering eye from the water's depths. Time for the big skink hunt.

I gathered my sketching stuff, water bottle, and trail mix from the car. Then on to Huff's Trail, where sunlight dappled rough tree trunks and leafy understory. No skinks. But a vibrant millipede dotted with orange scutes along its shiny black armor crept up a mossy stone. Reaching the top, antennae twitching, it looked like a preacher on a pulpit. *What's the sermon today?* Maybe it changed its mind about a homily as it scuttled back across the spongy forest floor on all those yellow legs—though hardly a thousand. I plucked it up, and the millipede

oozed a dab of murky juice in my palm before coiling into a perfect spiral. A whiff of its almond-scented fear rose as I placed it back on the earth. All the while overhead a vireo was endlessly asking then answering its own questions: *Dedalee? Dedalee. Dededaleeee? Dedaloo.*

Amid all this serenity, I could suddenly think of nothing but how desperately I had to pee. *Idiot, why didn't you think of it at the visitor center?* I had little choice but to slink off the public path and find somewhere I could secretly squat to add my nitrogen to the forest soil. I slipped behind a tulip poplar wide as a semi tire, and just as the warm fluid pattered onto the dry leaves below, I spotted something orange zipping round the gray hickory bark above me. *A skink?*

Hitching up my shorts, I dashed round the tree, twisting my ankle skidding on a mound of leaves. A small lizard eyed my antics for a moment before scurrying behind the trunk.

It *was* an orange-headed skink! Forget that broad-headed stuff. I felt high; quest fulfilled. Well, nearly so. I hoped to find one tranquil enough to pose for a while. But still, I'd really seen it.

I headed down Middle Hollow Trail circling back toward the lake, pausing now and then to check another local species on my fauna and flora list:

✓ovenbird (*teeter teeter* TEETER! — heard but not seen)
✓wintergreen (what a fresh scent)
✓whitetail dragonfly (an inch above my head)
✓chestnut oak (gleaming scallop-edged leaves)

And so on until I reached the lake. As I edged along the reed-lined shore, frightened green frogs plopped in the water — *EEK-splash!* My

love of that sound surely began when as a girl I'd wade along the bank of a northern Wisconsin lake every summer.

But wait: What was that on the log? Sure enough, there basked my second skink. I had to gloat for a moment thinking my turtle rescue had stoked my karma.

I reached into a deep vest pocket for my drawing pad and pen. Trying not to frighten the lizard, I mimicked how a cat sneaks up on prey: start/stop...start/stop...start.... So far, so good. I began to wisp ink back and forth until a vague shape slowly transformed into skinkness, there, on the cream paper. I darkened the edges of its flank, then moved gradually down the tail, my touch light as if caressing a newborn.

Ten minutes passed. The skink still hadn't budged. I wondered what cold-blooded eyes see; how sunrays feel on stiff scales rather than skin. Though its expression remained torpid, its toes tensed, as if ready to scramble for cover in a flash. *Torpid-tense*—a uniquely reptilian state of being.

I took a moment to jot a few color notes alongside the image—"polished olive-brown body, carroty head"—knowing I'd paint it back at the studio. (And I would later learn that only males have orange heads, and only in spring.) Time also to detail those delicately curled toes, the slightly cross gaze, and, yes, its rather broad head.

I live for such moments when eye and line link with a creature—a true *inner* time warp, since drawing transports me to life before virtual reality. If anything turns *my* God gene on, it's witnessing Earth's small lives. Now that's something I could have told regal Thomas Cole.

Just then a beefy guy in a camouflage shirt with matching cap came tramping down the path gripping two fishing poles in one hand, a bucket in the other. Padding behind him was a boy in an "I ♥ Virginia" shirt clutching a net.

"Any luck?" I asked.

"Two brookies." Dangling from a stringer his small catch glimmered, pale spots dotting the trouts' silvery sides.

"Nice!" And then impulsively—wanting to share my curiosity with a child—I said, "See the skink?"

"Awesome! Look, Dad!"

"Dad" only grinned and answered flippantly, "I see those things all the time in Charlottesville."

Things? I gulped but showed no reaction. Sees them "all the time"? For a moment I felt a little foolish about my lizard quest, but just for a moment. Because in my book, wonder doesn't rely on whether a species is common or rare. What matters is that a discovery reels me in to glimpse another world. What matters is seeing freshly.

Which means seeing like a child. That's a perk of being an artist: fascination unhindered by what others may dismiss as commonplace. Sure, sometimes I seek a rare species. But mostly I seek the rarity of a human mind—my own—witnessing another living being.

Now on a log fallen into the lake basked a not-*so*-scarce bronzy creature eyeing me with a mysterious cold-blooded gaze, cadmium-orange head flaming in the sunlight. And slinking along on all fours, the boy crept up from behind. As he turned to flash me a smile, the skink darted behind the limb—gone! I smiled back, hoping this child would be one of the lucky ones whose wonder-spark is never snuffed out.

Coal Tattoo

APPALACHIA

I SET OUT TO search for a coal mine. Not that I could enter it. The reason? I was seeking the type of mine where a vast region — an entire mountaintop — had been dynamited to oblivion. You might say the mountain is removed from the coal, rather than the coal from the mountain. Mountaintop removal is what folks call it. I call it a sacrilege.

On that late summer day, I headed west on Route 19 into Virginia's coal country. I thought about how that black seam of hidden energy wriggles through this part of the southern Appalachian Mountains, how it has shaped this region — both the landscape and the humanscape.

Passing through the heart of Wise County, my vision was a split screen: lush green forests enveloped me while my mind's eye projected scenes from what I'd viewed the night before on "iLoveMountains. org": scars of barren earth, blasted hills. Now as I cruised up Route

160, my eyes ricocheted from side to side, then back to the asphalt as I searched for the blighted crest of Black Mountain. Around a bend, a cluster of signs signaled I was close.

Even though it was Saturday, a couple of eighteen-wheelers heaped with their bituminous load barreled down the road. *Whoosh!* A monster truck's gust of wind nudged my Subaru near the precipice. My fingernails dug into the wheel's vinyl as I steered firmly, imagining plunging off the steep cliff.

Out the corner of my eye I glimpsed layers of exposed gray bedrock, so I pulled off on the narrow shoulder. Standing on a steel road barrier, I got a better view. There it was. Or should say, there it wasn't? Black Mountain had been reduced to a lunarscape of rubble.

If it were the dry, rocky terrain of the North Dakota Badlands, the artist in me might view the sunlit mounds and shadowy depressions as starkly beautiful, like a charcoal drawing, a tonal rendering of lights and darks. Or if the scar of dozer tracks had been pathways of ancient glaciers, I might have seen them as gestural lines drawn by giant chunks of ice gliding across an earthen canvas.

What I did see was a bleak pit of terraced rock girded by green woodland, resembling a healthy head of hair shaved and gashed from a botched surgery. My naturalist mind saw an earth wound, one that would never fully heal. I was sickened. I couldn't fathom the countless creatures crushed or poisoned from explosions, rockslides, or acid runoff.

Then I remembered that the coal-powered plant fueled by this very mine provided electricity to my own home.

I flick on the light—a hundred salamanders smother beneath rubble.

I blow-dry my hair—a toxic orange goo slurries down the hillside into Looney Creek.

I switch on the dishwasher—a boulder falls from a mine, crushing a sleeping child. (Yes, it happened.)

Then the ultimate irony: I admire a nineteenth-century landscape painting celebrating the divine in nature that a coal company's CEO gifted to an art museum.

There in Wise County, I gazed at the gray gash of our needs, aware of the cycles of creation and destruction, aware of how we're all entwined. And I prayed what a friend had said was true, that "the days of mountaintop removal are numbered."

NOW I SWITCHBACKED UP to the Kentucky border, circling around toward the town of Appalachia. On the way down the mountain, I pulled over to read white graffiti sprayed on an enormous stone. The words cracked and weathered against the rough rock held a certain appalling beauty to me. They read (a few yards from a cliff overlooking the mine): I AM THE ONLY WAY—THE ONLY TRUE GOD JESUS CHRIST. For a moment I questioned how this believer didn't seem to see radical mining as a desecration to God's creation. But only for a moment. Because soon I heard a Paul Simon line in my head: "A man hears what he wants to hear and disregards the rest."

On Main Street, I parked a few spaces from a blue Dodge Ram bearing a FRIENDS OF COAL bumper sticker. Dark shop windows faced the near-empty street like so many vacant eyes. The only visible life was a couple of old men lounging on a bench outside an eight-story brick building at the end of the block, surely a hotel in better days when deep mining employed hundreds.

Hungry, I scurried over to a little diner, only to find a "BE BACK AT 1:00" sign dangling wonkily from a string. My watch said 1:35, but the door was locked when I twisted the tarnished knob. Cupping my hands on the window, I could see chairs and tables knocked over and strewn across the dusty debris-covered floor, like the aftermath of a blast.

An old-timer with silvery two-day stubble strolled up, tipped his worn fedora. "Ma'am, I don't reckon that diner's been open for years." As he spoke, my eyes lifted from his craggy hands to the dark-blue mark on his left cheekbone. I wondered if it was a coal tattoo, that indelible splotch left when coal dust gets ground into a wound.

"Anywhere else in town to get a bite to eat?"

"Dairy Queen's got burgers down on Fifth," he said, and pointed. He climbed into his truck and rattled off.

Across the street a banner on Sue's Dress Shop read: "SALE! STORE CLOSING." The lights were on—was it open? My growling stomach would have to wait because—I confess—I'm a sucker for deals. Before crossing over Main to check it out, I threw my ball cap in the car. (Not sure why—perhaps some throwback to feeling shy about not looking feminine?)

I felt a tinge of nostalgia as the bell tinkled when the big glass door swung open. Behind the revolving rack of yellowed greeting cards, knit tops and sweaters lay neatly stacked on tables, while dresses with plastic dust jackets slouched on heavy wooden hangers against the wall. I'd stepped into a dress shop of my girlhood. But I was no longer that girl—even my yearning for prettiness had become a vestige.

The store seemed empty until a woman behind an old manual register called, "Hello! Can I help you?" Dressed in a neat lavender cardigan, her gray hair waved around a pale soft face, rouged with a trace of rosy blush. Fiddling with price tags strewn on the counter, she smiled, "You'll find some denim shirts and jackets on the back wall." No doubt she sized me up, as my frayed jean shirt could use upgrading.

I felt obliged to look. Tops embroidered with pink hearts or apples or bedazzled with beads — I'd pass. Moseying around, I did find some flannel pajamas for four bucks, then a pair of my favorite spongy-soft slippers that I like to paint in — half of half price. As I raked through the hangers, they squeaked against the metal bar until I stopped at an open-weave rust sweater, a perfect birthday gift for my mom.

Feeling sheepish for my shopping spree on the day I'd seen so much devastation, I still had an urge to be friendly.

"Shame the store's going out of business," I said, as I walked up to the counter. "Are you Sue?"

"No, just work here. Part-time." The woman fondled the silver petals of a flower pendant.

"That's a really pretty necklace."

"Why, thanks. Husband gave it to me for our fortieth."

"Have you lived here all your life?" I asked, opening the door to the whole story about her growing up there, marrying a serviceman, "livin' in

army bases" all over the country "while the kids were growin' up," before retiring back to Appalachia.

"But it ain't the same since the deep mines closed." Then, looking me in the eye, she shook her head. "The town's done dried up bad." (I didn't mention that I'd noticed.)

Figuring there was nothing to lose, I asked: "So, um, what do you think of putting up wind turbines here?"

"Honey, anything that'll bring us work here's okay by me."

"So why do locals hate them so much?" I'd seen a billboard nearby with "DON'T RUIN OUR MOUNTAINS!" over a picture of windmills on a mountain. It wasn't meant to be ironic.

"Folks 'round here…" She paused. "Well, coal's been in their families so long they can't imagine life without it. For years goin' down in the mines was the way most men made their living."

"So what *was* the town like before those mines closed?"

"Oh, everything's changed. I grew up in Andover, the coal town just up the road. This here's where we came to shop—hard to believe." She shook her head. "Now everybody drives to Walmart in Big Stone Gap.

"Don't let anyone tell you different, it was a good place to live. Everybody knew your name. All of us kids played together—kick-the-can, skipping rope, you name it. Daddy'd get home from the mines soot black, but he'd trout fish in Callahan Creek on Saturdays. And you wouldn't believe the big gardens—Mama canned quarts of tomatoes and beans for the whole year."

Her openness made me feel I could ask, "How do you feel about the kind of mining they're doing off Route 160? I mean, destroying the whole mountain?"

"They ruin our creeks doing that. Besides, not near as many jobs. Nope, I don't like it. Not one bit."

Who would have thought I'd find such a spirit at Sue's Dress Shop?

I STUFFED THREE CRINKLY pink shopping bags in the car. Now my stomach was *really* growling, so I drove to Double Quick on US 23 to gas up and get a snack. The back window of a rusty Pontiac Firebird parked outside sported a "SONS OF COAL MINING CLUB" sticker with helmeted skull and crossbones. No, wait, not crossbones, crossed *pickaxes*—mining gear. If pro-coal, why the skull, which to my simple mind suggested death?

A burly fellow squeezed out the door with a case of Old Milwaukee, his jean jacket cut at the shoulders revealing that same symbol inked on his bicep. He smiled as he held the door open for me with one boot. Would he notice my I BREAK FOR TURTLES bumper sticker?

I asked the cashier what the skull meant, pointing to a similar sticker on the counter.

"You're not from 'round here, are you?" He handed me my change.

Hmmm. From 'round here—I felt sure the saleswoman at Sue's and the Son of Coal both felt deep connections to the region. But did leaving it, experiencing other worlds, and then returning (as she did) have everything to do with openness to change?

The door banged my back on my way out.

Behind the dashboard again, I brooded on the skull's glower. My first naive assumption was that when the underground mines closed, when mine owners showed their true colors, then the miners' solidarity

would vanish, too. But no. However odd it seems to outsiders who associate coal mining with black lung, climate change, and union busting, it's a way of life fusing danger and manliness with friendship. Later I asked my friend Marie, a coal miner's daughter, what she thought about the skull and crossed pickaxes. "Knowing that the person you went to work with in the morning may not be coming back out alive, I imagine creates powerful bonds," she told me, bewildered herself by her dad's loyalty to coal.

So the skull with pickaxes is a badass symbol of toughness and camaraderie with fellow miners. You can't easily chuck that combo out a psychological window. Ask any combat soldier about the bonds forged in battle, and there you have it.

WITH MY COLD CAN OF V-8 and tube of shelled sunflower seeds, I drove to a roadside pull-off near Roaring Branch Creek for an impromptu picnic, straddling a log under the shade of a tall buckeye. A wood thrush fluted overhead—heard, not seen. Ferns breeze-fluttered along the bank, living mementos of ancient coal swamps.

Foraging close by, a nearsighted groundhog nibbled leaves as if the world were one giant salad bar. It suddenly stood bolt upright, sniffed the air, skull flat as a stump; our eyes met for a split second before the creature lumbered away—it knew my kind.

A bee scrambled into goldenrod's yellow fluff, oblivious, tiny hairs clogged with golden dust. Buzzing to another flower, it sensually wiggled its abdomen before plunging head first into golden-orange pollen. How cool to dive headfirst into what you love. Maybe that's close to what an artist does when she brushes gooey paint on a panel?

As I watched the bee, a trickle of tangerine-orange slime oozed around boulders in the creek. Mine waste? I wasn't sure. But I was sure that the buzzing and foraging and singing and, yes, art-making are fragile when pitted against the human need for electricity or steel or heat.

I threw my head back to get the last trickle of tomato juice, and my mind drifted to the studio. How could I shape my experience of this place? The living hills. The blown-up ones. Whole communities left dying because cash flowed somewhere else. The beauty. The wounds.

I began talking, or rather whispering, to an imaginary companion: *If you throw in the towel and quit making art because of the destruction, you're saying "you win" to the bulldozers and dynamite. You're letting them rob you of what's meaningful about being human.*

You have to keep making art—it's more than about making objects or self-expression. It's about civil disobedience, about keeping a deep relationship with the living world alive, a relationship that recognizes profit isn't all we are. Sure, we indirectly get sucked into that plunder, but that's not reason to give up.

A ground beetle scooting from one log to another had no need for my advice. As its twitching antennae checked out a red-capped mushroom, I told the insect: *You live as you have for millennia, my friend, totally unaware of what people are doing to the earth.*

To shake my dark mood, or maybe to put it to use, I imagined rubbing a map with gritty coal, layering it so the fossilized past merged with the fluttering, pulsing present. Maybe I'd affix ferns and herbs now tickling my leg to the map. I could fabricate a surface only to destroy it.

Last, I doodled a few thumbnails in my sketchbook, scrawled "coal tattoo" in the corner.

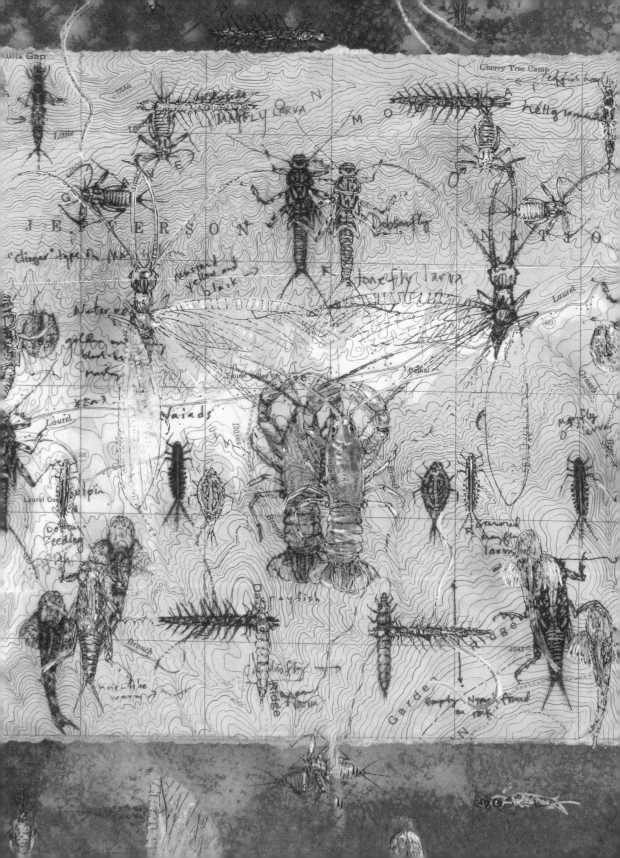

Water Way

WHITETOP MOUNTAIN

A SMALL BOY — I'd say about four years old — clenched his fists tight as he crouched over a yellow bucket. As I passed by, he pointed: "A hellgwamite!" Doubtful that this little tyke knew the larval stage of a dobsonfly, I checked it out. Sure enough, an inch-long hellgrammite — all sharp jaws and amber segmented legs, a creature surely dreamt up by Hieronymus Bosch — clambered about clumsily as if to disguise its ferocity.

So there I squatted on the banks of Big Laurel Creek watching a bug in a bucket with a little kid: over half a century between us, but little difference in our sense of wonder.

"Adam loves to play in the creek," his dad told me. Why was I surprised he knew water bugs if his parents taught him their names? If children can learn Disney characters

by heart—Elsa, Aladdin, Kristoff, Ariel—why couldn't they learn aquatic invertebrates? That's the scientific term for insects that live in water during their early stages, emerging as winged adults when ready to mate. When they do appear, we spot them lording over the air as dragonflies, or glimpse them at porch lights at night—mayflies, stoneflies, and those huge dobsonflies with their long mandibles and lacy wings. Once out of the amniotic safety of the water, most mate and die in weeks. Sometimes days. And most people, with the exception of fly fishers who tie trout bait, live and die without a clue about these insects' watery ways.

That cool cloudless day in mid-May, I was part of the Aquatic Invertebrates Field Trip at the Mount Rogers Naturalists Rally. Eleven

of us piled in a van shuttling to a clearing alongside Big Laurel Creek, where pure mountain water swirls around smooth boulders, bordered by tangles of leathery-leaved rhododendron boughs.

Our leader, Mike, a slim, bearded, slow-speaking biology professor from a local college, stood knee-deep in the creek. Holding a seine, he dipped it in as one of the creature-seekers lifted a rock. The flow of water sent myriad insects, fish, and crustaceans into the net. Mike emptied this cache into large flat pans on the bank, exposing animals once secreted under creek boulders, hidden from our snooping eyes. They now scuttled about in shallow water, frantic for cover.

A magician amazes his audience by pulling a white rabbit from a top hat, but there in the Blue Ridge an entomologist's *abracadabra* conjured astonishing critters from a cold mountain brook.

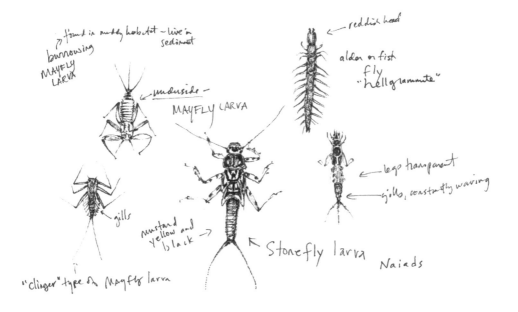

Real magic. Or should I say magic of the real?

A fellow field tripper, wavy hair cascading over his bony shoulders, discovered a long, tapered damselfly nymph with two caudal gills sprouting from its abdomen: "Coo-ol," he said in his two-syllable Appalachian tongue.

"A sculpin!" A woman I'd noticed at previous rallies (always in an ankle-length skirt, long hair coiled in a bun) called me over. There scurried a fish smaller than my little finger, its pectoral fins like scalloped fans behind each gill.

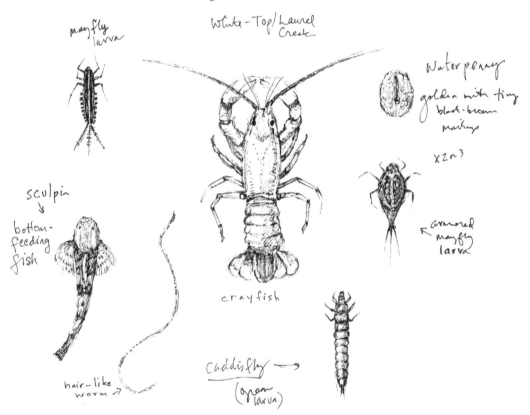

mayfly larva

White-Top/Laurel Creek

Water penny golden with tiny black-brown markings

x2 or 3

armored mayfly larva

sculpin ↓ bottom-feeding fish

crayfish

hair-like worm ↗

Caddisfly ⟶ (green larva)

Then there were the ink butterflies fluttering up the leg of a sprightly young woman, their frozen flight disappearing under her cutoffs, emerging on her neck from her red-and-white Radford University sweatshirt. She leaned over the pan of creek life and asked, "What are these little round guys?"

"Water pennies," Mike said, as we gazed down at the flat coppery creatures. "They become small terrestrial beetles at adulthood." He turned up the volume for everyone to hear. "The presence of these animals in the stream means the water quality is excellent. They can't tolerate pollution or thick layers of algae growing on rocks. If the water is clean and full of aerated oxygen, they thrive. Since you can measure water quality by the species found in a creek, we call these bio-indicators."

I call them beautiful.

Nearby a family of four clustered together, comparing their illustrated checklist with a wormy-looking thing sporting six stubby legs. Someone murmured, "Cranefly?"

But I didn't check that one out. I was busy drawing as the congregation of newly converted aquatic insect devotees dumped more small life into tubs. I hunkered over my sketchbook, recording each species. Or *trying* to. It's a challenge when your model zooms off by squirting gas out its anus—exactly what a dragonfly nymph was doing as I fast-sketched its roundish body. Its legs angled back and up in a gesture like that of a Malaysian dancer.

Next up: the tortoiseshell-like mottled back of a stonefly. After that, the three sharp prongs of a mayfly's pulsing gills, reminding me of fringe on a fine embroidered cloth.

Which made me pause there on the banks of that Appalachian creek, remembering my recent trip to London's Victoria and Albert Museum. There I saw gold fringe on silk religious vestments embroidered with precious gems. I saw limewood intricately carved into Mary's rumpled robes or a saint's hand on which each finger—each *knuckle*—articulated into knob and bone. I saw ivory whittled into netsuke: crouching frogs, sun-basking turtles, and lacy-winged cicadas. I saw gilded silver chalices decorated with intricate filigree.

I even saw a Leonardo codex with its delicate pen-and-ink drawings bordered by calligraphic mirror writing.

But nowhere within those alabaster-columned halls did I see anything *more* intricately fashioned, more stunning, than the evolutionary art scuttling at the bottom of Laurel Creek. And standing there on the bank, looking between the mayfly larva and my sketch, it occurred to me that the difference between life and art is that life can reproduce itself. Simple as that. Or maybe not so simple.

I FINISHED A FISHFLY with a few scribbled lines; a scattering of insects now swam on my page. As I started to pack up, a young man with wire-rimmed glasses asked shyly, "Mind if I look at your sketchbook?"

"Not at all." He paged through quietly.

A middle-schooler, thin brown hair braided close to her head, sporting a JUST DO IT sweatshirt, begged her mother, "Can I bring my colored pencils next time we come?"

Down at the creek's edge, her father pushed up his Braves hat and called, "Hey, Claire, you might like to see this-here bug. I think it's an alderfly." The girl skipped off.

Just then, Mike held up what looked like a tiny scrap of crinkled Saran Wrap clinging to a green stem. "A shed skin of a damselfly," he told us. "It crawled out of the creek, wiggled out of its exoskeleton, then dried its wings before flying away. They emerge at night when there are fewer predators."

Mike glanced down at his watch. "Time to go. Carefully pour all the critters back in the creek. Nets and pans in the truck. Clipboards in this box." I took one final look at the nymphs and larvae at the bottom of a pan; they'd left trails like Etch-a-Sketch lines in fine silt, cursive of the creek spelling: *Which way back to my home boulder?*

As we returned to the van, there was no sign of our ever having been there but for trampled grasses.

From the back of the Plymouth Voyager, the spring mountainside blurred green as we whizzed down Route 58 back to the Konnarock Community Center. The smell of sesame sticks filled the air, along with chatter about insects in their watery world.

A red pickup screeched around us, teenage testosterone breaknecking over two yellow lines into oncoming traffic, veering in a split second back to the right lane.

"I think he's late for the afternoon bird walk," the driver grinned, sending everyone into an uproar.

Someone called out "Cucumber magnolia!" All eyes glanced roadside to the tree's floppy greenish-yellow flowers. And under my breath I whispered, *This is who we are.*

Natural History of an Art Museum

RICHMOND

I PERCHED ON A canvas-sling campstool sketching a red-bellied wood-pecker. Not under a towering oak's cool shade, but within the cool white walls of the Virginia Museum of Fine Arts (VMFA). And the bird? Since the late 1700s, it's dwelt in an old plantation scene painted by an anonymous eighteenth-century Virginia artist. In this picture, a boy clutches a bow and arrow in his right hand, while the woodpecker dangles lifeless from his ruffled-cuffed left. The bird's black-and-white-spotted tail and wing feathers, downward curving beak, brilliant red cap and rouge belly blush are rendered so beauti-fully—obviously observed closely and loved. For isn't willingness to spend hours studying and then recording an act of love?

But the pasty-pale lad is painted only competently. So, too, his little brother, his African American nanny-nurse, and their little lapdog.

All appear stiff, wooden, as if painting *them* were just another job for the artist. It was.

There's no mention of the bird in the title: *Alexander Spotswood Payne and His Brother John Robert Dandridge Payne, with Their Nurse.* What does the accompanying label say about the woodpecker?

Not one word.

Really?—nothing about what the artist clearly thought most fascinating? Strange, because it's clear as day to me.

Here's my revised title: *Woodpecker Sacrificed to the Whim of Two White Boys as an Enduring Enslaved Woman Looks On.* And my label:

> *In colonial America, limners were artists with little formal training who traveled from place to place soliciting commissions, usually portraits. When anonymous, they are often referred to by one of their works, as in the case of the "Payne Limner" who roamed the state of Virginia in the late 1700s. His proficient painting of the figures and background distinctly contrasts with the skillful touch and intense observation lavished on the red-bellied woodpecker. Perhaps this is a veiled statement about the Paynes or the upper class in general. Or possibly the bird fascinated the artist while executing a routine portrait commission.*

MY STUDY OF THE Payne Limner's woodpecker was part of a two-day expedition at Richmond's art museum, where the galleries morphed into habitats, hallways into trails. In much the same way I hunted for salamanders under stones, or focused binoculars on elusive warblers, I searched for, identified, and drew animals inhabiting paintings or sculpture.

Months before my visit, I requested consent from museum higher-ups to draw in ink—usually forbidden in the presence of artwork at the VMFA. My description of the project along with a pile of credentials would hopefully prove my trustworthy character. It did.

On entering the museum's spacious hall, I whipped out my consent letter, legitimizing my concealed carry. "Security was briefed about you this morning," the head guard informed me, arms crossed over his barrel chest.

Briefed! Heck, that puffed up my feathers.

And so I wandered through the galleries seeking animals, campstool resting on my shoulder, pack equipped with Micron Pigma pens, pencils, kneaded eraser, and black clothbound sketchbook.

My first stop was Jan Brueghel the Younger's *Landscape with View of the Castle of Mariemont.* A hip young man with black spiked hair peered over my shoulder. Out of the corner of my eye, I could see him adjust his red-framed glasses as he compared my drawing with the painting, looking up, down again. His brow knit, puzzled.

No castle on my page. Instead, a scattering of birds: an owl, two pheasants, a magpie, a hoopoe with its buzz-saw crest, a woodcock rising from the brush, and a lark ascending.

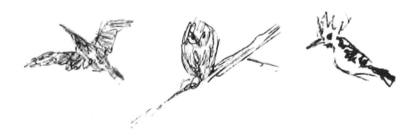

"Mind if I look?" he asked.

"Not at all. I'm identifying birds in the painting—this over here is a hoopoe, a really exotic-looking bird indigenous to Europe," I pointed, as if his question were an invitation for bird ID. "I'm working on a project documenting animals in art."

"Hmm," my observer nodded, strolling away politely (maybe to think it over or maybe to escape a balmy birdwatcher).

THE CLOMP-CLOMP-CLOMP OF MY hiking boots echoed in the marble halls between galleries as I got down and dirty with animals.

I sketched:

- a bat swooping on a Chinese porcelain bowl
- Thomas Eakins's sora rail probing mud in a Pennsylvania wetland
- Sesha, the Hindu cosmic serpent sporting oodles of snaky heads
- a grinning hyena from Mali ("a strange and uncouth creature carved to illustrate how not to behave")
- a housefly fidgeting on the Virgin Mary's soft robe as she receives some surprising news

Forging on to the equine art collection, did I smell hay wafting from the gallery? It seemed so in this stable of horses: Gleaming steeds. Stubbs's bobtail horse. Massive draught horses with rippling muscles. Wild West broncos. Degas's racers prancing on the green. But of all, Albert Bierstadt's *Swaybacked Stallion* moved me most. Maybe because

of the bowed head and jutting lower lip or maybe because of the half-opened eye or now-useless organ, its gesture conveys an internal life. Who knew the nineteenth-century painter of theatrical panoramas could pluck such a deep chord?

I continued my day's ramble with more sketch-stops:

- Audubon's golden eagle, proud bird with a troubled brow
- Picasso's pigeon, painterly brushstrokes morphing into feathers
- Strozzi's mother nursing a child, an image of our beautiful animalness

THE MORNING OF DAY 2, I roamed the jewelry galleries, where a sterling silver long-horned beetle crawled across an Art Nouveau buckle. Did the jeweler wander the Austrian woodlands finding inspiration in the arabesque of antennae?

The eagle looks a bit dismayed — guess I would be, too, if caught in the sights of Audubon's rifle.

On to the Antiquities collection, where I doodled creatures frisking over Greek urns. A red-figured ram's-head rhyton caught my eye, a Mouflon sheep with a mug on its head. Drawing its curving horn and seeping eye, I wondered if the ceramic artist also made sketches — from life? In the wild or in a butcher's shop?

–125–

LUNCH BREAK AT THE Best Café. A familiar pair of red glasses peeked from behind *Since '45: America and the Making of Contemporary Art*. I set my tray down on a table nearby with a clatter. This time I wanted to interrupt.

"Love that publisher's logo," pointing to the binding, where an upside-down ant holds a globe.

He stuck a finger in the book to mark his page, then closed the cover to check it out. "Oh, yeah, figures you'd like it. Having any luck finding creatures today?"

"A veritable safari," I grinned, dipping a pita slice in baba ghanoush.

Minutes later he shoved his plate away, wiped his hands on his napkin, and asked if he could see my sketchbook.

"You know," he said abruptly, halfway through, "what you're doing is deconstructing the museum. In this one, you're decoding the Western worldview of dominating nature." He held up the red-bellied woodpecker sketch.

"You might say that," I nodded. It had occurred to me, though not in those words.

THAT AFTERNOON I MOSEYED around a mother lode of Egyptian animals—not surprising, since their pantheon included ibis, scarab beetles, falcons, even an otter.

And then leaping from ancient culture to my own lifetime's modernist art, I was greeted by some goofy dogs inhabiting

Egypt

Sculpture of an Otter

Otters in Egypt? Well, there must have been some in the 7th or 6th centuries BCE when this statue was made. Are there still otters in Egypt?

Roy DeForest's *Out West*. Nearby, Ben-Day-dotted
gulls soar in Lichtenstein's cartoony *Gullscape*.
Sophisticated spoofs.

On to the contemporary galleries. Has there
been an attitude shift toward the natural world in the past
few decades? It seemed so. Witness works such as Julie Heffernan's
Self-Portrait in a Coral Bed, with its willowy nude surrounded by anem-
ones, sea urchins, and starfish glazed in glowing oil paint. Or James
Prosek's *Sailfishe*: one multicolored wing lifting a fish into naturalistic
surrealism. If the VMFA is any indication, from the 1990s to the
present artists have embraced nature's mystery and diversity, or, perhaps
equally to the point, curators have taken it seriously.

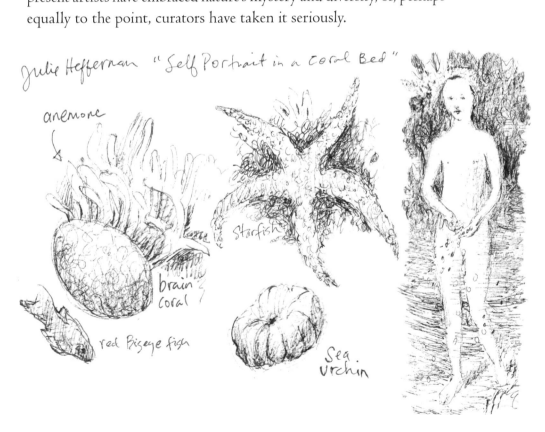

Julie Heffernan "Self Portrait in a Coral Bed"

anemone

brain coral

red Bigeye fish

Starfish

Sea urchin

Isaac Soreau Flemish
"Still Life with Grapes,
Flowers, and Berries
in a Wanli Bowl"
ca. 1620

Soreau paints
the butterfly's cast
shadow — even its
hair-line leg has
a shadow

Tan butterfly
with black markings —
does this species still
flit around the Belgian
landscape?
Who knows. But I assume

This is the
"Small Tortoiseshell"
butterfly,
Aglais
urticae,
a little browner
than they really
are — did
the artist
simply want
it to work
better with
the painting,
or
was he using
a faded specimen?

this little fly still populates
the country. The artist lavished
equal attention on each.

A visit to Golden Age Flanders was my last stop. In Isaac Sorem's *Still Life with Grapes, Flowers, and Berries*, I loved the way a fly and tortoiseshell butterfly cast shadows—even their threadlike legs! I hoped the fragile russet-and-black-spotted butterfly still flits in the Belgian landscape. No doubt the fly does.

Expedition over, I strolled through the Fan district of Richmond, ducking in a little coffee shop to flip through my days' sketches. Seeking fauna, I'd globetrotted through India, Asia, Europe, Africa, and the Americas. Outside the window, people with roots in those very places passed by. And it occurred to me then that the art museum is like a vault safeguarding our ancestral connections to the animal world.

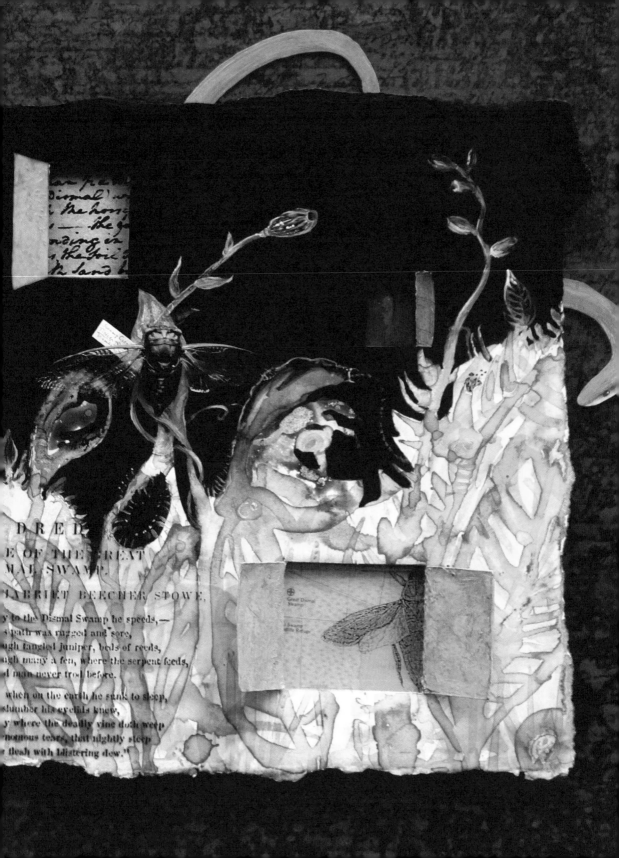

DRED

E OF THE GREAT
MAL SWAMP.

HARRIET BEECHER STOWE,

y to the Dismal Swamp he speeds, —
s path was rugged and sore,
ugh tangled juniper, beds of reeds,
ugh many a fen, where the serpent feeds,
d man never trod before.

when on the earth he sank to sleep,
slumber his eyelids knew,
y where the deadly vine doth weep
nomous tears, that nightly sleep
e flesh with blistering dew."

Refuge

GREAT DISMAL SWAMP

I YANKED THE VINYL curtains wide. The Econolodge parking lot glistened slick black from a nightlong rain, a dip in the asphalt a virtual pond around our tires. Dark clouds threatened more of the same.

"I think we're in for a soggy walk," I called to Dan.

He leaned into the mirror, mumbling something lost in the drone of his shaver. "Don't use any face cream," I teased. "The mosquitoes will love you."

"They already do."

We left Suffolk around 9 a.m. for our planned hike: four and a half miles through Dismal Swamp Refuge to Lake Drummond. Nine miles round trip. I was edgy. I wanted Dan to enjoy it, but worried about his trouble with the little whiners.

As a lure for the swamp hike, I'd promised that we'd head to the ocean the next day, the reason he was drawn to this Tidewater trip. The sea holds special meaning for him: as a child he frequently sailed the Atlantic on an ocean liner to his mother's native England. And exploring the coast of Japan with his poet father is a cherished memory. But swamps? Well, they were *my* "thing"—the abundance of life from water birds to bugs to snakes coiling in the mysterious murk seduced me into a world both stunning and foreign. Unwelcoming habitats and animals pull me in like an organic magnet.

"Drummond is one of only two natural lakes in Virginia," I told him as we drove down White Marsh Road. "On Google Earth, the lake within the refuge is like a glowing blue nucleus in a pea-green cell."

A few silent moments passed. I read from some notes: "This wetland used to cover over a million acres but it was drained or logged back in the 1700s—part of young George Washington's engineering project. Now it's only a little over a hundred thousand acres."

Twenty minutes later, we pulled into Washington Ditch Trail's empty lot. As the motor idled, we watched mosquitoes drift toward the windshield. It seemed as if they knew the doors would soon open to release their quarry.

"Some kind of welcoming committee!" I forced a grin, rounding up the gear before slamming the door. Time to make an exception with pesticides. We sprayed on OFF!, buttoning our shirts up to our chins. We crammed our pant legs into socks. I knotted fabric softener strips around my neck, sleeves, and cuffs (legend has it the little

suckers hate the scent), while Dan pinned yellow citronella buttons to his shirt, pants, and hat—seven in all—looking like some wacko at a political rally. One glance at us and another hiker might bolt in the other direction.

But there wasn't a soul out on that humid August day. Cicadas ratcheted from the crowns of trees as gunmetal clouds clotted the sky. Our backpacks bulged with water bottles, apples, trail mix, and binoculars. And ponchos—we had no illusions about the day. Well, maybe some. My sketchbook earned the honor of a HydroLock Dry Sack.

Off we strode down Washington Ditch Trail. Running along a flat raised mound, swampy cypress forest to either side, the path reminded us of a rail trail. It might have been a pleasant hike without the mosquitoes. They seemed to snicker, "Did you forget your repellent?" Soon we both swept leafy branches around our heads to keep them at bay.

Farther down, a boardwalk jutted through a stand of tall black tupelos and sweetgum trees. "I'm going down here. You go ahead. I'll catch up," I said, starting off on my detour into the dim, dense woodland.

At the end of the planks a vine dangled from an overhanging branch—but wait, it moved…a green snake! My first. Sensing me, the serpent flicked its barbed tongue my way—*How would my scent translate into snake thoughts?*

Scales sleek and fresh like spring leaves, it slithered close as I snapped a photo with my pocket-size Nikon. By swaying my leafy switch like a windblown branch, I believed the serpent was momentarily fooled, for it coiled around a branch closer and closer until—*swat!*—I impulsively slapped a mosquito bloodletting a bumpy vein on my hand, sending the snake slithering up the trunk.

My gaze shifted to the swamp below, where a giant water bug bobbed on the surface. Bigger than my thumb, it slowly oared the water with paddle-like back legs. I reached for my sketchbook, scratched a few quick lines when—*zoom!*—it dove, leaving shimmering ripples as it chased a hapless minnow. I shuddered to imagine that bug's mouth—a combo sword and straw—sucking the critter dry.

What an awful death. Nature's beautiful, but sure ain't pretty.

The shadowy mire sucked me into its secret life, life oblivious to human concerns. For me, nothing beats knowing that snakes loop and giant water bugs paddle their entire lives free of my tribe—all the better for this pocosin, the Algonquian word for "an impenetrable thick growth on a rich layer of soil over sand." A habitat I hoped would endure forever, protected, whether my species "enjoyed" it or not.

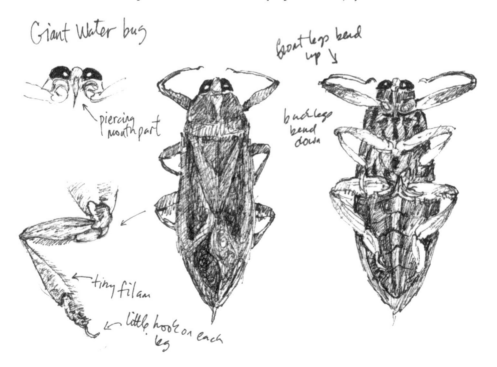

Giant Water bug

front legs bend up ↓

piercing mouthpart

back legs bend down

tiny filam

little hook on each leg

WHEN I CAUGHT UP, poor Dan was batting a cloud of bugs orbiting his head. Some people attract mosquitoes more than others, mostly due to their blood chemistry. So thank Mom or Dad, because it's a genetic thing. Amazing that a small difference in our DNA distinguishes us to an insect—a small wonder, albeit a tough one to admire if you've inherited the seductive scent.

Female mosquitoes have an organ that detects exhaled carbon dioxide from more than a hundred feet away. I thought of telling Dan to "just stop breathing," but it didn't seem particularly funny. Instead, I misted bug repellent on the back of his neck.

"She's the one who *likes* bugs," he grimaced, whacking a few.

"Don't exert yourself! They're also attracted to sweat, lactic acid, movement, and even beer. So don't ever go jogging in a swamp if you're breastfeeding and you've just swigged a pitcher of beer—the mosquitoes will devour you!"

That made him chuckle.

"Well, ladies, do you really need *my* blood for your babies?" He remembered what I'd told him, that it wasn't dinner they're after. It's that female mosquitoes seek a smidge of blood protein for their developing eggs. Gentle male mosquitoes flutter flower to flower, tipsy on nectar. Quite a family arrangement.

The sky darkened. Drizzle sent us scrambling for our ponchos. We resolutely forged on.

"I think we're following something big. A bear?" Dan pointed down.

"*What?*" I swiftly glanced right, left, then saw animal tracks in the mud below—*huge* paw prints. The guy at

the Suffolk hunting store, the one who had given us directions the day before, claimed: "Thar's bar in thar." Here was proof. The size of my hand, the print's five round toe pads spread over an elongated heel. In smooth patches of mud, spookily fresh, one print followed the other as if pigeon toed, or as if it were treading a narrow plank.

"Some tracks are longer than others," Dan showed me. "Here's one with dots over the pads—claw tips?"

I turned around 360 degrees: Could bear eyes be fixed on us? Perhaps one lurked behind a cypress. The tracks disappeared into the swamp. In one lay a cicada, stiff legs angled up over a chalky-white underside. I turned it over, and its humped thorax gleamed black as if varnished, mossy-green triangles edging copper-streaked wings. I

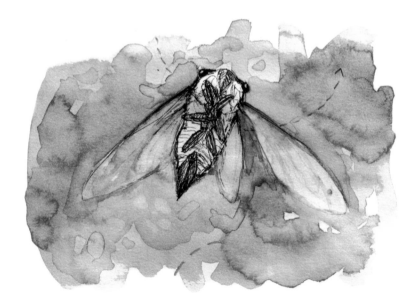

pinched a wing to shake off an ant, setting off a feeble fluttering. As if on cue, the grinding drone of a swamp cicada above me came to a crescendo — *errrmmm, errmmm, errmmm. errmmmmmm,* fading to a jittering rasp: *ahhhhhhhhhhhhhhhh.*

Drizzle turned to light rain. Dan hurried on, determined to reach the lake (or determined to show me he was a good sport) while I lingered behind, listening to raindrops popping off my plastic hood, hoping to spot a cottonmouth, that swamp-loving viper.

The Dismal Swamp brochure states, "A five-mile hand-dug ditch leading from the western boundary of the refuge to Lake Drummond may be the first 'monument' to bear Washington's name." Wait…*hand-dug?* It hit me what they meant: enslaved people dug that ditch. The leaflet makes it sound so quaint, like a craft fair that boasts of hand-made ceramics. But once, right here, Black men waded ankle deep — no, thigh deep — in murky water, prying muck with shovels, casting the sodden stuff to where I now stood. I imagined the sucking slurp as each foot lifted. As they dug, cottonmouths whipped the surface of the water. Mosquitoes swarmed heads. Yellow flies fed on the sweat of their brows.

And there I was, grumbling about mosquitoes.

"You coming?" Dan called.

When I caught up, I told him what I'd been thinking. We trudged on in silence, or rather without talking, listening to the continuous percussive *plinks* of rain on leaves and ponchos, our switches by our sides now that the bugs had taken a rain break.

The shower steadied. Our shoes caked with mud caused us to move jerkily, shoulders hunched. I squinted to see ahead of me, my glasses

fogged. Once we were soaked, there was nothing to do but loosen up and surrender to water prickling skin, to mud squishing inside our shoes.

Sticking my tongue out, I tasted rain mixed with salty sweat as it dripped down my nose. Strangely delicious.

"Let's turn back," I sighed. I'm sure Dan was secretly relieved, though he hadn't complained. Beyond being soggy, beyond our dashed plans, we were troubled by the ghosts of Dismal Swamp's past.

BEFORE HOPPING IN THE car, I spotted a lacquer-red ant and a shiny black one battling over a dead butterfly, its gray wings ribboned with orange wavy lines. As the ants' sharp mandibles nipped, their wild fighting distracted them from the prize.

Dan started the engine. Fiddling with knobs for wipers and lights, he looked up. "I can't believe I hadn't thought of this. Harriet Beecher Stowe's novel *Dred* is about a slave rebellion set in a swamp. *This* swamp. Dred was a Maroon, the word for a fugitive who found refuge here."

Windshield wipers clacked like a metronome as we pulled onto US 13, past the sign for the Great Dismal Swamp National Wildlife Refuge.

"*Refuge* . . . so many shades of meaning," I said. But the defroster whooshed so loud I couldn't tell if Dan heard me or not. And I mumbled "Fugitive . . ." and paused, groping for how to say we're all dodging the reality of who or what's been exploited to provide for us.

"Did you say something?"

"I'll tell you later."

MONTHS AFTER VISITING DISMAL SWAMP, I leaned back in an old studio chair studying my assemblage-in-progress, *Maroon (Swamp Diary)*, propped on a table. A week before I was satisfied, but now I thought I'd crammed it with too much stuff. Should I take something out? If so, what? The green snake or the cicada? The title page of Stowe's *Dred*? George Washington's handwriting? The maroon drops of Dan's dried blood in the niche?

I removed nothing. After rearranging odd bits of paper scraps and bugs, I decided the piece might be flawed but in the right way: honest, layered.

But I continued to dwell on the notion of "flawed." Our rainy day at Dismal Swamp could be seen as flawed; had it been cloudless, we might have reached Lake Drummond. We might have witnessed a white

egret winging over that primeval marshscape spiked with cypresses, water sparkling silvery blue. Instead, the sky bruised, mosquitoes thick, we faced the dreadful reality of people forced to labor in the muck.

As thoughts drifted to the shadow of slavery, my struggles with Thomas Jefferson as slaveholder surfaced. Once, when questioned during a "Notes on the State of Virginia" gallery talk, I answered, "Thank Jefferson for our right to criticize Jefferson." But honestly, throughout this project I wrestled with how to admire him as the thinker, naturalist, and architect he was, while also acknowledging that he continued to own people, even fathered children with an enslaved woman, Sally Hemings. The word "flawed" came to mind again, meaning that which holds much value but isn't faultless. Yes, he was profoundly flawed, yet such a complex man: the same one who declared, "The earth belongs in usufruct to the living" —a *biocentric* view of the natural world (that odd word "usufruct" referring to what we borrow from future generations).

In her book *A Guide to Thomas Jefferson's Virginia*, Laura Macaluso hits the nail on the head. She writes: "Thomas Jefferson is not less important to know—he is more important than ever. He is a symbol of the paradox inherent in the American character and American history."

Returning to my assemblage, I felt it fit my idea of an honest document. *Keep it the way it is*, I told myself.

Dialogue on the Tides

SANDBRIDGE, ATLANTIC COAST

"Come quick!"

I glanced out the window of our vacation cottage to see Dan hunched over some bony thing on the picnic table. As I unpacked yogurt and eggs from the cooler, he called again, "Are you coming?"

I hurried out clutching an empty Kroger bag.

"A perfect fish skeleton," he pointed as I walked up. "Incredible. Looks like it's gasping for air. See all those delicate little ribs? You get your sketchbook. I'll unpack the car."

I did get my sketchbook without saying boo about not having to hurry. This fish wasn't swimming anywhere soon. No matter. I was grateful to dive into what I had come to do.

No sooner did pen touch paper than all of the names of bones once memorized slipped away, all the drawing techniques became instinctive.

Eye and hand and mind worked together on autopilot, pen welding me to this marvel of the universe. What more could one want in this life?

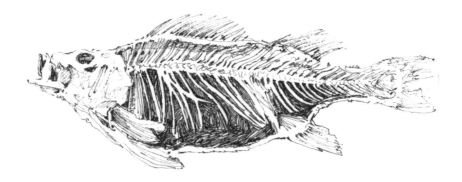

MY PLAN THERE IN Sandbridge was to walk the Atlantic shore early the next morning, south into Back Bay Refuge. So early I wouldn't see another soul. So early I'd witness the sun rising over waves.

When the alarm rang, dark windows betrayed no sign of morning. I sat upright. From the other side of the bed, Dan murmured, "Have…a good…walk."

After microwaving some coffee, I slurped it down while chewing on a trail mix bar, then grabbed my pack and flashlight. I needed to get to the beach before someone cleaned debris off the road with a noisy leaf blower, or garbage trucks made their rounds with all that backup beeping, to name a few of my pet peeves. Up before anything might yank me out of the mood of the morning. I wish I were stronger, wish I could flex my mental muscles to shut out distraction. *Wish.*

Clomping across our little deck, down a few stairs, I headed seaward. Beyond a narrow strip of blacktop, a ghost crab scuttled among clumps

of dune grass, its two black beads of periscope eyes poking up on stalks keeping watch as my human menace passed. Its dainty pinchers glowed as it tippy-toed sideways into a burrow; I smiled at this crab version of ballet's pas de bourrée, exit stage right. Reaching the lapping waves, a crack of pearly light fractured the horizon, splitting the gray sea from the darker gray sky, as if illustrating the expression *"break* of dawn."

My collecting bucket banged against my leg as I surf-walked, footprints embossing the sand with a jerky dashed line. I detected another set of prints in the dim light, stitching with mine like a phantom twin. My footprints were crisp, my doppelganger's faint—a vision of how our understanding of others and ourselves always hovers between clarity and obscurity.

I walked on in a twilight existence between dimness and light.

Twilight. Stars still sparkled overhead. Weeks before, I'd read about the three kinds of twilight—or three "degrees," according to astronomers—when Earth's atmosphere scatters light from a sun that's still behind our planet. The first is "astronomical twilight." After that comes "nautical twilight," and finally, "civil twilight" right before sunrise.

Such distinctions make me notice subtle differences, yet labels may also throw a net over spontaneity. Balancing this dichotomy has been my lifelong task. So I decided to call it all "magical twilight" as I plunked down on the cold damp sand.

Calm waves capped as if drawing breath, exhaling as they broke, foamed, and rushed to shore; the ocean's pulse transferred to my body as I synchronized my own breath to their slow rhythm—in, out, in, out. Then, as if the curtain were rising in slow motion, the world gradually became brighter, more focused. I opened a fresh sketchbook page:

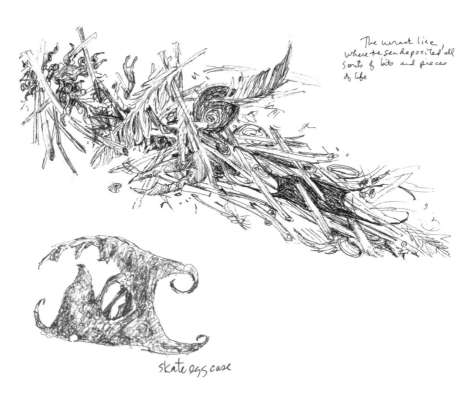

The wreck line, where the sea deposited all sorts of bits and pieces of life

skate egg case

August 25th, 6:50 a.m. I'm wiggling my toes in the wet sand of the Atlantic. Twilight's come and gone. Now the sun sits on the horizon, like a glowing lemon sphere in a still life, the ocean a giant table stretched with a rippling gray taffeta cloth. Gulls flap by. Their sharp wings and their sharp cries pierce the soft shushing of waves.

Just out of water's reach, I'm beyond the wrack line where waves dumped detritus in the night. Two skate egg cases — blackish pillows with long sharp points — lie in the flotsam. I pluck one from the mass of seaweed, sticks, and a green drinking straw. The damaged case, full of intricate curlicues and holes, reveals the empty hull. I'll draw the broken.

A flock of gulls lands a stone's throw before me. All face precisely northeast, positions choreographed on the sandy stage by thousands of years of evolution. Some say they face the wind to get instant lift should they need to fly off quickly. Is this pure instinct, or is their gullmind aware of it?

I stood up. The gulls flew off quickly, landing forty feet away in exactly the same orientation. They knew the rules. I placed the skate case in the bucket and continued down the seashore collecting shell shards, examining each miniature tablet lined with cuneiform writing. What did these runes say? That day, they advised me to gather seaweed with small air bladders, a brittle ribbon of conch egg cases (each segment holding a minuscule shell), and the ragged gray quills of seabirds. Wafting from the bucket, a dead fish stink stung my nose like lemon pepper.

Jointed crab legs strewn across the beach brought to mind the floor of a machine parts shop. Chitin's armor sure deals death a cleaner hand,

for what a ghastly sight had these been mammal parts! I gathered more. *Oh, my.* Wincing, I peered down into the bucket. *Claws, feathers, or the broken case of a skate—I'm plucking these from the natural cycle of decay. Suzanne, how unnatural to keep these frozen in time.* I gathered more.

Gazing out to the breaking waves, I imagined life squirming under the surface. Maybe sea bass or croaker—driven by hunger and instinct—were at this moment swimming toward the Chesapeake Bay. As surf foam lapped my feet, I pictured plankton tumbling in the salty swirl. Okay, so what I *really* saw in my mind's eye were microscopic animals from biology class, or rather mutant hybrids of zooplankton crossed with Dr. Seuss characters. One sprouted brushlike appendages beating around a huge black spot of an "eye." I stared at the choppy waves, wondering how plankton experience life as they spin, drift, and rush with the tides: copepods like miniature shrimp, angular diatoms, dinoflagellates—what a roller-coaster existence.

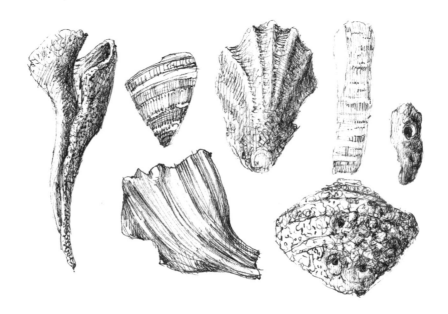

A fish crow's nasal *ah-wa ah-wa* jerked me back to the sandy shore, now glazed in golden morning light. On the littoral line, in a heap of washed-up wrack, lay shell fragments, a pink flip-flop, broken feathers, jagged sticks, and a child's blue shovel. I looped the pile twice, my footprints framing the broken and the trashed in an *enso* of imprinted sand.

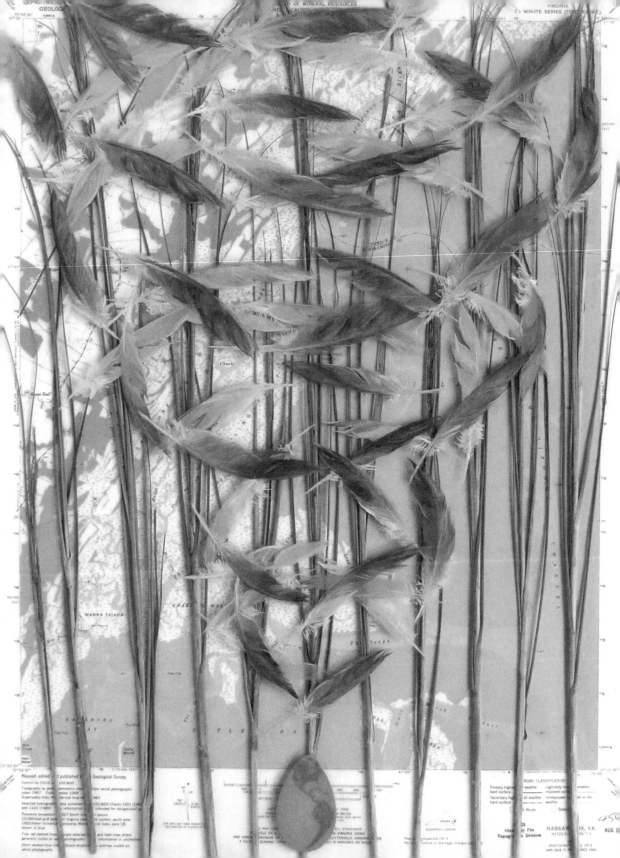

Flyway

EASTERN SHORE

I CLOCKED THIRTY-TWO MINUTES crossing the Chesapeake Bay Bridge-Tunnel—that masterwork of engineering—from the mainland to the Eastern Shore, a little finger of Virginia flanked by the bay and the Atlantic. It's a land where wind, weather, and moon-driven tides draw the map. There I'd mingle with the life on the peninsula's coastline for three new-to-me days.

Comings and Goings

The outboard motor roared as we scudded across Hog Island Bay. With one hand on my hat, the other gripping the boat rail, I leaned into the wind tracking a shorebird winging low over the waves. My guide that day was Barry Truitt, chief biologist for the Nature Conservancy's Virginia Coast Reserve. Such a privilege to be on a private tour with this no-punches-pulled authority on all things Eastern Shore.

Barry cut the engine. Now I could hear gulls screaming and the hollow beat of waves slurping against the bow's fiberglass sides—ga-lunk...ga-*lunk*...ga-*lunk*.

"Over there's Hog Island." My green cap reflected in Barry's dark sunglasses as he pointed toward a narrow landmass of tawny cordgrass. A dark strip of wax myrtles ran down the center like a zipper. He stroked his white beard, resting his hefty forearm on the wheel, as if the boat were an extension of his body. In a way, it was. He's been a waterman most of his life; boat-sense coils in his DNA.

"Native Americans called that island 'Machipongo,' meaning 'sand and mosquitoes.'" Barry was a fountain of facts both natural *and* cultural.

"Not too promising!" I joked, remembering my buggy foray that morning in the salt marsh. Barry continued, "Legend has it that the Accomac tribe went there only to fish and hunt."

"So how did it get the name 'Hog Island'?"

"No one knows for sure. Some say hogs released on the island inspired its name. Whatever, it stuck. In 1900, forty-two families lived there. Hard to believe now."

As the boat drifted, we gazed at the wild strip of land, now the domain of black skimmer and tern families. These days, sea turtles scramble onto shore to deposit their eggs deep in the sand, spared from the previous islanders' need for dollars or dinner.

"Some families farmed, but most fished or harvested oysters. In 1933, a hurricane leveled almost everything. Soon after, they did what they should have done: left. No government help, no insurance back then, so they just packed up and relocated to the mainland—some

even moved their houses!" he told me with a mix of crusty candor and respect for the rugged types who dared build a life on shifting sand.

Barry's narrative coupled with a photo I'd seen of the old island homesteads that morning, so off I hurtled on a flight of imagination. I pictured a woman hanging laundry on a line outside a white clapboard house. She shouted to children playing nearby, but they couldn't hear her for the strong gusts of wind off the sea. Wind blew her long hair in her face. Wind blew her long skirt as she scanned Machipongo Inlet for—*what?* Her waterman husband? A way out? Might she have been admiring the sharp wingbeats of a tern? A white picket fence enclosing her yard struck me as weirdly funny—such a domestic touch on a windswept sleeve of sand at the mercy of the waves. There in a habitat so untamed, so indifferent to human struggles, a feeble barrier.

One thing I knew for sure: that woman wouldn't have had time to paint anything but fences.

"Whimbrel!" Barry shouted. I spun on the hard seat in time to spot a brown-streaked curlew—crow-sized but leaner, with a long downward-curved beak—flapping fast. "They refuel here during migration. These islands make up a flyway for shorebirds, ducks, and geese. Even songbirds—warblers by the hundreds. That whimbrel migrates from South America to the Arctic and back."

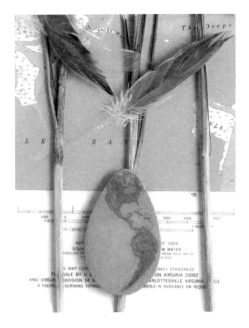

I shook my head in wonder as I watched the small winged life vanish on the horizon. How anyone—bird or human—could navigate this labyrinth of sea amid marshy bits of cordgrass blew me away. The wildness of these barrier islands reminded me of our limitations, just as a manicured coastal golf course tries to deny them.

"The last person left Hog Island in the late 1930s," Barry continued. "A few who grew up there still live on the Eastern Shore. I interviewed one old waterman named Berlie Bell for my book." (I'd later pick up his *Seashore Chronicles* in Charlottesville.)

We zipped over the water, jolting as we hit wave after wave. Slowing to a stop, Barry stretched out his large square hand, as if pointing with all five fingers at another island. It seemed fitting, as if he needed all five for each aspect of his expertise: naturalist, historian, waterman-angler (he holds the Virginia record tarpon catch), storyteller, and conservationist.

"Cobb's Island," he said. "There's ten feet of water over what was a fashionable hunting lodge a hundred years ago. Time was when men came down from northern cities—Baltimore, New York, Philly—to shoot ducks from blinds along that shoreline. Mallards, teal, buffleheads, pintails, geese, mergansers, you name it."

A black-and-white bird flew low over the waves. "Oystercatcher!" he abruptly called. "They stick around all year."

As Barry told tales of men's clubs in the 1800s, my eyes scanned the coastline, secretly glad the hunting blinds were replaced by a vast and beautiful absence of our own species.

One last stop. This time we stared at the surface of the choppy sea over the Eelgrass Restoration Project, an underwater meadow of long, swaying leaves below.

"Eelgrass is the keystone species of a healthy ecosystem in the bays," Barry told me. "Took a hit in the '30s when disease decimated it. Then the hurricane finished it off. Now we're replanting this bay." He swept his hand in the air, the way a conductor motions the audience to applaud the orchestra.

"All sorts of aquatic life depend on eelgrass," he continued. "It gives blue crabs a place to hide, and brant — a small goose — its choice food. Eelgrass also creates hunting grounds for fish, like red drum. And bay scallops, practically extinct here, are making a comeback because of the restoration. To date, five hundred acres of eelgrass have been seeded in four coastal bays, a total of six thousand acres. In one place, we spelled out 'NOAA' with eelgrass seeds, so when it sprouted it could be read from an aircraft overhead."

"So you're likening the eelgrass restoration to the concept of the ark?" I thought he'd said "Noah."

"Nah," he answered with gruff exasperation for my ignorance. "N-O-A-A. It stands for the National Oceanic and Atmospheric Administration."

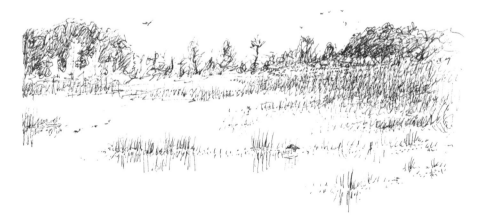

"Oh, yeah," I sheepishly murmured, though I thought my mistake had some merit. After all, restoration is very much like a biological ark, keeping many species — in this case a whole ecosystem — alive.

As we headed back to the dock, shorebirds' sharp wings beat over the waves. The island folk, the migratory birds: a landscape of comings and goings. Birds had adapted to the changing habitat over centuries of evolution. But people? Building their proverbial picket fences or clutching rifles, they sought to carve out a livelihood in the presence of a bountiful but unsympathetic sea.

People are a strange mix of hubris and vulnerability, I said under my breath as Barry nosed the craft, its motor puttering, through channels of marsh grass to reach the pier.

High Tide, Low Tide

Alone now on a morning visit to the salt marsh, I burst onto a mucky stage, mosquito net covering my head, pant legs tucked into knee-high waders. Fiddler crabs scuttled sideways in the mud flats, a corps de ballet making way for the prima ballerina: me. What grace! Pirouetting in boot-sucking mire, I tried to snare one in a net. *Tried.*

Later that afternoon at high tide, not a crab in sight. But the intrepid mosquitoes still hummed around my head as I searched the marsh. No birds. Only closeup views of yellow, green, and purplish-red cordgrass trembling in the wind. Then I spotted two oystercatchers, their red bills and slightly clownish yellow eyes doing the not-so-comic business of probing for food.

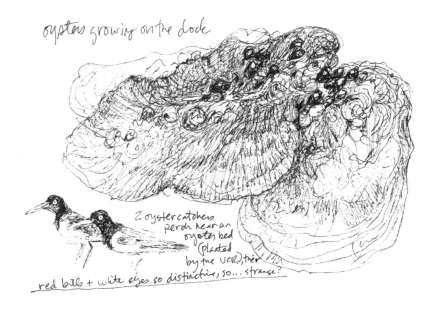

oysters growing on the dock

2 oystercatchers
perch near an
oyster bed
(planted
by the UCR), their
red bills + white eyes so distinctive, so... strange?

Nights on the Eastern Shore found me within a cozy eighteenth-century Brownsville farmhouse owned by the Nature Conservancy: a sprawling old shuttered abode, grooves worn on wood floors from hundreds of years of scuffling feet. Air-conditioning kept it free of mosquitos but also eerily quiet. On the dining room sideboard, a large sea turtle skull nestled in a basket among small shells and one hefty whelk, steely gray and pocked from tossing on rubble. As I arranged them to draw, their reflections glimmered on the polished surface of the dining table. I wrote in my sketchbook: *What did those eyes that once filled the sockets of this turtle skull see under the water? What is this whelk shell if not a vortex of calcium?*

Later that night, a crescent moon hovered above the dark trees. I perched on the closed lid of the toilet to draw a tree frog clinging to the bathroom window. Sticking to the glass with tiny suction-cup toes, it took advantage of moths attracted to my light. Every so often its tongue whipped out to snatch a winged dinner. After each gulp, the frog hopped to a fresh position. Its throat skin fluttered, reminding me of the thin white membrane of the egg I'd poached that morning as it bubbled in the pan.

My skin felt thin, too. Echoing in my mind was Barry's reaction to my comment that I was there for three days to experience the Eastern Shore and, from that, create an artwork about the place.

"Whaat? You think you can know this place in three days?" His mouth tightened to the side as he shook his head in disbelief.

I felt like an idiot.

But not for long, for I have my ways of knowing, Barry his. Just as the whimbrel evolved a long, curved beak to probe mud for supple bits

of life, and just as the oystercatcher's sharp bill adapted to pry oysters from their clamped-tight shells, so people have different skills. Barry can read ocean currents. He knows intricate waterways between islands. He knows shorebirds, eelgrass, and the shelled secrecy of oysters. And he knows island folklore.

And me? I can let the soft membrane of my mind absorb a place. Art, too, is a way of knowing. I flip out my aesthetic tongue to seize an image. But here's the upshot: art *embraces* mystery. I thrive in the zone that includes both ambiguity *and* knowing.

ON MY FINAL MORNING, I hiked around Cummings Birding and Wildlife Trail. Suddenly — *vrooom!* — a sound like a blast from a gas oven lighting startled me as hundreds of ducks rose from the salt marsh. I'd frightened them into a whirring frenzy as they refueled for the next leg of their journey south. I froze, a still point amid a dizzying vortex of feathered life.

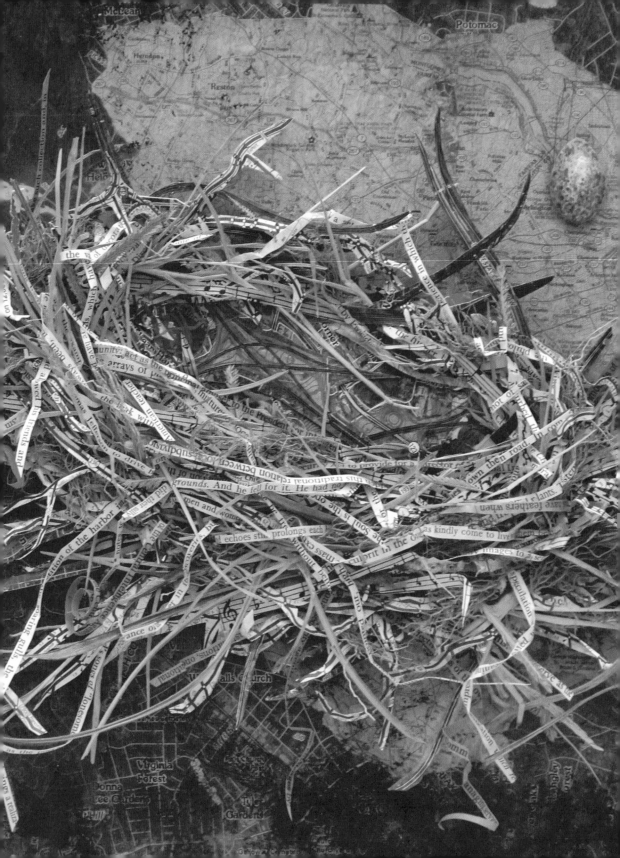

Nest-Making

NORTHERN VIRGINIA

THE SILENCE WAS palpable on the second-floor gallery. The staff at the McLean Project for the Arts hadn't arrived to help me deinstall my exhibition "Genomes and Daily Observations." Images lining the shadowy walls I knew to be a menagerie — cicadas to sparrows — amid fluid natural plant stains, but with no spotlights they seemed rather woebegone. Only one cold fluorescent hummed overhead, lighting the center of the floor where stacked cardboard boxes suggested a desolate city built on a lake of glistening bubble wrap. After the energy of installing, the publicity, the interviews, the opening, now I'd dismantle the show, load it into my car, and drive off, almost as if it had never happened.

My mood shifted when a fiftyish man strode into the room, ponytail spilling over a tie-dyed T-shirt. He flicked on more lights.

"Jake," he grinned, extending his hand. "I'm here to help load your car." While he stacked the big stuff on a rolling cart, a gallery intern joined us to help pack small drawings.

She brushed her blond hair back while lifting my image of a snapping turtle, its beaked mouth agape.

"My niece loves turtles!"

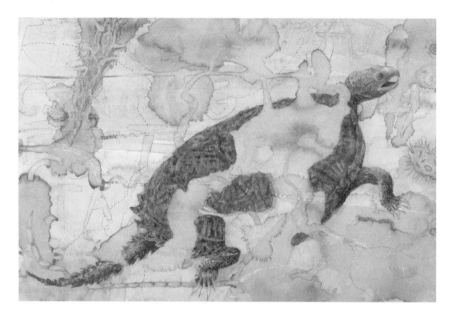

Whipping out her phone, she stroked the screen until a crayon drawing of a smiling kelly-green turtle surfaced—a *very* distant cousin of the primeval reptile in my painting.

We wheeled boxes out to the loading zone. But before driving off, I stopped at a book fair in full swing on the first floor of the McLean Community Center. For a quarter I bought *The Miner's Canary: Unraveling*

the Mysteries of Extinction, flinging it on the passenger seat before setting off for home.

That was in 2007. Why is this experience relevant here? Because for one, it represents one of my many trips to northern Virginia. For another, pages from that book would one day wind up in my "Notes on the State of Virginia" series.

But it wasn't until 2011, when I started my "Notes" project, that I *intentionally* collected materials from the northeastern part of the state. High on a studio shelf, I stashed sheet music from a musician-friend in Alexandria, Whitman's Civil War poems from Reston's Used Book Shop, and the dashed hopes of pink lottery tickets littering the Arlington Subway Station. I added roots and leaves of crabgrass pushing through cracks in a Manassas parking lot (*Why is she weeding the asphalt?*). A solemn brochure for Arlington National Cemetery made the stash.

From a colonial-style visitor center, I picked up a free Virginia road map with an inset of northern Virginia. On it, all of the distinct towns clustered south and west of DC had joined, the way spots of micro-organisms multiply in a petri dish until they fuse into one large mass.

FAST-FORWARD TO 2012. WORKING one morning in my downtown Bristol studio high in an old office building, I grabbed a king-sized Sharpie to label a cardboard box for my motley collection of papers, grass, and maps: NORTHERN VIRGINIA STUFF. I'd never ceased squirreling away "promising" mate-rial. Even a computer printout about the workings of the Pentagon got crammed in there. Finally a Mount

Vernon flyer topped the stack of tourist pamphlets, from a rack of "Things to Do in Fairfax County."

As a kind of free association with a driving force of the region, I photocopied a Jefferson $2 bill for my collection. (Can you imagine that inventive soul's fascination with the photocopier?)

Yet for months I remained clueless about what to do with it all.

ONE SLOW, SULTRY SUMMER day, as I trudged up the two flights of stairs to my studio, I swore to myself I'd tackle a northern Virginia assemblage *that day*. Light filtered through the transom as I unlocked the peeling oak door plastered with old exhibition flyers.

As I entered, the sun blazed through the tall eastern windows, heating the space like an oven, so I flipped on the AC. Lugging the NORTHERN VIRGINIA STUFF box to a quadrangle of sunlight on the worn floorboards spattered with crusty paint, I dumped it out.

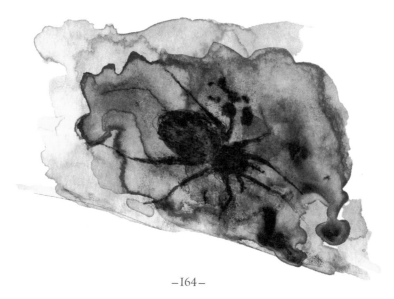

The heap hardly looked promising, more like rubbish really, and I worried that old Marvin the custodian might sweep it up, thinking he'd be doing me a favor throwing out this trash. Staring at it, I hoped the spark of a gaze would ignite some idea. Nothing. For several mornings dust motes haloed the pile as I entered the studio. Then one afternoon a large brown spider scuttled from under the clutter—spontaneous generation? It might generate rodents before long—after all, it did look like a huge rat's nest.

That's it — I'll weave a nest out of it.

Soon I was digging out my yoga mat (well-intentioned exercise I'd neglected) from the closet and rolling it out near the mess. With a Ravi Shankar raga jangling from the boombox, I steeped lemongrass tea—all in preparation for shredding nest material. Around the mat, I carefully arranged a salt-glazed teapot and stoneware mug, a large pair of Fiskars shears, and small curved manicure scissors, along with a stack of long Styrofoam vegetable trays.

All set to go.

Feeling like an acolyte in a funky religious ritual, I sat cross-legged on the spongy mat while cutting strips from printouts, maps, sheet music, and tourist brochures—sitar music infusing the atmosphere.

Pausing, I gulped, then sliced a page in *The Miner's Canary*. I girded myself to clip the Whitman, too. It rankled me to destroy books, even cheap paperbacks. I snipped the photocopied bill—only Jefferson's eyes remained—and went on to cut roads and rivers from maps into curlicues of red or blue.

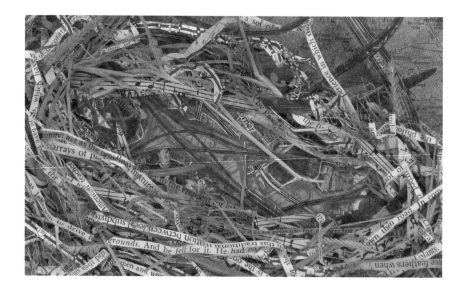

"Road cuts," I mumbled while scissoring zigzag contours of the Beltway. Soon strips of text, maps, and grasses with roots piled up in separate trays.

As my eyes moved down another page of Whitman's poem, they snagged on some underlining. A past reader had pencil-marked a passage, pressing a nugget of wisdom into the soft pages of her mind: *To know the universe itself as a road, as many roads, as roads for traveling souls.*

The mystery reader's interest now seemed serendipitously under-scored for me alone, what with all the roads I'd traveled for my project, both literal and metaphoric. After all, what did all these snippets of paper represent but ways of knowing the human universe? What were all these byways but arteries to carry us to our destinations? I knew then that the nest I'd weave would be a cultural cup holding our human enterprise, our parallel evolution apart from the natural world.

Hours snipping and sorting passed until the noon light slanted in from the south. I struggled up. My knees had locked from sitting cross-legged too long. *Ooooh*, I moaned, clumsily easing myself up, kicking over the teapot.

THE NEXT MORNING, AFTER switching the CD from raga to R.E.M. to shake things up, I gathered snippets of plants and cuttings on the worktable. A gray map with red cloverleaf interchanges of Interstate 495 would serve as my nest's foundation. I began tipping paper parings with just enough glue to secure, while allowing them to loop in and out. Michael Stipe sang "Stand in the place where you live," the soundtrack to my task.

It took days to weave the nest. While the adhesive dried on each layer of map or text strips, I painted a cardinal egg, brushing splotches of umber over a creamy-white shell. Painting detail is the closest I come to pure undistracted meditation. Add composition to the equation and my mind takes over, struggling, deciding, arranging and rearranging. But painting detail, looking through a magnifying lamp, reaching over to my palette *without thinking* to mix an exact color with dabs of raw umber, ocher, and white, or any other infinite combination, is my bliss. It is intuition melded with experience. In the animal world, it's this: a nuthatch deftly plucking insects hiding under bark, or a frog's tongue swiftly nabbing a fly. In other words, spontaneous, without hesitation, yet precise.

Back to my construction, and its not-so-meditative process. As a foundation, I layered the gray aerial photo of the region, a colorful road map, and an old mirror with silver flaking off the back.

Meanwhile, the nest had become a mesh of red roads, light blue rivers, splayed crab grass, and layers of text. Some fragments remained readable — lines from different sources merging into a cryptogram:

> *. . . men and women . . . down the open road . . . in those days . . .*

> *. . . to the President for intelligence . . . echoes still prolong . . . extinction . . .*

I can't honestly say what those lines mean together. Good, because an artwork should always leave some questions unanswered. Even for the maker.

After securing the nest to the mirror, poking yet a few more tawny strands of grass to splay into the surrounding space, I floated the egg on the mirror — not *in* the nest, which would make the image literal, but hovering over, ensuring it would be seen as distinctly apart, almost celestial.

Assemblage finished. A displaced egg in a human-made world, suspended over urban networks of roadways.

I enclosed the piece in an acrylic box resembling a specimen case, propping it against a white wall, and stepped back: nest, gleaming egg, road maps — the composition seemed right. After years collecting stuff, after racking my brain about what to do with it all, the assemblage I now stood before seemed inevitable. It occurred to me then that the sense of inevitability is what all artists are after. In other words, whether an artwork took two hours or two years to create, whether it's figurative or abstract, whether created with traditional oils or with a mash-up of materials, it must hold together as if it were destined to be that way.

Later I'd title the assemblage *Urban Nest*, a chalice holding the flotsam and jetsam of city sprawl. But now my eyes drifted down to follow a paper trail from worktable to messy mound of scrappy books and shredded maps still on the floor. Like Hansel and Gretel's breadcrumbs, they led me back to the starting place. Time to swap the scissors and brush for the broom.

Lost and Found

APPOMATTOX COURT HOUSE NATIONAL HISTORICAL PARK

FROM ALL THE Civil War battlefields in Virginia, I chose to visit Appomattox. For a few reasons. For one, I grew up in the North, even lived in Galena, Illinois, for a spell—Ulysses S. Grant's hometown. Yet half my life I've called southwestern Virginia home, living right off the highway named after Robert E. Lee. Beyond that, I'm interested in peace. And I'm attracted to the acts of grace and surrender that took place at Appomattox. But would that be what I'd think about when actually there? I'd soon find out.

As I drove south from Charlottesville, clumps of forest nestled between fields of tobacco and corn. On a whim, I pulled off near Scottsville at Horseshoe Flats to get a closer look at the James River. Parking near a Chevy Cobalt wallpapered with bumper stickers, the "OBAMA/BIDEN '08" caught my eye. Next to the blue compact, a Dodge pickup sported a lone Confederate flag sticker: "RED NECK AND PROUD."

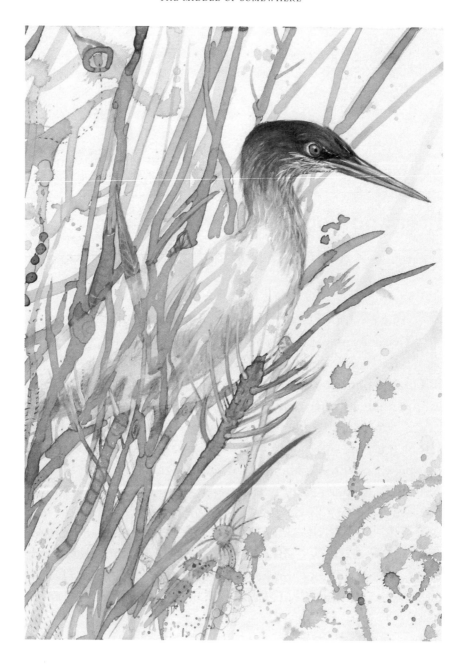

Two men fished on the bank not far away. One wore a bandanna headband; his blondish-gray hair flopped over it like a pony's bangs, but his neatly clipped handlebar moustache belied his casual gear. On the younger one's tanned shaved head was a skull tattooed at the base of his own skull. Which was the Rebel, which the Democrat? I peeled back the wrapper of a Power Bar and took a bite as I walked up.

"What ya catching?" I heard myself trying to sound laid-back. The guy with the bandanna replied: "Smallmouth bass. But it's too damn polluted to eat 'em, so I throw 'em back."

The other shook his head. "Bullshit," he glanced over at his buddy with a mock-sneer. "I fry 'em up." With that, he spit a wad of tobacco into a can about two feet away.

"Bullseye!" I laughed, admiring his marksmanship.

He grinned, eased himself up, and stumbled to the Cobalt to get something—another Bud?—from his cooler.

I wandered off downriver, away from the sour scent of beer, sweat, and smothered earthworms. A green heron hunched stock-still in the shallow water...*Jab!*—it speared a minnow, gulping it down instantly. The bird had no choice but to eat it, polluted river or not.

Time to be on my way.

AFTER AN HOUR, I pulled into the Appomattox parking lot, where a few cars were scattered between a yellow Roanoke school bus and a massive tour van. At 11 a.m. it was already ninety degrees. And humid. I stuck my sketchbook in a vest pocket, flipped on my ballcap, and headed to the visitor center, a two-story building that stood tall among smaller red-brick-and-white-clapboard houses in the restored town.

On the way, I sidetracked over to a man dressed in Civil War–era garb addressing a motley gaggle of preteens. The reenactor posed as "Mr. George Peers," resident of Appomattox Court House, the full name of the town back in the 1860s. His black hat, black vest over a blousy white shirt, and flax pants (he told us) seemed ungodly hot in July. He was explaining the "new" game of baseball to the students.

"You may know of which I speak?" he asked. The kids giggled.

My gaze shifted to a pale blond girl with a pink peace sign stitched on her shoulder bag. Next to her, a skinny boy in a Nascar T-shirt busily stamped on ants scurrying over the gravel path. One foot, then the other, arms at his side, Irish step dancing the insects to oblivion as he missed his history lesson.

Then again, I too missed the lesson as I watched the little ant killer wage war. The next thing I knew, Mr. Peers was saying, "It was in the newspaper; therefore, it must be true." The teacher and chaperones chuckled, but the students didn't get the joke. Give them time.

I left the group to stroll about in the Appomattox Court House compound, reading plaques but mostly watching carpenter bees burrow holes in porch poles, thinking: *These are descendants of bees alive in April 1865 when General Lee's army trooped through Appomattox County, when General Grant's troops followed, when young men aimed muskets at each other, when a truce was made. What are war and peace to a bee?*

Reaching a grassy meadow, a sign related the apple tree myth. The story goes like this: Soldiers observed Grant and Lee conversing in an orchard under an apple tree, igniting a rumor that that was where the surrender took place. Rebels and Yankees alike flocked

to the grove for a souvenir of the truce until, twig by twig, branch by branch, no more apple trees. Decades after those collectors of Civil War memorabilia passed away, their descendants likely wondered, "Why the hell did Grandpa keep that stupid stick all these years?" as they tossed it in the woodpile. Little did they know that to the old codger that brittle branch held no less than bravery, youth, cowardice, loyalty, and betrayal, or maybe ornery racism or noble sacrifice.

(Don't we all cling to something that was meaningful in our own youth, something of little interest to the young? We all have that stick somewhere in our homes, or in our minds; sometimes I think mine is the sketchbook. Perhaps it's obsolete in our high-tech age, but I won't let go.)

Sweat trickled from the rim of my cap as I trudged from the former orchard to the visitor center. Opening the door, a blast of cool air welcomed me. *Ahhh…*relief! I made a beeline to the clean, well-lit restroom. The irony of all this comfort while visiting a battlefield wasn't lost on me.

What would I have experienced here in April 1865? I imagined the gut-wrenching cries of maimed soldiers mingling with song sparrows piping and flies buzzing, the stench of dried blood and sour gunpowder. A far cry from my here and now.

Wandering from display to display, I sketched unearthed artifacts: a corroded pocketknife, a battered round canteen, stirrups, a broken spoon, some tarnished medals and soft lead bullets, a pair of rusty scissors—all frozen in crisply arranged rows. I imagined swarthy hands lacing fingers into those scissors to cut—what? Pants before

an amputation? I imagined blood — whose? — on a white bullet before being washed clean by rain. And I wondered who once proudly pinned those now-corroded medals on his lapel.

BACK IN THE MIDDAY SUN (it actually felt good to warm up), I gathered tree leaves around the park: leathery oak, compound leaflets of ash and locust, and maple dappled with beautiful rust and yellow dots of blight. I'd press them in an old phone book when I returned to the car. A US Park Service landscaper, wearing a baggy green uniform a size too big, knelt beside a hole in the dirt.

"What kind of trees are you planting?" I asked.

"Red maple and white oak. They grow naturally around here," he answered, sitting back on his heels and pushing his glasses up his sweaty nose by the bridge. Seeing the leaf in my hand, he pointed: "Black locust trees have silica in their trunks. They'll ruin a saw blade. But they make great fence posts. Never rot."

"Would people in the 1800s have known that?" I asked.

"Heck, yeah. Though maybe not *why* the wood was so hard."

I looked around. "Were any of these trees here in 1865?"

"Only that cedar over there, for sure," he told me glancing toward the tree. "The land was clear-cut by the 1860s for corn and tobacco. It was so deforested you could see all the way to the present town of Appomattox from here." He nodded toward a solid stand of woods across the highway. "Now we're planting indigenous trees in the park."

I wanted to say "for the sake of 'authenticity'" with a wink but didn't want to sound snarky. "That's really interesting—thanks."

"Sure thing." He didn't look up as he knocked dirt off a burlap-balled root.

I scribbled a note about trees in my sketchbook. For it occurred to me then that there are certain places where the human drama would always cast a shadow over the natural one. And that idea would reso-nate, would become the impetus for my assemblage about Appomattox.

I continued on to the McLean House, where the surrender in fact occurred. There, I stood alone in the parlor behind a glossy red rope cordoning off two empty chairs, replicas of the ones Grant and Lee settled in: one tall cane, the other a puckered-leather desk chair. A catbird mewed from a tree outside. I was feeling uneasy, but wasn't

quite sure why, not until a chattering tour group clomped up the stairs into the house. It was then I fantasized playing their tour guide:

Hello, welcome to the McLean House where Robert E. Lee surrendered to Ulysses S. Grant. These chairs are empty now, and it makes me wonder what becomes of the meaningful events—big and small—of our lives. Do all our battles, our victories, our defeats—Poof!—vanish? Or do they live on in others' lives, morphing into something different—but what? We'll never know.

Or will...

My inner spiel stopped abruptly when a woman in bright red capris bumped me with her flowered handbag big as a suitcase. "Oh, honey, I am soooo sorry!"

"No problem," I murmured, scuttling out of the house.

TIME TO CALL IT a day. On the neatly clipped grass by the parking lot, a half-eaten Burger King Whopper buzzed with flies. Not sure why, but I gingerly picked up a corner of the wrapper stuck with bits of bun and onions to toss into a trash bin.

Before heading home, I sat in the open hatch of my car placing wilted leaves in a plant press. Meanwhile, the middle school kids—also wilted—lined up to get on their bus. Even the little ant killer seemed pooped. I wondered if they'd have to take a test on their Civil War field trip. On a lark, I made up my own multiple-choice quiz:

What will you remember from your day at Appomattox?

1. rusty artifacts and bullets neatly displayed in a glass case

2. tree leaves, especially the fronds of black locust

3. carpenter bees and their indifference to our dramas

4. the sickly smell of onions in a BK burger buzzing with flies

5. two empty chairs

6. an apple orchard with no apple trees

Maybe the best way to learn is to make your own test, I thought as I sped south down the highway, thinking of the artifacts each soldier lost, each one I found.

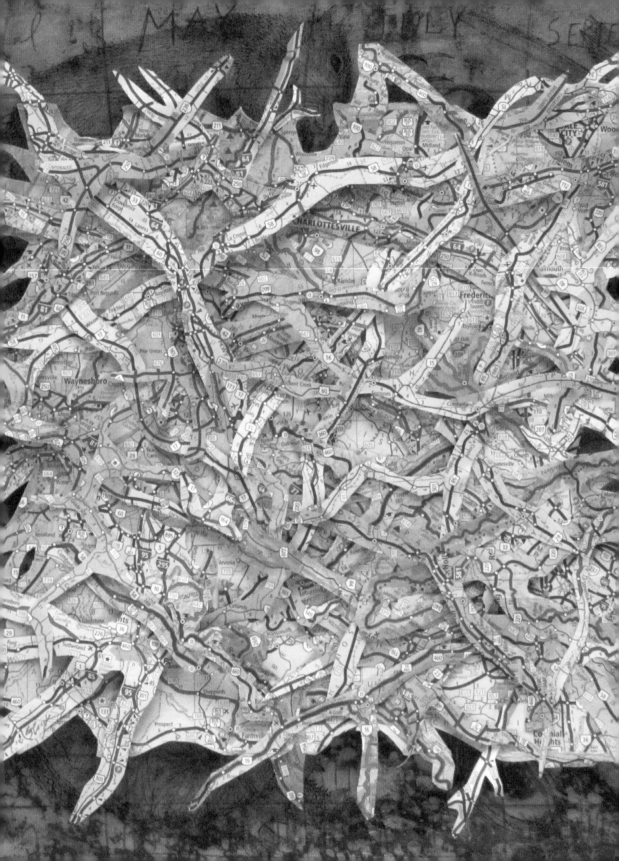

On the Road

STATEWIDE

TIME BEHIND THE WHEEL — speeding down interstates or bumping along gravel roads — is the connecting tissue between destinations. Road-mind moments, or thoughts just beyond the slam of a car door, are as much part of the going as the being there.

Blue Ridge Parkway

Here's what was framed in the windshield: forested hills, banks of rhododendrons, panoramas of slate-blue mountains, and big puffy cumulous clouds — all painted with a wide brush. Individual trees blurred to one green hue, as if a palette of blue, yellow, red, and blackish green were spun in a centrifuge. Life had turned to landscape.

I had a dashboard moment as I asked myself, *How would you paint this scene?* The quiet and isolation of the car focused my thoughts. Like a

flash, I was transported back to 1985: an Illinois meadow on a sunny day, canvas propped on a Jullian easel. I'd stopped midstroke to examine a grasshopper clinging to my work shirt. Jabbing my brush in a jar of turpentine, I grabbed a 2B pencil to sketch the insect's striped leg, its blunt head. It was the moment I realized I was not a landscape painter. Or no, it was when I got an inkling of what *my* aesthetic calling might be: attention to small lives. To this day, even when I paint more conceptual images, they arise from the particular.

As I cruised along, monster cloud shadows slid over the land. I was thinking about how landscape painters revel in light and space. But how I revel in *that* grasshopper whirring, *this* abandoned barn laced with the flight of barn swallows. *That* scarab rolling dung balls or *this* chipping sparrow trilling with gusto from a fencepost.

Right then I itched to pull off the road to find what crawled or tweeted or coiled among the brush. I parked in the Rocky Knob Overlook

lot, and no sooner did I unlatch the seatbelt than I spotted a spiderweb beyond the concrete wheelstop.

Spiders aren't spooked by cars, so this one stayed put. It was one of my favorites, an arrow-shaped microthena, a real orb-weaving gem. Some three feet above the earth, strands of sparkling silk fastened a dry stalk of chicory to a goldenrod stem. I sketched the spider's spiky black abdomen smeared with neon yellow dotted with red. Head pointed down, its skinny striped legs stretched out on radial guidelines. When a small brown cricket leaped into the web, a switch flipped in the arachnid's brain: instantly the once-placid spider plucked its eight-legged way to the struggling captive, injecting venom before rolling the victim into a burrito of silk.

I'd witnessed one of many dramas on this mountain stage, and I thought: *This spider is a citizen of Virginia, too. A citizen hanging upside down in its marvel of a web whose deed to the land is stored in the vault of a nucleus.*

Roadkill

One night in May as I piloted the car down Middlebrook Highway to Staunton, red eyeshine beamed in my headlights. *Possum? Raccoon? Skunk? No time to find out!* Quick glance in the rearview mirror. Pray the creature had some sense of the two-ton metal monster racing toward it.

It did. I veered left while the shadow-shape dashed right. *Sigh.*

The following morning, I discovered others hadn't been so lucky. A possum curled on the highway's shoulder, mouth frozen in a ghastly grin.

Farther down Route 252, a screech owl stuck to the asphalt in its own blood, one wing flapping in the wind.

After that morning, I recorded roadkill on my Virginia trips. It seemed a small effort to acknowledge all the senseless carnage. A cardboard chart and pen on the passenger seat served to list sightings without taking my eyes off the road.

Occasionally, on the gravel edge of speed, I gripped pen to paper, straddled one of the bloodied victims.

A swallowtail butterfly was the only animal I (knowingly) hit.

Overlook

I cruised east on Route 64, stopping at the Rockfish Gap Overlook, where a dozen cars pointed toward the panorama. Walking over to a silver Dodge Avenger, I asked the suntanned driver if I could collect bugs stuck to the grill of his car.

"Huh? You want to do *what?*" he winced.

"Collect dead insects." I pointed.

"Uh…sure, I guess that's okay." He cleared his throat, scanning me head to toe—from gray streaks in my hair to clodhopper sandals—assuring himself that I was harmless.

Harmless, indeed. Little did he know he was looking at a wannabe revolutionary bent on liberating people from prejudice against insects.

Rockfish Gap
64 between
Charlottesville
+ Staunton

I pinched a fritillary wing and leggy crane fly off the metal.
Cupping the creatures in my left hand, I lifted the hatch of
my Subaru wagon with my right. *Now where did I put the collection
box?* I'd been on a scavenger hunt for a week, first up in
the Alleghenies, then at the Shenandoah Valley farm,
so finding anything in this chaos would be a task. It
occurred to me, as I surveyed boxes of collected specimens
and stacked paintings, that my car was a moving cabinet
of curiosities. A wonder room on wheels.

Deer antlers jutted from a milky plastic box labeled BONES.
Buried below was the tip of a huge bony blade, a cow scapula I'd
found in a weedy pasture. Another box marked FRAGILE held smaller
finds: a starling skull and a mummified bat veiled in bubble wrap
(discovered in the ashes of the farmhouse
chimney). OWL PELLETS / REGURGITATED
RODENT BONES was scribbled on a small
Riker specimen box.

–185–

I grinned. *Wouldn't it be funny if thieves broke into my car to steal the box marked* FRAGILE *guessing it held valuables? Imagine their surprise: "Shee-it, we risked gettin' busted for a dead bat and owl puke?"*

On a cardboard box I'd scrawled HUMAN ARTIFACTS with a big red Sharpie. At the top, eyelets of a worn leather shoe peeked out. Under cases marked MAPS and FIELD GUIDES a makeshift Masonite plant press clamped delicate blue bell-flowers and ferns. To its left, a row of blunt-headed cicadas hunched like linebackers within the INSECTS box. My search was closing in.

At last I found INSECT FRAGMENTS, grabbed a hinged box divided into little cubicles (the kind sold for screws and bolts), and slammed the hatch. From grills of cars parked at the overlook, I collected tiger swallowtail wings and grasshopper legs adorned with zigzag designs. A mud-splattered Ford Explorer offered a buckeye butterfly, abdomen ripped, yet umber-eyed wings still beautifully intact.

Back at my own car, I took one more look at the brittle corpses. Maybe I'd sketch some that night—the fishing tackle box near the driver's seat held art supplies. Maybe one day I'd use some fragments in a collage.

About to drive off, only then did I really take in the Rockfish Gap panorama. Layers of cobalt-blue mountains faded into the distance, reminding me of those Renaissance landscapes with mountains paint-ed unbelievably blue to achieve the latest artistic breakthrough: aerial perspective.

I cruised along I-64 again, through the Blue Ridge Mountains' lush crazy quilt of emerald fields and dark forests west of Charlot-

tesville. This route was once a Native American trail. What did a Monacan woman spy as she padded softly along this path? Back then, it would have taken days or weeks to cover ground I zoomed across in mere hours. While hurtling through space, I imagined what speed eclipsed: living, whirring grasshoppers, tiger swallowtails sailing in the wind, but also (let's be honest) horseflies with their razor-sharp bite. I remembered my car-grill collection of scraps, pictured the silver moons of a living fritillary glinting in sunlight, fluttering out of reach.

Poplar Forest

Mapped, edited, and published by the Geological Survey

Control by USGS and NOS/NOAA

Topography by photogrammetric methods from aerial photographs taken 1963. Field checked 1965

Polyconic projection. 10,000-foot grid ticks based on Virginia coordinate system, south zone
1000-meter Universal Transverse Mercator grid ticks, zone 17, shown in blue
1927 North American Datum
To place on the predicted North American Datum 1983 move the projection lines 11 meters south and 22 meters west as shown by dashed corner ticks

Fine red dashed lines indicate selected fence and field lines where generally visible on aerial photographs. This information is unchecked

SCALE 1:24000

CONTOUR INTERVAL 20 FEET
NATIONAL GEODETIC VERTICAL DATUM OF 1929

UTM GRID AND 1965 MAGNETIC NORTH
DECLINATION AT CENTER OF SHEET

THIS MAP COMPLIES WITH NATIONAL MAP ACCURACY STANDARDS
FOR SALE BY U. S. GEOLOGICAL SURVEY, RESTON, VIRGINIA 22092
AND VIRGINIA DIVISION OF MINERAL RESOURCES, CHARLOTTESVILLE, VIRGINIA 22903
A FOLDER DESCRIBING TOPOGRAPHIC MAPS AND SYMBOLS IS AVAILABLE ON REQUEST

ROAD CLASSIFICATION

Heavy-duty Light-duty
Medium-duty Unimproved dirt

☐ U.S. Route ○ State Route

QUADRANGLE LOCATION

Revisions shown in purple and woodland compiled in cooperation with Commonwealth of Virginia agencies from aerial photographs taken 1982 and other sources. This information not field checked. Map edited 1985

FOREST, VA.
37079-C3-TF-024

1966
PHOTOREVISED 1985

Looking Backward

POPLAR FOREST

TUCKED IN MY mother's antique glass cabinet, a rose-colored sash lies tenderly folded alongside a photo of my grandmother, Anna Alexander. In the 1918 sepia print, that same sash drapes over her silk recital gown, collar abloom with embroidered blossoms. How strange to gaze at that young woman, her head tilted demurely, lips pressed into a faint smile, and know she was about to sing her last concert before her fiancé would die in a boating accident on the Kankakee River. Drowned with him would be this soprano's passion to perform onstage; her future children would hear only her "ironing songs" sung while bowed over a daily chore.

Strange too how that sash floated into my mind hundreds of miles away as I peered into another glass case, this one holding artifacts from the excavation of Thomas Jefferson's retreat, Poplar Forest. As

I stood with my forehead pressed against the cold pane, it occurred to me that a museum is but a personal display case multiplied to the nth degree. Grand or intimate, both attempt to keep the past on life support.

I'd come to this spot southwest of Lynchburg to find its genius loci—a special atmosphere of the place where Jefferson had written a good chunk of *Notes on the State of Virginia* in 1781. But on that bright summer morning of my visit, as my footsteps echoed the sparsely furnished rooms, I couldn't conjure any aura of his *Notes*. Sun streamed through the tall triple-hung windows like a radiant presence, reaching the leather sling of a Campeche chair, where it gracefully curved in a body of light. Nearby, a wooden writing desk cast stark rectilinear shadows on knotty floor planks. Was *this* where Jefferson compiled his observations of Virginia?

I tried to envision that thirty-eight-year-old's feather pen jittering, as if in flight, while his other hand drooped from a sling. He'd broken his arm while fleeing the British army's march toward Monticello—a painful ride to elude capture. Injury left him no choice but to lie low for two months (and, as I'd find out later, not in this octagonal villa, which he designed and had built for him much later).

We can thank invading redcoats and a tumble from his spirited steed, Caractacus, for forcing this busy Virginia governor into seclusion, thus allowing him time to write amid the dense forest of poplars. I shifted my gaze from the fine-grained desk out to the Peaks of Otter (named for a Scottish clan, not the weasel), their soft blue-gray fading in the distance. Likely Jefferson gazed at these mountains from this very spot, believing them the highest in Virginia.

IN THE CENTRAL ROOM I craned my neck to view the famous frieze Jefferson thought up himself, alternating ox skulls—Roman symbol of agriculture and sacrifice—with the classical sun god. Hard to imagine that this touch of Jeffersonian *feng shui* was seen as quirky at the time. Odd that he had to coax New York sculptor William Coffee to carve it, claiming that since it was his own home he could follow his fancy. Though much too formal for my rustic taste, the impulse to merge the earthy with the divine resonated with me.

A shaft of sunlight slanting through the skylight above reminded me that Jefferson's granddaughters, Ellen and Cornelia, embroidered here under that natural light—girls in floor-length dresses, drawing their needles in and out of circular hoops as they stitched little flower petals—perhaps for the collar of a gown? Touching, but the thought made me happy to live in an age when I could pull on some jeans to ramble around the surrounding woods, maybe even climb nearby Sharp Top peak to enjoy its 360-degree view.

A cramped winding stairway took me down to the rough brick cellar below, now converted into a state-of-the-art museum for "artifacts unearthed during renovation." One case displayed a curious way to retrieve the human past: "rat's nest archaeology." Here's how it works: rats sneakily gather materials to hoard in nests hidden in attics or walls, thereby preserving what would have otherwise decayed—a letter, perhaps, or bits of fabric. Thus (as crews restored the original construction) have interesting scraps turned up. Like snippets of newspapers, telling me that the naughty rodents were busy when the property—sold two years after Jefferson's death in 1828—became a commonplace farmhouse.

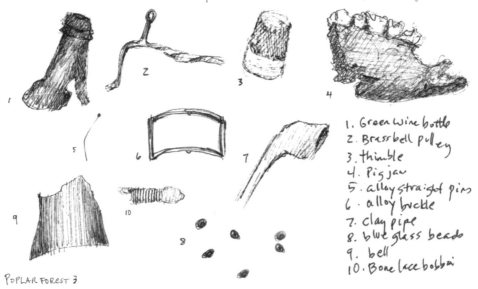

"Puzzle - finding the pieces but not knowing what the picture should look like" is the line I overheat on a video in the other room. Seems particularly apt as I draw these fragments of Poplar Forest.

1. Green wine bottle
2. Brass bell pulley
3. thimble
4. Pig jaw
5. alloy straight pins
6. alloy buckle
7. clay pipe
8. blue glass beads
9. bell
10. Bone lace bobbin

POPLAR FOREST 3

Within the museum's cool space of brick and stone, another case caught my eye. A broken clay pipe lay alongside a shard of green glass, a chunk of pig jawbone, and a puckered metal thimble — all excavated from slave quarters. These fragments occupied a freshly excavated zone, as if a dark chapter omitted from a novel were reinserted: one that changed the Jefferson narrative.

I imagined an enslaved man's calloused hands clasping the bowl of that pipe to tamp down tobacco. Weary from laboring in the fields, he puffed to stoke a light, then slumped back. But how could I ever *truly* imagine his life? Well, I could try. Or, rather, I should try. After all,

isn't this what the best exhibits do—thrust visitors to peer through a peephole into the past? To glimpse what life was like for another?

Meanwhile, a video murmured behind me. Not paying full attention, I caught a slice of the voice-over about the "puzzle of excavating Poplar Forest…finding the pieces but not knowing what the picture should look like." I jotted that line alongside my numbered drawings of relics. *Puzzle indeed*, I thought, *which might be said about all our lives.*

Suddenly a school class burst through the main door, teacher clutching a clipboard to her chest. Like a mother goose leading her goslings, she led the kids briskly along, their clomping shoes echoing. Her lecture began before an exhibit of archaeological strata: wood planks at the top, under that rough bricks, then gray fieldstone and, at the lowest layer, chunky umber earth.

My stomach rumbled, loud enough that I feared the kids would giggle. Time to head to the Poplar Forest shop, where I'd grab a turkey wrap and canned iced tea.

BESIDE THE PICNIC TABLE, a red mulberry tree dripped with juicy fruits—my dessert! As I picked a couple handfuls—both to draw *and* to enjoy their sun-ripened sweetness—I thought about the first owner of the house behind me, his architectural vision so beautifully revived, his passion for the fruits of the earth staining my hands. Fruits that now burst in my mouth. I wanted to linger there.

But the sky overhead was darkening. Puffy cumulus clouds rolled in, so I scurried to the excavation site. There a young intern in a Lynchburg College pullover, brown ponytail flopping from her denim ballcap, knelt at the grassy edge of a 5-by-5-foot earthen pit cordoned

off with hemp rope. Rulers, buckets of red clay, and dirt-caked shovels orbited the hole. I crouched closer, breathing the sweet earth scent while catching the glint of a blue-and-white shard of pottery embedded in clay. It blew me away how the mystery of the past fused with my visceral present.

"Is that from Jefferson's time?" I pointed.

"Yep—probably a fragment of a dinner plate." She carefully brushed soil off the china, examining it up close. "This one's marked with a single potter's symbol." She held it up for me to see. What looked like a faded smudge was, to her trained eye, a distinguishing stamp. "This tells us *where* it was made, and *when*, since we know what years the potteries were active. Helps date the entire layer."

"I read that young Thomas loved to dig around the Indian mounds near his boyhood home in Shadwell, that he speculated layers might help date artifacts. Wonder what he'd think of excavating *his* life," I said, opening my sketchbook to jot down details of the scene. Just then, a man walked over, his finely trimmed beard framing a warm smile.

"I often wonder what Jefferson would be like in our times. I think he'd have had a laptop with a file on sustainable agriculture," he grinned, looking down at my drawing. "You must be Suzanne? I'm Eric."

Weeks before my visit, I'd emailed the supervisor of Poplar Forest excavations, Eric Proebsting, about a behind-the-scenes peek. Before following him to the archaeology lab, I paused to fill a quart-sized Ziploc with red clay.

"I may use it in my assemblage," I said, poking at the gooey earth with a trowel.

"So you're using earth to make art?" His bright eyes seemed pleased, if a tad quizzical.

AMONG THE SPLAY OF artifacts in Eric's lab, stacks of small cardboard boxes and plastic bags held yet more fragments of glossy porcelain or dull glass shards, along with corroded metal buckles, crusty pulleys, even some old bells.

"We're piecing together a picture of life during Jefferson's time," Eric explained as my eyes roved around the collections, landing on

a big rusty fork resting on a soft bed of white cotton, its worn bone handle stained celadon green. Following my gaze, he told me, "Jefferson preferred a two-prong fork like that one over the more common three-pronged. We don't know if this one was actually his, but it could have been."

"What?—for *eating?*" It was as big as a pot fork used to keep down a roast while slicing.

"In those days—we're talking late 1700s to early 1800s—folks customarily used large forks to hold pieces of meat or vegetables on their individual plates. Then with a smaller knife they sliced their food, eating the cut bit from the tip of the knife blade."

As Eric left to answer a phone in his office, I stood alone among all the fragmented, weathered relics. All the cold and lifeless shards of people's lives. A clay pipe. Chipped remains of glazed porcelain. A corroded fork. All of these were once fondled in flesh-and-blood hands.

I didn't know then that months later I'd re-create that very fork with paint and rust granules. But not before I slathered an entire topo map with clay collected from the excavation site—all, that is, but a small square revealing Poplar Forest marked with a pin. Within the dirt-caked surface, I created a murky window from which Jefferson's eyes peered, as if curious to see how his story had evolved through the years. And I fashioned faux-pottery shards with my own take on imagery gathered that day, all coated thick with resin to emulate pieces of china. The final touch was to place the fork to the left of the plate: a *place setting* in cracked earth.

I REACHED MY CAR before the downpour. Wiping the foggy windshield with my sleeve, I leaned my sketchbook against the steering wheel for support. In the dim light, my hand's bluish veins bulged round a fan of tendons as I clutched a pen. And through a curtain of rain I peered out, crosshatching until the villa emerged on the page, dark but for one glowing poplar sapling.

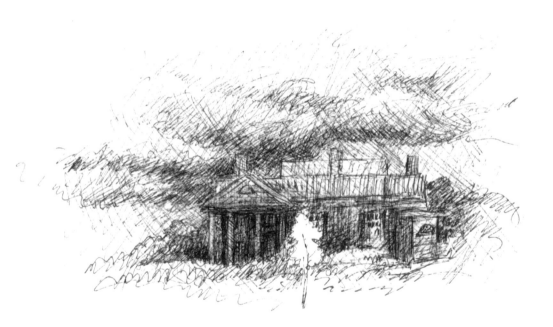

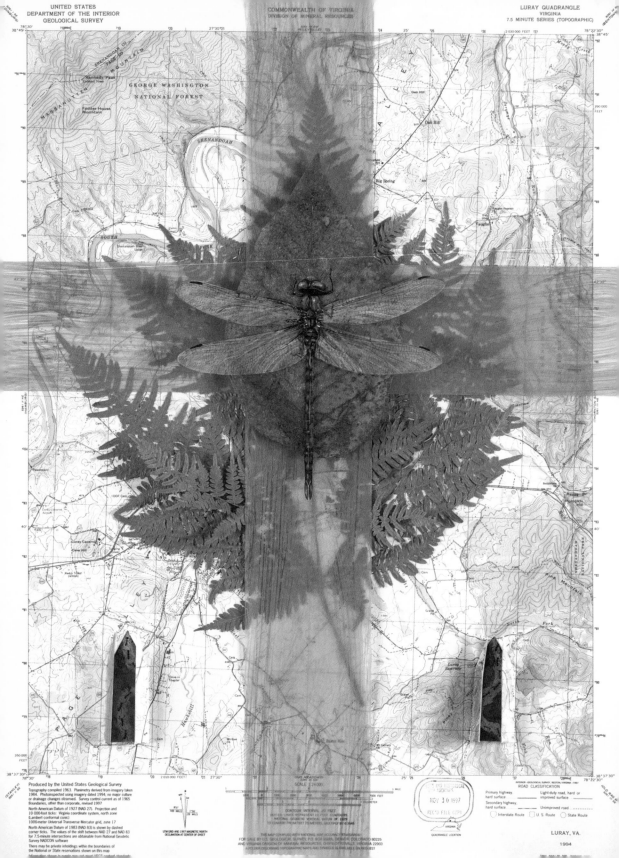

Sacrament

SHENANDOAH RIVER

O N A COOL, bright day in late September, I launched my kayak in the Shenandoah River at mile 8 — Bealer's Ferry. There, north of the town of Luray, the south fork flows in big serpentine loops between the Massanutten and the Blue Ridge Mountains.

For a while I drifted lazily, hardly dipped my paddle. Not for long. Rough waters churned ahead — Goods Falls. As the current sucked me in, my heart beat at double time: boulders whacked the boat's hull — a sudden splash soaked my pants as I stabbed the water madly, maneuvering around rocks lurking under roiling water — *thump! Thump-thump!*

Keep with the flow, keep with the flow, I chanted under my heaving breath, blood pressure rising.

I was running rapids! Oh, I know, pros judge Goods Falls easy — Class I whitewater. But to *me*, kayaking alone for the first time, they seethed with danger.

Then, utter calm. Sunlight glittered off the tranquil surface where striders circled like so many skaters on an ice rink. Horizontal threads of golden leaves shimmered in crisp reflections of tall trees overhead. I paddled leisurely, glancing back to see the churning cascade, then forward to water so still you could see bladelike leaves swaying from the river bottom. A whiskered carp big as my forearm lazily cruised by, disappearing with a quick flick of its silvery tail.

The river and I were collaborators in whatever happened next.

And next? A red-bellied cooter basking on a stone. Who knows what was in the mind of that big old turtle, but it seemed oblivious to my glaring orange kayak, turquoise plastic paddle, and neon-blue life jacket strapped around my chest. Its flashy red plastron circled the stone, leading me to imagine how I might mix that color: glazes of cadmium red plus yellow ocher, or maybe burnt sienna with a pinch of primary yellow for that rich lacquer-like glow. I paddled closer to the sun worshipper. Its nose remained pointing skyward: Did it sense I was merely another river creature? If so, that would please me to no end.

A blue heron didn't agree with the turtle. At first sight of me—forty feet away—its inner alarm bell rang. I watched huge wings unfold slowly before it flapped downriver, long sticklike legs trailing like a kite tail.

A bald eagle agreed with the turtle, though: I was merely another creature drifting on the current—no more, no less. It didn't budge from a riverside snag as I sculled beneath. Both eagle and dead tree fused, like a charcoal drawing against light gray paper.

On I paddled when two rubyspot damselflies zipped by, mating on the wing. The male grasped the female's head with claspers on his abdomen as she looped hers forward to accept his sperm. My presence didn't hinder their passion one iota. Taking a break on the bow, she detached from him, but he kept his grip tight. A blue darner—three times larger—whizzed by, head twisting in robotic jerks. Would the lovers be its dinner? That remained a mystery: all three dashed upstream as I floated down.

Still soggy from Goods Falls, I passed through High Cliff Rapid like a master, sliding through a narrow passage of churning water.

Avoiding the sandbar at Cook's Ledge—no sweat. I remembered then what Rick from Shenandoah River Outfitters had told me in his dusty truck on the way to the launching point. After my flurry of questions, he yawned, blinked his heavy-lidded eyes, and calmly said, "There's going to be things you'll know by the end of the trip that you don't know now." Rick's expression betrayed no awareness of his nugget of wisdom, so he probably wondered why I scribbled it in my pocket notepad: *There's going to be things you'll know by the end of the trip that you don't know now.* Which is to say, no one can prepare you for everything on a river run; you just have to learn as you go. Much like art, like life itself.

Before dropping me off, Rick pulled the green wool cap down over his long brown hair and called, "See ya in a few hours at Mile Marker 19."

DRIFTING WITH THE CURRENT, water gently lapping against the hull, I entered rivertime. A kingfisher rattled overhead, its reflection piercing the sycamores' coppery yellows. I was alone by choice to follow the flow of my thoughts, to draw whenever I pleased.

This waterway had flowed in my mind since childhood, gaining a kind of aura, and all because of the spell cast by the famous song. But not just anyone's rendition. It was Paul Robeson's baritone "Oh Shenandoah" that haunted me like a secular hymn.

Buoyed on the waters of the actual Shenandoah River now, I meditated on that singer's intense longing for an untroubled, peaceful homeland. Although I'd never experienced *that* degree of longing, I've always yearned for a homeplace within the natural world to wander, right outside the slap of a screen door. It occurred to me the word

"Shenandoah" had come to embody that very thing: yearning for a place, but not just any place. A place offering a personal sanctuary.

A streak of silver vanished under my craft, pulling me out of my reverie. Watching the shimmering fish emerge again, I remembered Rick's comment: "It's only safe to eat two fish a month from these waters."

"Why?" I couldn't believe my ears.

"Mercury discharged for decades by DuPont in Waynesboro. That was before the EPA. You wouldn't know it just by looking at the river," he paused. "They stopped polluting in the '50s, but toxic mercury lingers in sediment."

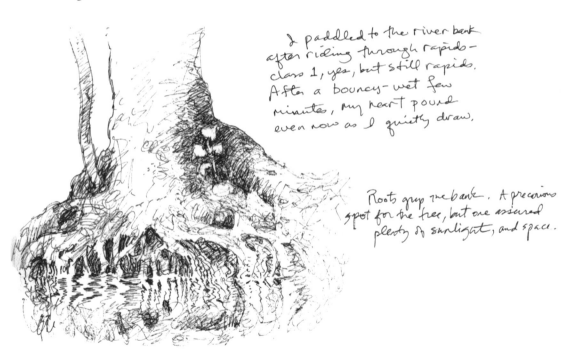

I paddled to the river bank after riding through rapids— class 1, yes, but still rapids. After a bouncy-wet few minutes, my heart pound even now as I quietly draw.

Roots grip the bank. A precarious spot for the tree, but one assured plenty of sunlight, and space.

Two fish a month. Mercury. *Shenandoah River?*

As I stared into the depths of the rippling water, my mind drifted back to a basement rec room at my friend Kim's house. Two freckled third graders in pedal pushers and pigtails gawking at the adult world of her father's medical books (*Oh my God!*). Pictures, lots of explicit black-and-whites of goiters the size of softballs swelling from a woman's neck, or a skeletal leper with a hole in his face where once there'd been a nose. Our childish eyes widened; jaws dropped. *Eeeeyuuuu!* Then a close-up of a freckled teen with rashes splotching flaking skin, her hands gnarled in a fist: *mercury* poisoning. She could have been our own sister.

Still looking over the kayak's rim at my own warped reflection, I shook my head. How could this sacred river be someone else's dump?

The low pitch of bubbly gush yanked me back to the now. Compton's Rapid, Class II whitewater, was tougher than the rest, and the last in my journey. I kept "right near the cliff face," as the outfitters had advised—otherwise I might be sucked into the roiling current. Although I was grateful their tip kept me from wiping out, I was also grateful for the unexpected along the river.

I ARRIVED AT MILE MARKER 19 before Rick. While the kayak coasted toward the ramp, a comet darner alighted on my oar. The dragonfly's lean abdomen glimmered brilliant red, like a thin vial of blood. Its olive-eyed head twisted as airborne prey flitted by. For an instant, translucent wings formed a cross on the paddle, an intersection between the natural and human domains. Then off it dashed after a gnat.

For the first time since launching, I unfolded the now-soggy outfitter's map across my lap. What was once a page scattered with lines and symbols had transformed into hieroglyphs of palpable memories. Loopy lines stitched rushing water with remorse for the mercury, with joy for the dragonflies, with glittering riffles. Scalloped lines revived places where I got drenched, where I'd paddled like crazy. Numbers marked spots where poplars shimmered gold or a turtle's rich red plastron gleamed in the sun. The Eagle's Roost symbol brought to mind that real bird, hunched over me like an omen, its huge beak pointing earthward. A map comes to life once its territory is traversed.

I was still mulling map-thoughts when Rick rattled up in his flatbed.

"How'd it go?" His hands stuffed deep in his jeans pockets as he shuffled toward me.

"Well, I made it without capsizing. And there *are* things I know now that I didn't know before."

Though he grinned, I couldn't tell if Rick recognized his own words.

As we shuttled back toward the outfitters in silence, I asked to check out a rental cabin set a few yards from the ferny riverbank. I jotted down the phone number posted on a sign near the screen door—maybe I'd return someday with my tackle box crammed not with fishing gear but with art supplies.

Rick shifted gears. Gazing out the window as the truck bumped along the potholed road, I considered what I might say in paint or in words about the Shenandoah. I wanted to say something about longing, about the sacredness of place. Something about where a river had taken me.

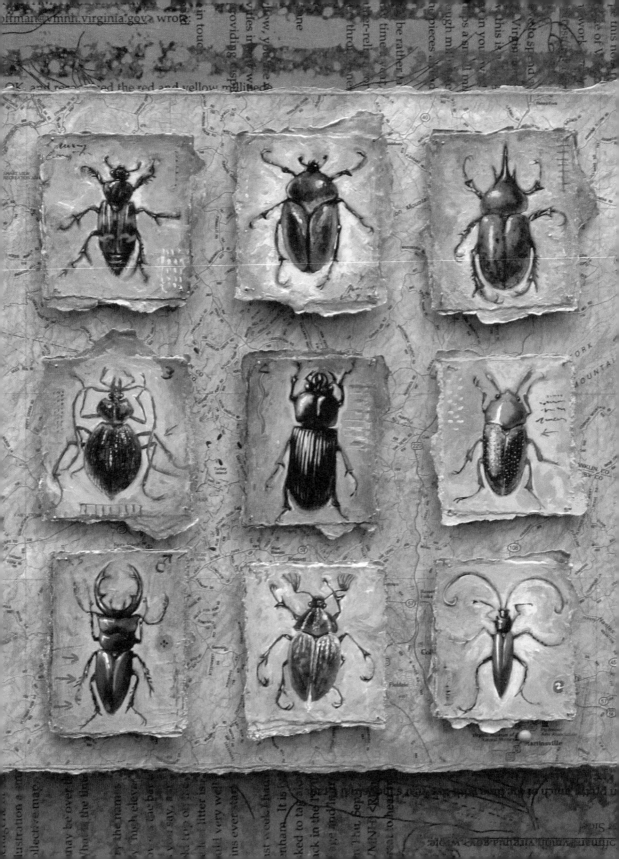

Collecting the Wild

VIRGINIA MUSEUM OF NATURAL HISTORY

P ICTURE THIS: PEOPLE mingling around platters of appetizers like the gentle swoop and flutter of birds at a feeder. Some clasp plastic punch cups, balance paper plates while circling walls of spotlit pictures. A typical art opening. But not so typical is one elderly man who stands out from the rest, stooped slightly in a safari-type jacket as he peers at a painting, white hair wisping over large ears. A magnifier lens dangles from his neck.

But it isn't so much *what* he looks like, but *how* he looks at the art. He examines the painted feathers or grids of gleaming beetles as if examining biological specimens in the field—so close to the surface his nose might rub against the crusty paint. And then he paces back slowly to take in the whole composition. Not mere looking, but focused attentiveness. All the while, his hands remain clutched behind his back, as if drawn to smell the roses yet knowing not to touch.

This was the scene at my "Collector's Confession" exhibition open-ing at the Piedmont Arts Center in Martinsville, Virginia. The idea behind this body of work reflects my passion for the living world and our strange compulsion to collect it. Hoard it. Eulogize it. Honor it. Kill it. Name it. Shelve it. Love it. Box it. The images dominating the paintings are rows of insects or floating feathers—from a large red-tailed hawk's to a tiny polka-dotted woodpecker's—along with tangled nests splaying across rough plaster-like surfaces.

"WHO'S THAT?" I WHISPERED to the curator, nodding toward the intensely absorbed viewer.

"That's Dr. Hoffman," she answered. "State entomologist—did you know the natural history museum is next door? From what I hear, at nearly eighty he's still discovering new species of beetles and millipedes."

I continued to watch the scientist edge around the gallery as another visitor rushed up—a woman in a purple cape, toying with a turquoise stone set in her silver ring. "I'm a jeweler," she said, holding up her creation, and went on to explain how she inherited her artistic talent from her woodcarver father: "All during my childhood, he whittled ducks and sandpipers in our garage after coming home from the office."

I felt a tap on my shoulder.

"You're the artist? I'm Richard Hoffman. I've never seen paintings quite like yours. How do you make art so...so, well, creative yet accurate? I mean, I can identify the species of scarab in that one," he pointed at a big grid of beetles.

We now circled the gallery together. Before one painting, he paused: "The image of that feather emerging from a cracked egg makes me think

of how the egg holds the idea of the feather before the bird's even formed." Because he asked how I'd sculpted the nests on the panels, I described the process of carving modeling paste with a Dremel tool. "And the DNA," he pointed, lassoing our dialogue back from shoptalk toward a coiling double helix. "That is the way an egg imagines the future feather, in a molecular way, as it were." Which led us both to get a tad rhapsodic over what genetics reveals about the workings of life.

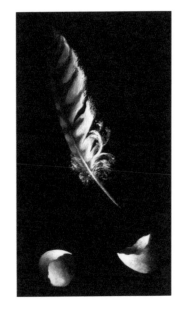

A WEEK LATER, IN our first email exchange, he confessed: "The three things I wish I could do are speak French fluently, play the piano, and create good art, like yours. I suppose that if I wanted to devote a huge amount of time, I could pick up the first two but lack the ambition. The third is beyond me, as I do not have the imagination."

Later Dr. Hoffman confessed he could never loosen himself from "the rigors of scientific training" to pursue an art. Yet his close examination of many-legged creatures demanded a special kind of vision. A vision that would enable him to discern minute differences among species, one that would transport him to new habitats in search of its denizens. It takes a special kind of imagination to be absorbed by such an intense practice—whether under light bulbs or under the sun—requiring a mental reaching out. And let's be frank, it takes creativity to be a great appreciator, listening and looking with deep curiosity and focus on another's work.

And so this humble world-class biologist became "Richard," my friend. In the years that followed, we rallied emails about insects and art and Virginia topography. What's more—and this is no small thing—he never made me feel like a fool when asking a "What's that bug?" question, even for a common species. Perhaps those of us captivated by chitinous lives, with their alien life cycles, form a special tribe, whether we're experts or rank amateurs.

Yet while I cherished what Richard imparted about what lurks in leaf litter or swoops around a porch light, something else he'd do would leave another kind of lasting impression. But I'll get to that.

TWO MONTHS AFTER THAT art opening, I visited the Virginia Museum of Natural History specifically to see Dr. Hoffman surrounded by his entomological collections. He promised me a behind-the-scenes tour. As we strode between vaults of stainless steel cabinets, opening electronically at the push of a button, I joked that it was "something out of a James Bond movie." Richard shook his head at "all of this elaborate security."

"I preferred the old museum building where I could work late into the night—didn't have to leave at closing time! You know, there's no closing time for research. I often did my best work when burning the midnight oil."

"True for art, too," I muttered.

Enclosing us was a metal fortress securing Virginia's trove of the living world, which struck me as strange for something as intimate as the study of small lives. From the shelves, Richard pulled a maple box filled with gleaming beetles, earth-gems, looking so fresh they

might have scampered away at any minute. Pointing through its glass top, he began to speak of key distinctions among the insects pinned within.

"Here's one an artist might find fascinating—a dung beetle collected in the Shenandoah Valley. It's a cousin to those Egyptian scarabs pictured rolling the sun up." The beetle's forelegs raised over its head did indeed resemble Khepri, the ancient god of creation.

"Oh, and this handsome guy is endangered in Virginia," he pointed to a burying beetle dotted with crimson polygons on each ebony wing.

"Why?"

"Most likely habitat fragmentation—you know, we preserve nature in islands between farms, roads, neighborhoods, shopping centers. Some animals require vast natural areas to fulfill their life cycles. These beetles"—he held one up by the pin—"they're the undertakers in nature: ecologically essential, breaking down carrion into smaller particles so plants can absorb the nutrients. They're the original recyclers. We have to worry when insects go extinct. If they go, we're next."

A YEAR AFTER THAT first trip, I visited his lab again. This time I perched on a metal stool surrounded by clusters of insect specimens, microscopes, jars filled with mysterious amber liquid, and broad trays of millipedes curled into leggy spirals—all part of the Hoffman domain. My aim was to study high-elevation species inhabiting the Mount Rogers habitat. In other words, small mountaineers.

"There are a number of arthropods that dwell above three thousand feet in this region." Richard ferreted through boxes of beetles. "Here are some beauties."

Removing a few from the case, he pinned them on a board—natives with suggestive names such as "long-horned beetle" and "snail-eating carabid," which, with its long mandibles (like long-nosed pliers with teeth) ripped mollusk flesh from its coiled shell. I'd seen plenty of ground beetles before, but nothing like this, so I was excited to draw it. Long black legs, long knobbed antennae, its purplish-green elytra glinted gold along the edge. I imagined a snail's panic sensing this fellow sneaking up from behind. (Wait, what would snail panic look like?)

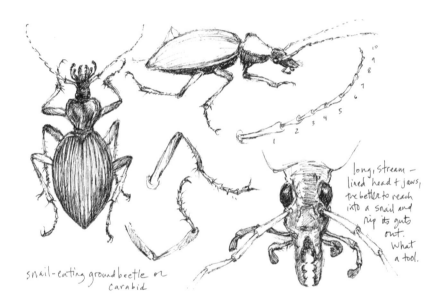

snail-eating ground beetle or carabid

long, stream-lined head + jaws, the better to reach into a snail and rip its guts out. What a tool.

Adjusting the light, I spread out my paper and sharpened pencils, then hunkered down to work. These drawings would serve as preliminaries for a series of paintings destined for "Along the Trail," an

exhibit at the Blue Spiral Gallery in Asheville. But in truth, my deeper motive for being there was to work like a colleague beside my venerable entomologist friend.

As I began to rough in that small but voracious predator, classical music crackled with static as it drifted from a radio balanced on a shelf above. Richard had returned to his own work, now softly humming a melody from Mozart's *Jupiter* Symphony, his eye pressed against the lens as he focused his scope. Without looking down at his paper, he outlined his subject with a pencil. Countless diagrams of millipede anatomy lay scattered among calipers and pipettes near dissection trays. And so we passed the afternoon. As I packed up to go home, I snatched one of his sketches from the trash bin. "May I keep this?"

"Sure. Bet you're going to frame it!" he joked. And, pointing to a particularly convoluted shape: "If anyone ever thought evolution was logical, they should take a look at millipede gonads. The creatures have multiple pairs of sexual organs along many leg segments—totally unnecessary, really weird. Sometimes truth is stranger than fiction."

Before leaving, I asked him what he was doing with the jumbled boxes stacked on the floor, all holding a hodgepodge of moths—from little dusty-gray critters to giant yellow imperials with their gorgeous purple streaks—knowing Lepidoptera wasn't his thing.

"Simply sorting a collection donated to the museum," he admitted. "Not my research interest. It's just pure and simple library work. But I find it rather addictive. I've missed more than one lunch because I couldn't stop! There's probably some obscure 'curator gene' in some people that takes over. I sure have it because I get an immense satisfaction bringing order out of chaos."

We paused. Then I asked, "Did your interest in insects begin in boyhood?"

"No, if you'd seen me as a boy, I would have had a turtle in one hand and a frog in my coat pocket. Reptiles and amphibians, they were my first love. But as a biology student in college, I just couldn't make myself kill them to study. Insects, while they fascinate me, don't give me a problem collecting."

WINDING THROUGH THE MOUNTAINS on my way home, I thought about drawing in a lab the day before. It wasn't the first time. Decades earlier, working as a scientific illustrator, I'd drawn zoological and botanical illustrations, created charts and diagrams, and even prepared a display of prairie plant root systems—all for a university biology department in Illinois. One devoted botanist would check the length of the hairs on wild dahlia stems I'd inked, concerned with the minute differences in a subspecies of that genera. And so, when drawing at Richard Hoffman's lab—comparing one beetle's knobbed antennae to another's—I experienced again what deeply satisfied me about this practice: the unhurried egoless process of sustained looking—"egoless" because in the service of science, not for personal expression alone.

IN AUGUST 2009, RICHARD stopped by my Bristol studio, climbing the old wood stairs to my third-floor domain, my "osprey's nest" due to its height and, well, its general disarray. I was honored—yes—but also a little apprehensive. What would he think of my shabby insect collections of beetles missing legs or antennae? After all, my specimens were

found dead under streetlights, window wells, gas station lights, and such. Canvases chaotically strewn over tables or leaning against walls on the paint-spattered floor were a far cry from well-lit white gallery walls. But I was eager for him to see one particular painting-in-progress of a millipede. I'd spotted the animal during an artist's residency at the Hambidge Center, located in a lush valley of north Georgia's Nantahala Mountains. When I'd emailed my sketch of it, he replied,

"That's one of my own children, one that I named back in 1958 as *Sigmoria nantahalae*. In the published description, I was moved to add: 'Living specimens are rich and glossy in coloration, with pearl-gray crossbars, appearing as though enameled, and are the most attractive diplopods which I have encountered.'"

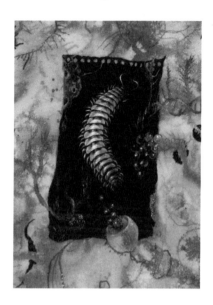

"Painting so many legs is bound to keep me out of trouble," I wrote back. (I didn't mention that in 1958 I was only five years old or that the painting would one day be a gift for him.) "And knowing *you'll* be looking at it, I must get the legs coming out of the right places!" In all truth, this time balancing art with scientific accuracy was super tricky.

IT WASN'T UNTIL SEPTEMBER 2011 that I asked: "Next time you're doing fieldwork in my neck of the woods, might I tag along?"

"You are more than welcome to accompany me on my next collecting trip to southwest Virginia," he replied. "I need better precipitation

than we have had this summer; the leaf litter is too dry and millipedes won't become surface active for a good while yet. I'm planning to be traveling out your way in early October if the darn rain ever falls."

But not enough rain fell that autumn. I'd have to wait until the following year to be the field companion of the "millipede man," as some folks called him.

ON JUNE 11, 2012, an email from the Virginia Museum of Natural History popped up in my inbox: "It is with deep regret that we share news that Richard Hoffman has passed away. What a tremendous loss for all of us. For Richard, though, he was doing exactly what he loved until realizing he needed to go to the Emergency Room."

For a long time, I just stared out the window. It was as if an entire library had burned. How could it be such a "normal" day? Squirrels leapt branch to branch, a cardinal whistled overhead, and a small green scarab crept around a flowerpot outside my door. In the human realm, no headlines announced the passing of one who revered and protected the natural world, a *genuine* national treasure.

I felt a deep personal regret, scolding myself: *Why hadn't you thought of taking a field trip with him long ago?* Selfish, perhaps, but, I confess, true.

Yet those words "he was doing exactly *what he loved*" before his heart gave out resonated, despite my grief. Because even now I could imagine him peering through his microscope over yet another many-legged evolutionary oddity. Until meeting Richard, I'd been skeptical of the proverbial myth of folks following their passion into their final hours—but now I believed it possible. Would my own final hours be in the studio?

I couldn't answer that question. But I could begin layering Richard's emails on clear Mylar over his own schematic studies of millipede dissections, those I'd retrieved from his circular floor file. And I could imagine how an old tarnished mirror with silver peeling from its back could reveal those words and drawings underneath. With that, I attached a map of the Martinsville area onto the mirror's surface pinned with painted beetles — the very ones he'd once pulled from the vault for me to draw.

Finished.

I darkened the room but for one lone spotlight on the assemblage. Walking up close to check out an antenna or a curved tarsus, I kept my hands clutched behind my back. And then I slowly backed up to see the grid as a whole.

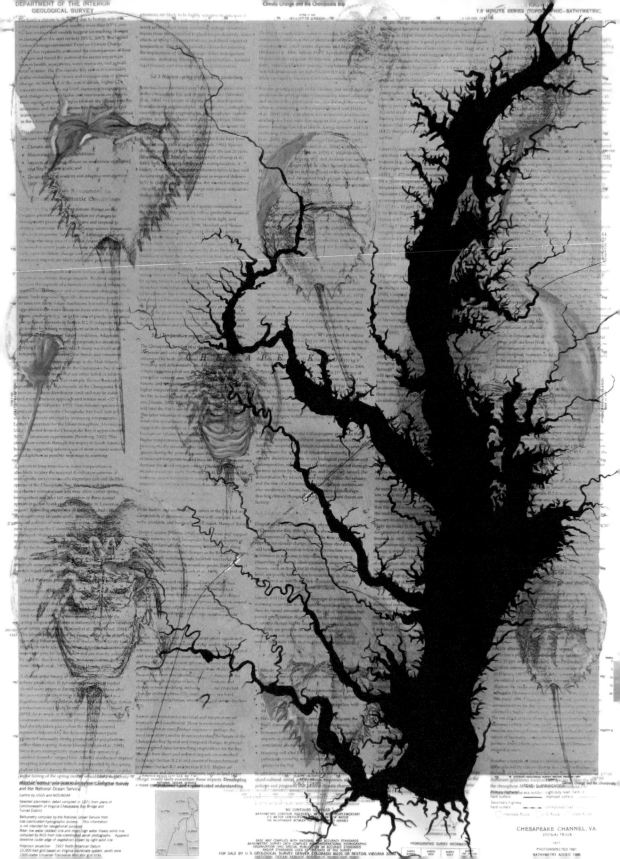

How the Past Returns

CHESAPEAKE BAY

WHEN I WAS a tween in the mid-1960s (miniskirt, white go-go boots, and all), I thought there was meaning in sharing my birthday, October 9, with John Lennon. His picture replaced Pat Boone's on my turquoise bedroom wall. Like an icon, my favorite Beatle grinned over a heap of abandoned stuffed animals and rag dolls.

A horseshoe crab eroded that youthful delusion of my being so special.

On a summer night in 1965, I begged to go with my father to his business partner's home. Mr. Shifter had a kidney-shaped pool where I could swim by underwater lights below, moonlight above—it didn't get much better than that. So we cruised across our Chicago suburb in Papa's polished blue Oldsmobile. While the two men sat on the

screened porch in their Bermuda shorts clinking ice in cocktails and strategizing how to market pneumatic vacuum pumps to dentists, I balanced my transistor radio on the pool's tiled edge. Then I "danced" a water ballet routine to John's nasal "I Feel Fine," dipping and diving like a graceful otter under the night sky. Afterward, swathed in a terrycloth beach towel, I flip-flopped onto the porch. That's when I saw it: a huge helmet-like creature with a dagger of a tail. Its spiky shell dangled in fishing net along with starfish and conchs, all draped over a shelf of shiny golf trophies.

"What is *that?*" I pointed. Mr. Shifter told me it was a crab. But it didn't look like my idea of a crab. I'd never been near an ocean, but did know my mom's Cancer zodiac sign.

Later I asked my sixth-grade teacher, Mrs. Barnett, about the strange creature. She told me it was a horseshoe crab and they'd been around for millions of years.

Millions? Really?

"Really." Mrs. Barnett's red-polished nail pointed to a picture in the encyclopedia. *Yes, that was it.* I leaned to get a better look, so close her flowery perfume made me woozy. Horseshoe crabs, she read, had existed over 450 million years ago, long before humans, who appeared on Earth only 8 million years ago. *Only* 8 million years ago?—that still seemed a lot in my book. It dawned on me how many October 9ths there were in all that time, which meant I shared my birthday with gazillions of people.

I couldn't have articulated it then, but it took the wind out of my sails. Or, another way of looking at it, it blew me in a different direction.

IN SUMMER 2011, THAT girlhood memory came to mind as I straddled a horseshoe crab stranded on the shore of the Chesapeake Bay. I'd crossed the Rappahannock on the Robert Norris Bridge to a peninsula bound by river and bay. A sign on a Jeep Cherokee's back window greeted me: "Keep the Northern Neck Beautiful: LEAVE."

Well, I'll leave, but not for a little while, I assured my welcoming committee under my breath. Honestly, I do empathize with locals trying to keep up with rising prices and developments (read: second homes) that come when outsiders discover the beauty of a place.

I finally reached Westland Beach in Lancaster County. Water sparkled under an overcast sky as I meandered along the sandy shore near the point where the river flows into the bay. There a large horseshoe crab lay on its back. I would say the body was at least ten inches long, twenty inches with the tail. Languidly rowing the air with all ten legs, the crab reminded me of a Hindu goddess waving her many arms. Its huge chestnut-gold shell, half-cracked and encrusted with the small gray coolie-hats of barnacles, suggested a nimbus.

Was this a female come to spawn, fulfilling the last task of her life? I didn't know. But as the dying crab feebly struggled to move, barely alive, I thought that soon it would be dinner for gulls, or maybe a night-hunting raccoon. After that, myriad little critters would whittle it into minute fragments. When it finally landed on the plate of plankton, they'd hardly know their fare was once a horseshoe crab.

As waves lapped gently behind me, I inked the jagged margins of its shell in my sketchbook, its

long spike of a tail extending into the space of the opposite page. Flipping the crab over on its back, I drew the jointed legs, the fans of overlapping gills. It occurred to me then: *These creatures scuttled around long before there were dinosaurs. They were doing their thing in the bay when mastodons roamed Virginia, when John Smith landed. And now.*

I lifted the crab, holding its shell in my hands like an offering bowl, hard points of chitin poking into my soft palm. I yearned to see its bluish blood—blue because it uses copper the way our blood uses iron. But even though the creature's days were numbered, I couldn't bring myself to rip off a leg to glimpse the crab's royal goo.

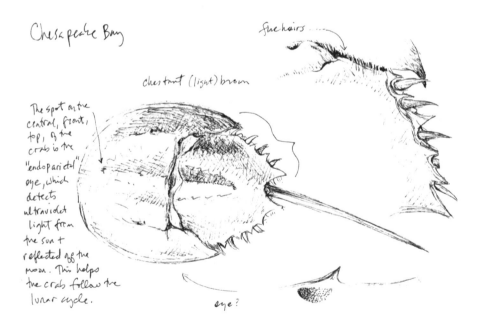

Chesapeake Bay

fine hairs

chestnut (light) brown

The spot on the central, front, top, of the crab is the "endoparietal" eye, which detects ultraviolet light from the sun + reflected off the moon. This helps the crab follow the lunar cycle.

eye?

Along a sandy beach, dead —but still alive looking— horseshoe crab washed up.

Somewhere someone lives because of a horseshoe crab's noble blue blood. Because this fluid holds amoebocytes that immobilize bacteria in a matter of minutes; they do this by releasing a clotting factor, which traps toxins in a gel-like prison. The crab I held might have been one of thousands "milked" for its useful juice, then released. (After an animal has "donated" 30 percent of its blood, though, it's tough going for that creature.) Hospitals scour medical equipment with this cleansing life-juice before surgery. Perhaps an icon of the Atlantic horseshoe crab should hover over medical labs and hospitals everywhere—a true blue-blooded saint, saving thousands from dying of infection on the operating table.

I'll volunteer to paint *that* icon.

Toes to heel, I scraped off my sandals and stepped into the cool water. Gazing toward the distant shoreline, what glittered before me seemed like a lake. But no, remembering the Chesapeake Bay on the map, it was actually one of the many offshoots of a spiky waterway coiling between Virginia's mainland and the Eastern Shore, the "spikes" being the many rivers flowing into this watershed. The Potomac creates a crooked left "arm."

As my toes squished wet sand, a breeze caressed my face. It all felt so fresh, so intimate. Yet this is the largest estuary in North America—and so incredibly old.

Back on shore, I grabbed a long, smooth stick bleached from bobbing in saltwater and drew a line in the sand, beginning at "my" horseshoe crab, up to a piece of gnarly driftwood about ten feet away. I connected the line from wood to a pinkish rock, from rock to a mound of washed-up seaweed, from seaweed to a battered whelk shell, and last

of all, to my footprint. Sand mounded in two ridges around the line connecting all these points.

I'd drawn a crude timeline. Here's the key:

1. 450 million years ago: Horseshoe crabs appear on earth.
2. 35 million years ago: A fiery meteor strikes North America (right about where I stood), creating an impact crater where a river (later known as the Susquehanna) flowed to the ocean.
3. Ten thousand years after the last ice age: The frozen sheet of water melts, filling the impact crater with water and creating a two-hundred-mile estuary with more than 150 rivers or streams flowing into it.
4. Native American peoples inhabit Virginia around the bay.
5. Seventeenth century: English settlers arrive and name the watercourse "Chesapeake" after the Algonquian "Chesepiooc," the Powatan tribe's word for a place near the oyster- and fish-rich "great water."
6. My life begins, which shouldn't even be on the timeline, but there you go, in my mind it's a key event.

A meteor impact, the ice age, Native Americans, early English settlers—all old, yes. Yet hands down horseshoe crabs—ancient relative

of the spider—beat them all by *millions* of years. I've been trying to get my mind around that since sixth grade.

Backtracking to the dying crab at the water's edge, I thought: *Wow, a body that's hardly changed in all that time. Its motto must be: Stick with the plan! If it ain't broke, don't fix it.*

As I stepped away to view my fifteen-foot sandchart, a honey-colored lab galloped up the beach with the abandon thrill of running free. A leash dangled from her owner's hand some forty feet away. After a tail-wagging greeting slobbering my hands, she plunged toward the water, but not before squatting to pee on my timeline—between the Europeans' arrival and my birth—around the late 1800s.

"Way to go, girl. You just marked the point where overfishing decimated fish and oysters in the bay big-time." Either my tease or my chortle excited her: she bounded back, leaping up with her big front paws, knocking her new best friend down on the sand.

Her owner ran up, hand on binoculars to keep them from flapping on his chest. "I'm so sorry! Are you okay? *Bad* Sissy. *No jump!* Are you okay?"

"Oh, I'm fine." Brushing the sand off my legs as I got to my feet, I chose not to mention Sissy's contribution to the timeline.

BACK AT MY BRISTOL studio, I researched more about the horseshoe crab. Tucked in the margin alongside my sketch, I wrote, "The spot on the front part of the crab is an 'endoparietal eye' which detects ultraviolet light from the sun and reflected light off the moon. This eye helps the

crab follow the lunar cycle." A *moon eye*—how astonishing! Perhaps if I'd had a moon eye in my younger years, my monthlies might have been a far more profound experience as my body followed the lunar cycle.

I also happened on the article "Climate Change and the Chesapeake Bay" during a Google search. With a click of the mouse, I read about future scenarios: rising sea levels, the Hampton Roads region flooded, the Chesapeake Bay Bridge submerged, and the roofs of beach condos peeking from the sea like the tips of icebergs. No doubt about it: water will someday redraw the shorelines of the Northern Neck and Eastern Shore.

And the horseshoe crabs? Will they survive our tampering with the Earth's climate? I decided they would (whether humans are still around or not).

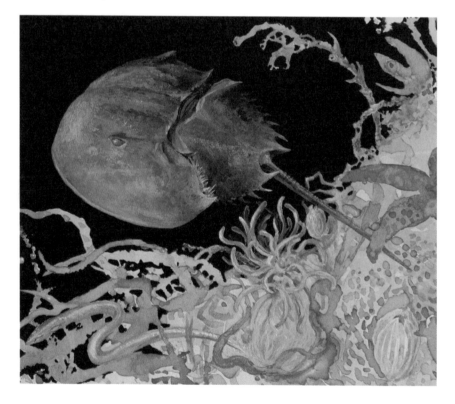

Deep in a submerged Holiday Inn, at the bottom of the Atlantic, barnacle-covered TV sets will face eels hiding in lampshades, and sodden mattresses will crawl with blue crabs, ghost anemones, and those slow-moving bumpy sea stars. Out from under it all will scuttle a horseshoe crab, sensing a new moon with its magical lunar eye. And in that dim light, it will paddle toward the coast of the Chesapeake Bay — whatever its future shoreline — to spawn.

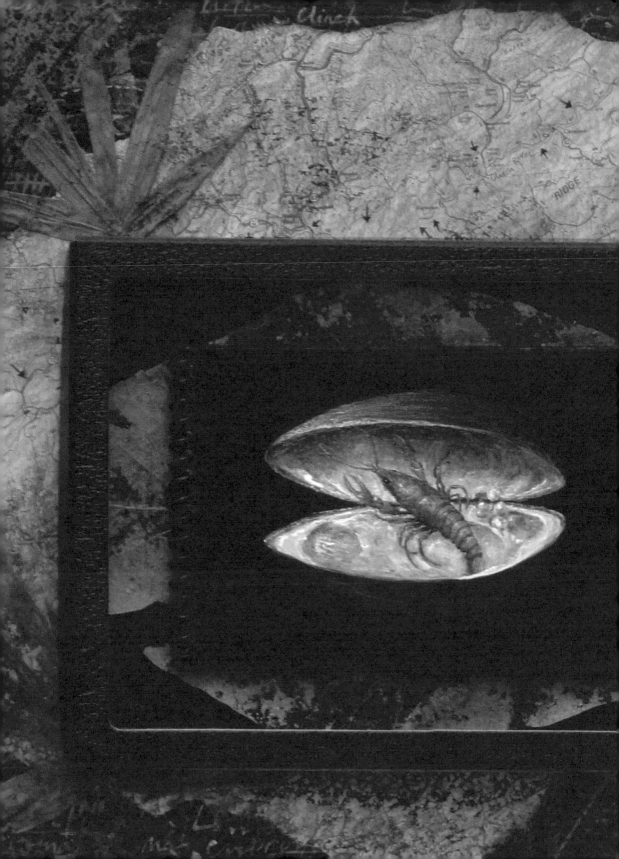

World Enough

CLINCH RIVER

Some jobs are thankless, I thought, cupping two halves of a mussel shell in my palms. Heck, mussels filter all sorts of gunk from the water—shouldn't they get more gratitude for their cleaning service? But most people think of them only as empty shells, if they think of mussels at all.

Standing on a sandbar in the Clinch River that summer day, I imagined *living* mussels doing their praiseworthy thing under the flowing water. But why just imagine? I peeled off my shoes and socks to wade onto the shoal. *Ouch!* Something sharp on the sandy bottom—cracked shells? I stuck my hand in the cool water to find out, touching the way a raccoon feels without looking, "seeing" with my fingertips. After poking around the—yes—debris of shells, I brought up one clamped shut, with the heft of a live mussel inside.

Silky green algae sprouted like hair from its four-inch armor. I knocked on its shell, prying gently, but it refused to reveal itself to big meddlesome me. I envisioned what I'd seen in photos: the soft body, foot squeezing out like a flattened tongue to inch along or dig into the river bottom, openings for siphoning water, ribbon-like gills. But honestly, I couldn't quite imagine how this creature—so locked in, so slow moving, so bound to its wet world—experiences life.

I gently lobbed it back in the current, where it disappeared in a gulp of gray-blue watery lips.

On shore, empty shells scattered like pearly ears cupped to the August wind. Or, when turned over, like oblong fans banded with concentric circles. Some were streaked bright white and crusty black, others raw ocher with pearly gray circling their oblong shell. Yet others were mossy green. One's growth rings told me of its twelve-year lifespan, though it was hard to make out *all* the lines. If I were to paint its olive-green shell, I'd mix black, yellow, and white, black and yellow being the fastest way to make a warm green. Funny, because whoever once lived in the shell could have cared less about a fast way of doing anything.

BACK ON THE RIVER, green pastures dappled clumps of wooded hills as I kayaked down the Clinch. Months before I'd visited ecologist Braven Beaty at his Nature Conservancy office in Abingdon, where he showed me his mussel collection; it includes all fifty species from this very watercourse. Maybe because of the boyish flicker in his dark eyes, I expected him to blurt, "Isn't this one *cool?*," holding up a particularly

large knobbed shell. Instead, he told me about mussels' "vital link in the food chain" and "the biotic community's ecological versus state boundaries." The bivalves he showed me that day did have super-cool names, though, like Cumberland combshell, littlewing pearlymussel, shiny pigtoe, and rough rabbitsfoot. Malacologists (biologists who study mussels) get a blue ribbon for creative naming.

Some of those species were likely the very ones I was finding now as I explored another sandbar. One empty shell was still hinged, and I wiggled it back and forth to get it fully open, then closed, and then open again, reminding me of a butterfly in flight, or closed hands ("I've got a surprise!") opening to reveal…Nothing! Everything! I placed that shell in my backpack. Later in the studio, I'd translate its pearly gleam into the language of paint.

A small crayfish carcass dead on the rubble of shells caught my eye. Crayfish also clean up debris in the river, which I learned both from Braven and from the children's book *Russell the Mussel* (my speed, since pictures fast-track to my brain). A faintly foul scent wafted from the brittle crustacean as I carefully picked it up. Swaddling it in a soft towel so as not to lose any of its jointed legs, I placed it gently in the bag, balanced on the shell—it, too, would find its next habitat in a painting.

That's when I heard the sloshing of paddles.

"Whatcha find?" a man shouted from about twenty feet away. Before setting off downriver, I'd noticed his gray frizzy hair and black shades at the Clinch Valley Outfitters.

all this intricacy, all the hinges and
tubes and claspers, all the golds to
rusts to black-greens, all the pink
glowing aliveness—all this spending

"Mussel shells," I said.

He paddled closer. "They're so pretty. Wonder if any can make a pearl?"

"Good question." I suddenly worried about making a traveling companion. So I didn't tell him that early settlers harvested mussels for pearls before they fed them to pigs. I might have joked, "Pearls before swine" if I'd wanted a friend for life.

"When you look at the shells, it's hard to think they were ever alive," he said.

"Yeah, that's true."

"Bet you no one has a pet mussel!" He laughed at his own joke.

"Hmm, no, I don't guess so."

"They don't have eyes, and hey, and they don't even have a face!" He drifted closer to shore. "You know, people usually need something with a face to love."

"Yeah, that's one way of looking at it."

"Name's Buzz. I live in DC. You from around here?"

"Yes, I am." I tried to sound slightly aloof.

"Well, good luck!" He paddled away. I waved without looking up. Alone again, I considered what Buzz had said, about mussels not having a face. Oddly, he'd hit on something. Babies denied seeing a caregiver's face may have developmental problems. A face means a lot to us. Eyes, nose, and mouth—but especially eyes—bond us to everything from dogs to deities.

SLIPPING BACK INTO THE kayak, I leaned over to stare at my own reflection, watching as my features—but especially my eyes—warped into squiggles and dark blobs in the wavering water. Water that held so much life beyond my gaze—a whole realm of swimming, hiding, sucking, filtering, gobbling, excreting, and finally dying. And always, always, procreating. Braven had told me about the unusual life cycle of mussels: "Some lay their larvae in a little packet that looks like a worm. A fish comes along and snaps it up for a meal. Once the mussel packet is in the fish's mouth, it explodes, and then the larvae find a place on the gills for food and protection, living there a few weeks."

"Does it hurt the fish?" I asked.

"No, and fish benefit from mussels in the long run because they keep the water cleaner."

After floating with the current awhile, I checked out some river cane, a kind of native bamboo, growing lush along the bank. A few gathered leaves would one day splay like pointy fingers in an assemblage.

Paddling on, I passed Holsteins bunched together in a pasture behind a barbwire fence, their black-and-white patterns like jigsaw

pieces in search of a puzzle. I imagined how serene the scene would be if they were knee-deep in the river, slurping water, right out of a Dutch Golden Age landscape painting. But ecologically the river's better off without cows, or, more to the point, without cow poop. It's just more labor for the mussels. Fertilizer runoff and pollutants from coal mines already beleaguer the shelled cleaning service. As if that weren't enough, a few drastic chemical spills on the Clinch River were a death knell to some species of mussels, while others teeter on the edge of survival. Odd how we seesaw between destruction and preservation: one person spills lethal chemicals into the river, killing all life for seven miles, and another dedicates a lifetime restoring that life to the river. We humans are strange animals.

I REACHED THE TAKEOUT at Slant with twenty minutes to spare before the outfitter would pick me up—time enough to cross the swinging bridge. I yanked the kayak ashore; what glided effortlessly on water clunked awkwardly as I dragged it across the stone-studded ground gouged with tire tracks. *Sigh.* In a little while I'd be on four tires myself, zooming down the highway, homeward.

Likely, I'd succumb to that irresistible urge to punch on the radio, scan the stations for acoustic music that draws me out into the surrounding hills. But news? No. Not *that* world. And soon I'd be studying striated mussel shells on my painting table, matching those subtle pearly grays with paint, in the studio, where worlds filter through a siphon of eye and hand.

But now the narrow footbridge dangled precariously over the Clinch. *Only as strong as the weakest link,* I thought, pausing before the chain cable

draped with fencing bolted to pylons on either side of the river. My nerve quivered like a compass needle before it points north. *C'mon*, I coaxed myself. *Don't overthink, just go.* My wish for a bird's-eye view beat my fear of heights.

Well, sort of. My hands griped the metal cords tight, knees jelly weak, heart pounding in my throat from the slight swing and bounce of the swaying bridge.

Centered now, I peered down to the river below. Under glittering riffles, a whole world flourished—mussels, fish, crayfish, and so much more, doing what *they* do. World enough.

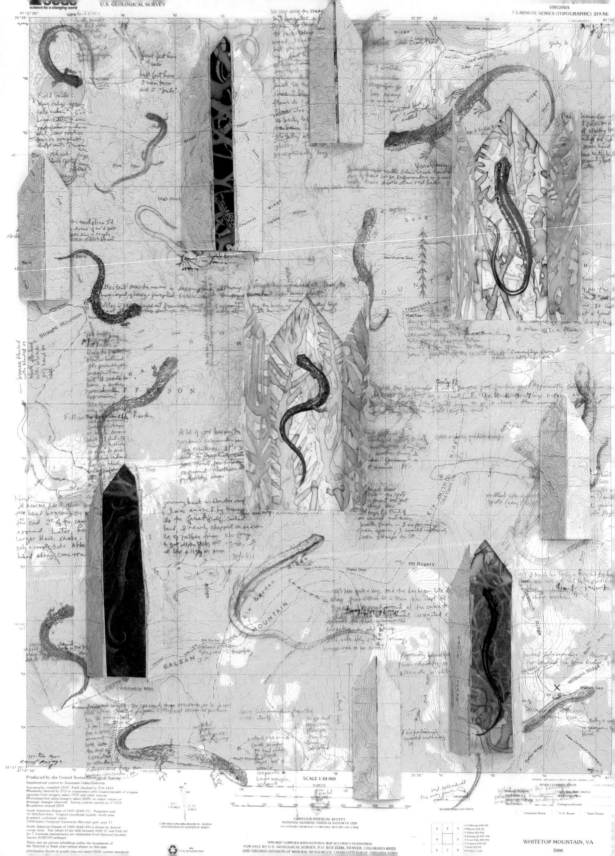

Salamandering

SOUTHERN BLUE RIDGE MOUNTAINS

A WIGGLE-FLASH OF BLACK and rusty red—all I saw of a salamander as it dove down a burrow. What did I expect? I'd tipped over its rock, scaring the bejesus out of it. I imagined myself shrinking, a sort of Alice in Salamanderland, venturing down that earthen tunnel to get a good look, when I stopped short: *You fool, Suzanne, that gentle-looking creature would gladly eat you if you were that small.*

My mission that day at Grayson Highlands State Park was to draw a particularly large salamander called a Yonahlossee (pronounced *yon-ahh-low-see*). Most visitors head to the highlands for spectacular mountain views where they'll find a trail to Mount Rogers, the highest peak in Virginia at 5,728 feet, and where they can frisk with shaggy-maned wild ponies.

But salamander hunting led me the other direction, down Cabin Creek Trail. I ducked under rhododendron thickets and hiked amid

a tall canopy of mixed hardwoods. I tripped over tree roots and rocky outcroppings. Meandering rivulets required a leap if I didn't want to get my shoes soggy. I finally did reach Cabin Creek, chocked with smooth boulders, lushly lined with lady ferns. But all along the way I looked for small lives, turning over boulders and fallen logs, carefully placing them back in place—after all, these aren't mere rocks but shelter for myriad animals.

My first Yonahlossee of the day dashed down its burrow. I forged on. Under a mossy log, a pygmy salamander curled, its characteristic chevrons zipping down its back, dark brown on light buff. A couple more stones: nothing. As I pried up a granite boulder, a two-lined salamander tried to make a getaway, its black racing stripes streaking

eyeline

down saffron sides. It was as if the land were a *Wunderkammer*, a sort of earthen cabinet of curiosities, opening to reveal natural treasures. Pausing a moment, the golden amphibian scrambled into dry leaves, as if to say, "Now you see me, now you don't."

Finally, I flipped a flat slab of limestone exposing a "giant" Yonahlossee salamander—five inches long—posed like a red-robed king surrounded by his court of isopods (you may know them as roly-polies), two amber millipedes (conferring over a dab of white fungus), and a black ground beetle gleaming like patent leather.

As the grizzly monster—*me*—towered over, they scattered. All, that is, but the Yonahlossee. Its bulging eyeballs reminded me of pop-up headlamps. It didn't budge. Our eyes met with a spark—mine wide at such a beauty, its likely dazzled by the sudden light. A Buddha-like expression conveyed calm, though I bet it wasn't too thrilled about losing its cover.

I coached myself: "Take your time…slowly cup your hands around it…be ready to move fast…block the direction of its burrow…" and so on until—*voilà!*—I cupped the animal in my hands. Its red back glistened over gray marbled sides, gray fading to pale lavender along the long tapered black tail.

No way to explain the thrill of seeking salamanders. Something about the hunt, the near misses, and then the discovery of a creature living its own furtive life, a life linked to these mountains for millennia. It goes beyond merely observing the creature, as in a zoo. It's witnessing it on its own terms. Which makes me feel I'm in on a secret (how

many others elude me?). Now I placed the amphibian, mesmerized by the warmth of my palm, on a large flat stone. Its large U-shaped mouth suggested a smile: Happy? I knew better. But my model was tranquil enough to endure my fumbling around getting pen and paper out. As I drew, it occasionally attempted a slow escape, but I'd just touch its "nose" slightly to let it know I was still there. I write "nose" in quotes because this animal doesn't actually have one as we think of it. Plethodon salamanders, the family to which the Yonahlossee and many Appalachian salamanders belong, breathe through their skin.

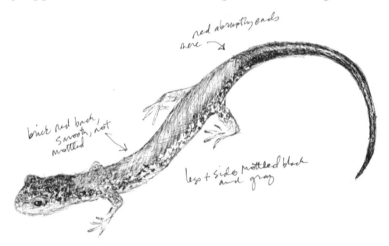

Since Yonahlossees live mostly in the dark, I wondered why their colorful back patch evolved. Perhaps to signal "I taste bad" to predators on those misty days when it roams leaf litter?

Sketch finished, I scooped up the salamander to place next to its stone. As I stood, it wiggled for cover. *Would it have a story for its friends!*

But, no, I was a mere blip on its radar, fading quickly as it returned to its timeless world. Salamanders put things in perspective.

ZIGZAGGING UP ROUTE 53 that morning, I remembered a time as artist-in-residence at Centrum Center for the Arts (north of Seattle) when someone asked me where I was from. "Southwest Virginia, in the southern Appalachian Mountains," I answered, adding proudly, "It's the salamander capitol of the world. There are more species of salamanders in the region than anywhere else on earth." They thought all of my salamander talk was kind of a jest.

Not so. Who says a mountain lion or an eagle is more worthy of our awe than a salamander? I threw out any hierarchy of wonder long ago.

But why *do* more salamander species live in this region? Because when glaciers receded after the ice age, salamanders survived at high altitudes—mountaintops—where the climate remained moist and cool. And mountains being mountains, these creatures became isolated, a perfect equation for the formation of distinctly new species in the course of evolution. Called "speciation," the process means salamander specialists flock to the southern Appalachians—a geneticist's paradise.

My salamander tutorials began in the early 1990s at the same naturalist rally where I seined Laurel Creek for many-legged life. One of those years the field trip guide was the legendary authority on all-things-salamander, the late Jim Organ, and his wise wife, Della. Most recently, the gentle herpetologist Kevin Hamed leads the amphibian quest. To identify a species, these experts point out minute features, such as a delicate line between an eye and corner of a jaw.

"Carefully return the critter near the stone where you found it," Kevin always instructs his group as he warns against dropping a stone carelessly. "We don't want to smash the little guys!" Loving something to death is sometimes literally true.

MOSTLY, I'M ALONE WHEN *salamandering*, a word I just added to my computer dictionary. Its first meaning: "To look for salamanders; to seek amphibian jewels of the earth." Second meaning: "To get delight from finding a creature that doesn't give a damn about humans." Third meaning: "To love that which cannot love you back." My definitions. My priorities.

As I sat on a log near the Yonahlossee's boulder, I felt good knowing it lived its life away from the stress of inboxes, insurance payments, leaky faucets, and — wait, no, it also has stress. Hungry crows picking at the leaf litter for food would be stressful to this small creature. Sharing space with a spiteful red centipede might be quite harrowing. Not tunneling down far enough during a cold winter? That could spell danger for an amphibian.

I fidgeted with the red seeds of a Fraser magnolia like worry beads, thinking: *What is the difference between a salamander's stress and mine?* This: There's a distinction between the vital and the distracting. A salamander's stress is due to essentials of life and death.

Can't say the same about many of mine.

I resumed my hike and my salamandering. Yonahlossee found, I casually turned a rock or log over now and then. I'd come to know which were the most promising: too deep in the ground, nothing, too lightly set on leaf litter, nothing. Good knowledge. Yet no one will

write a news story on my accomplishment. What would a world be like if newspapers slathered with stories of crooked politicians and faraway skirmishes instead featured stories about salamander life and those who seek them?

I pulled off my shoes and socks by the creek, rolled up my pant legs, and waded gingerly into the icy water. As I lifted stones on the edge, a salamander drifted down the current in cloudy silt I'd just stirred up, then vanished. Next time I was ready. Lifting the stone with my left hand, I held my right ready to catch whatever might float out.

A beauty! A black-bellied? I wasn't sure. But I could be sure the salamander was a creek dweller, for as I let it go its keeled tail flailed, gracefully swimming out of sight.

That's enough, I told myself, but this salamandering gets obsessive. I spotted a promising-looking stone in seepage near the stream. Is this what it means to leave no stone unturned? Underneath, an ocher-brown dusky with a stub of a tail looked up at me. Golden flecks circling its small iris made for a sleepy, rather disdainful expression. Gently lifting it up, I remembered what I learned from Kevin: "Salamanders can lose their tails escaping a predator, but that may make it a harder for them to breed until the tail grows back. Reason is they have a mating ritual called a 'tail straddling walk,' a sort of dance."

No tail, no *chassé* with a partner.

And standing there on the bank of Cabin Creek, I peered down at the glistening life nestled in my palm: *Imagine, they dance...*

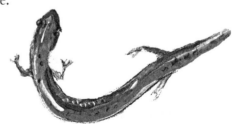

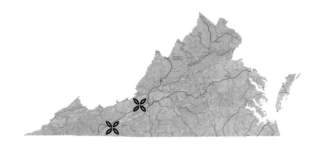

Pilgrim

APPALACHIAN TRAIL

It's the noticing that cracks us open, lets something in.
—Lia Purpura, *On Looking*

I'M NOT MUCH of a hiker. I'm a saunterer, preferring to sketch whenever the spirit moves me, meaning frequent stops, meaning my eyes do more roving than my feet. So the great path from Georgia to Maine called the Appalachian Trail is known to me only in short spurts as it meanders through Virginia. Yet I'm fascinated by the personal stories of trail people, whether thru-hikers or those who take it in shorter stretches. We are a subspecies of our human tribe, pilgrims scrambling up granite outcroppings sprinkled with crusty lichens, enduring an honest shiver from a sudden squall, or pausing to spot a mystery bird. We weave our own story with the stories of ancient rocks, fickle clouds, and secret nests.

Whitetop Mountain, Early Summer

I was mindlessly trekking uphill when suddenly a flurry of wings beat wildly under my boots—*Whoosh!* Plunging earthward, I shrieked—*Aaaaaahhh!*—as cheek hit dirt. Next thing I knew, decaying leaves filled my nose with sweet rot as I peered up at tiny golden spore capsules of mosses.

I was shaken but relieved I hadn't kicked the terrified bird. But why had it taken so long to make its escape? A nest nearby? I crawled on hands and knees, hunting. It couldn't be too far away, yet I searched and searched. Miraculous how birds camouflage their nests. At last, there it was, tucked under a boulder. Living green grasses curled around dry brown ones; a soft bed of fine tendrils cushioned four red-dappled pale blue eggs. This bird had mastered the art of cryptic concealment.

As I knelt near the whorled grasses, a hiker clomped up behind me. Because of his huge load—bedroll and tent strapped on the bottom of his backpack—I thought he must be a thru-hiker, one who traverses the whole trail.

"Hello," he whispered, peering over my shoulder. He was a wiry guy; sandy hair stuck out from his air-flow hat like straw. I guessed he was in his late twenties, but the three deep wrinkles lining his forehead like mountain ridges suggested older.

"I found a bird's nest. Want to see it?"

"Sure!" he stooped down.

I parted the grasses.

"Oh, wow." He whipped out his phone to take a picture. "What kind of bird's nest is it?"

"Not sure—I saw a blur of gray. My guess is a junco. I'll check my field guide to eggs when I get home."

As he peered into the LCD screen, deftly working the mini-keyboard with his thumbs, my eyes darted around for the mother bird. Was she eyeing us from the nearby bank of lady ferns in quiet panic mode or calmly waiting it out?

I brushed myself off as I stood, while the backpacker stuffed his camera in his cargo shorts, giving the Velcro a tap.

"Are you walking the entire trail?" I asked.

"No, I got on near Front Royal and will get off near Iron Mountain. In Tennessee," he told me. "That's where a friend from Johnson City will pick me up."

"Why'd you decide to hike the AT?" I now walked alongside him toward Elk Garden's short grasses studded with rock outcroppings.

"Oh, gosh…" he shook his head, clenching his walking stick tighter. "After teaching high school history last year, I needed to do something different. Really different. Thought this hike would give me time to think."

"So, you quit teaching?"

"Oh no. Have to be back in early August—that's why I'm just covering a section of the trail. Maybe someday I'll hike the whole thing." Then he stared off into space, as if he were addressing not me but the summit of Mount Rogers he knew to be up ahead. "I love dealing with real stuff—you know, sun or rain, watching buzzards soar overhead,

making a fire to cook when my stomach's growling—I mean, anything but worrying about the bell ringing for class," he sighed. "Guess it sounds weird, but I wanted to think about my life and *not* think, too—just be in the moment. I need to feel... *alive*... and not always making lesson plans or grading stacks of papers." He held the word "alive" in his mouth as if it were a scrumptious morsel of melted cheese.

"I know exactly what you mean, really, I do. Drawing works that way for me," I told him. "It's when I'm fully present—like you said, thinking but in a way not thinking."

He nodded. And I wondered if his wanderlust would deepen his teaching or divert it.

I pointed as a long-legged beetle scampered over leaf litter. Its iridescent blue-green elytra glowed metallic. My companion snapped a shot.

He pointed to a peak where one scraggly spruce leaned, bonsaied by the wind. "Well, so long, I'm heading up there. Good meeting you!"

"Safe travels!" I called, realizing I'd not learned his name, nor he mine.

Retracing my steps back to the nest, the mother bird was still nowhere in sight. I hoped she hadn't abandoned her eggs. I crouched down, got a whiff of sweet moss before peering once more into the whorl of grass secreting four feathered futures.

Near Roanoke, Midsummer

Even peanut butter and jam smells good when you're hungry. So though it was only 11:30 in the morning, after hiking uphill for an

hour I was ready for lunch. I clambered up an enormous boulder twice my height to overlook a panoramic ribbon of mountains.

I sank my teeth into a sandwich and raspberry goo squeezed onto my arm, looking like a bloody gash. As I licked the preserves off my skin (it tasted like salty candy), I stopped cold. Some creature rustled on the other side of the rock. From the sound of it, something *big*. I stealthily crawled over to spy on—what? The foraging hulk of a bear?

No bear.

Instead, a robust young woman in cutoffs and ankle boots leaned over the leaf litter. From her braided topknot, strands of loose hair spilled over hoop earrings.

"Oh, sorry, I thought you were an animal," I apologized, feeling weird about having sneaked up on her. Her hand lens dropped on the chain around her long neck.

"I *am* an animal," she laughed, pushing up the sleeves of her plaid shirt, exposing brawny arms. "Sorry if *I* scared *you*." Notebooks, small Ziploc bags, and a Sharpie fine-point lay near her feet on the bare ground.

She caught my eyes fixed on her paraphernalia: "I'm identifying lichens."

"What kind is that?" I pointed to sooty-black crumbly stuff in her hand. Now I was lying on my belly, chin resting on my hands, peering down.

"Common name is rock tripe—I'm keying it out to find the Latin name." She circled the boulder, leaping up in three bounds to give me a closer look at the crusty plant.

"You won't believe this, but I just made a drawing of that lichen, so let me jot down the name," I said. And feeling like a hostess with unexpected company, I held up the other half of my bagged sandwich. "Hungry?"

"Thanks, I've eaten. Mind if I look at your sketchbook?"

Paging through, she paused here and there to read a comment. She stopped at a dead warbler with ruffled yellow-green feathers, its feet sticking up like gnarly winter trees.

"Sad but beautiful," she paused, and then turned a few pages. "I wish I knew birds better. You know, these drawings are so cool. You should make a book of them." With that, she leapt down the rock. "I found some box turtle bones at the foot of the mountain. You might like them." She took a bag out of her pack and bounded back up.

"I can have them? Thank you." Pinching a small curved leg bone between my thumb and forefinger, I held it up: "Just think of how many journeys that leg's been on."

She nodded. "Slow ones."

I offered her coffee from my thermos. "Sort of lukewarm, but…"

"Sounds great," she smiled broadly. "Here, let me give it a gourmet touch—M&Ms from trail mix," picking out a few chocolates from the almonds, Chex, and dried cranberries she carried in a belt pack.

"How far are you hiking?" I asked.

"I'm here for only a few hours. I'm a single mom—getting out has to be during daycare." We sat gazing into the blue stretch of mountains.

After a pause, I asked, "Son or daughter?"

"A boy named Elijah. He's four." She fiddled with her hand lens. "His father and I divorced last year. I jumped into the marriage to get away from my parents' Tea Party politics, but my ex was, well, too political himself. Causes became more important than the baby and me. So we split. Funny, my folks are creationists who don't like my interest in evolution, and my husband called my interest in botany 'impertinent.' He thought I should be out protesting wage inequality, or at least finding a cure for cancer with all these weeds. My parents thought I should be homemaking and praying. Well, I do pray, just not the way they do. And heck, sure I'd like wage equality!" she laughed. "Soon as Elijah is in kindergarten, I'm quitting my greenhouse job and going to grad school."

"How'd you get interested in *lichens*?"

"In a sort of roundabout way…I always loved wildflowers, so I went into botany but never thought much about nonvascular plants. One

day after reading *Peter Rabbit* to Elijah, I Googled 'Beatrix Potter.' Turns out she was quite the scientist. And one thing she did was study lichens, believing—rightly—that they were more than one organism. She even separated the algal from fungal cells in her kitchen! I decided to try. Failed, but it got me really noticing them in the wild."

I loved her word choice: *noticing*. She hadn't failed at that.

"Ever take your son on field trips?"

"Oh Lord yes, but times I need to be alone."

"I hear you. Tell me—I don't know much about lichens—the stuff in your hand is, um, leafy, but the growth on this rock seems no thicker than spilled paint."

"Gotcha. So there are two kinds on this stick. The lettuce-like one is foliose lichen, but this sort-of prickly growth"—she pointed—"is fruticose lichen, maybe the one called bushy beard."

On the rock, concentric circles of turquoise bloomed like flowers over splotches of yellow ocher, suggesting an ancient wall painting. "These are crustose lichens. They grow very flat on rocks or tree trunks. All lichens are symbiotic—the fungus keeps the algae moist and safe. In return, the algae make carbohydrates—food—from sunlight. They're perfect symbiots. Someone once said that 'lichens are fungi that have discovered agriculture.'"

"That's a good one," I grinned. "So, we're sitting on perfect co-operation!"

"Yeah, you might say."

As we sipped coffee at our boulder café, a small bird with a brilliant

yellow breast and crisp black hood jumped on an overhanging branch.
Whe-ta whe-ta whe-ta-chew, he sang, paused, sang again.

She looked toward me, eyebrows raised, as if to say, "What kind
of bird?"

"Hooded warbler," I whispered.

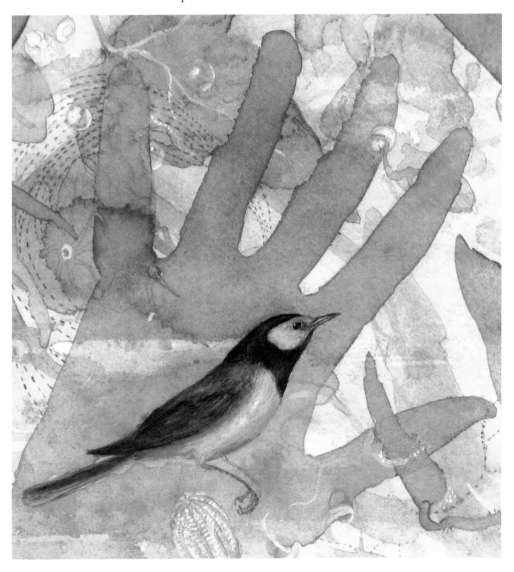

ALONE AGAIN, I HEADED down toward the car. A gray-bearded man with an overstuffed pack hiked up the trail, reminding me of an upright turtle walking on its back legs. With every step, he stabbed the hard ground with his walking stick carved with diamond designs. We shyly smiled "Hello," the way you do with a stranger when you make eye contact. I wanted to ask him, "What's *your* story?" I wanted to find out if there were clocks or bells or voices he left behind or what he came to find on the trail. But shadows lengthened as the sun set over the Blue Ridge, and I knew I'd better get on the road home.

IMAGE NOTES

Every chapter begins with an assemblage from my "Notes on the State of Virginia" series; those with USGS map borders are 27 by 21 inches, and those without margins are 12 x 12 inches cropped. Paintings and drawings in these combination artworks are on paper or Mylar, created with pen and ink, watercolor, or acrylic. Other mixed media in the assemblages may include maps, book pages, genetic printouts, and found materials (plants, rusty bits of farm implements, bark, insects, an old leather shoe, soil, and so on). Details of these assemblages are included in some chapters. Please visit my website, suzannestryk.com, for more information about these works. Images from my "Genomes and Daily Observations" series appear on pages 162, 172, 226, and 253; these are mixed media on paper. The painting *Primitive Science (Millipede)*, on page 215, is acrylic on canvas. All other images are a full page or detail from my sketchbook (5.5 x 8.25 inches) and are pen and ink, pencil, watercolor, or a mixture of these.

ACKNOWLEDGMENTS

A venture of this kind relies on the expertise and generosity of so many individuals. I'm very grateful to the following Virginians who've shared ideas, provided materials, and guided me through special places they know and love: Teta Kain, Bobby Clontz, Barry Truitt, Kevin Hamed, Pat Brodowski, Eric Proebsting, Elizabeth Sproul Ross, and the late Richard Hoffman. One of the great pleasures of this project was to witness your worlds, with you.

I'm indebted to a Virginia Commission for the Arts fellowship for travel and art materials, without which my original "Notes on the State of Virginia" project might still be a scribbled note in a folder.

Special thanks to the following people, many of whom I've never met, yet who aided my research or fact-checked chapters with kindness and expertise: Bill Kittrell, Doug Ogle, Rom Lipcius, Braven Beaty, Chris Bingham, Andrew Marshall, Mark Barrow, Nigel French, Gail Pond, Deloras Freeman, Terry W. Mullins, Link Elmore, and Laura Macaluso. A big thank-you to all those folks who offered insight, discoveries, even poems, and thus made a cameo appearance in these pages: Marie Bridgeforth, John Sproul, Matthew Brien, Carolyn Kreiter-Foronda, and so many others (some whose names I never learned). I'm grateful to Nina Rizzo, an artist herself, for skillfully photographing many of the assemblages. And to Leah Stoddard, whose curatorial vision for the first museum show of my "Notes" series launched the statewide tour.

Thanks to *Orion: Nature, Culture & Place* for publishing an early version of "Salamandering."

The following cultural organizations have proved so valuable: the Nature Conservancy in Virginia, Thomas Jefferson's Poplar Forest, Monticello, the Virginia Museum of Fine Arts, the Virginia Museum of Natural History, the Blue Ridge Discovery Center (sponsors of the Mount Rogers Naturalist Rally), and Friends of Dragon Run.

Deep thanks to three gifted writers willing to read my working manuscript. Laura Parsons's discerning eye—for both writing and art—edited an early draft, launching me into the new medium of words. Rick Van Noy read it at the midway point, revving me up for the long haul whenever I'd see his "Yes!" in the margin. Linda Parsons so graciously applied her editorial art to the manuscript as it neared the finish line.

Heartfelt appreciation to Rebecca Davison, agent-editor, designer, and kindred spirit, who shepherded these pages from manuscript to book. For her faith in this project, her insightful suggestions, and her vision of what the book might look like in the hands of a reader, I'm honored.

It's been a pleasure working with everyone at Trinity University Press. I'm especially grateful to Steffanie Mortis Stevens for initially seeing promise in my manuscript and for her spot-on suggestions. And to Sarah Nawrocki for her expert editorial direction as well as to Christi Stanforth, whose editing left no stone unturned. Thanks to Tom Payton who, while steering the ship, found special time to connect with this project. And to Burgin Streetman for casting *The Middle of Somewhere* out into the world.

I'm fortunate to have such a warmly encouraging family—special thanks to every one of you. Deepest appreciation to my husband, Dan, who accompanied me on a number of these Virginia trips, while always beside me on the longer journey of life and art. And whose deep love of language has kindled my interest in the written word's own expressive possibilities.

Finally, thanks to all the animals—skinks, dragonflies, salamanders, many-legged millipedes, the red-cockaded woodpeckers making a comeback, and those ever-mysterious ravens (to name a special few)—who inspired this book.

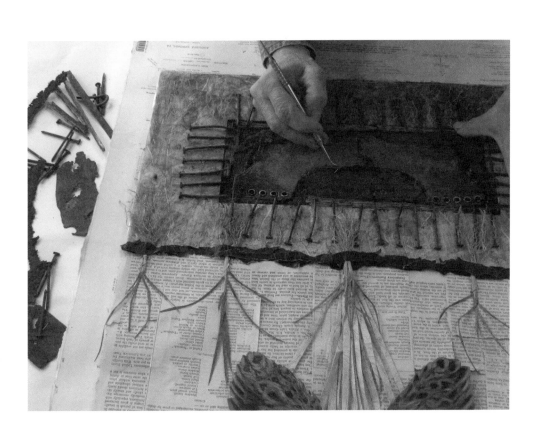

Trinity University Press
San Antonio, Texas 78212

Book design by Rebecca Davison, Branta Studio
Cover design by Anne Richmond Boston
Author photograph by Ted Stryk

ISBN 978-1-59534-961-3 paperback
ISBN 978-1-59534-962-0 ebook
Printed in Canada

Trinity University Press strives to produce its books using methods and materials in an environmentally sensitive manner. We favor working with manufacturers that practice sustainable management of all natural resources, produce paper using recycled stock, and manage forests with the best possible practices for people, biodiversity, and sustainability. The press is a member of the Green Press Initiative, a nonprofit program dedicated to supporting publishers in their efforts to reduce their impacts on endangered forests, climate change, and forest-dependent communities.

The paper used in this publication meets the minimum requirements of the American National Standard for Information Sciences—Permanence of Paper for Printed Library Materials, ANSI 39.48-1992.

CIP data on file at the Library of Congress

26 25 24 23 22 | 5 4 3 2 1

Suzanne Stryk is an artist who finds equal fascination in the natural world and the visual arts. Her conceptual nature paintings and assemblages have appeared in solo exhibitions throughout the United States, and her portfolios and related writings have been featured in *Terrain.org*, *Orion*, *Ecotone*, and the *Kenyon Review* She is the recipient of a George Sugarman Foundation grant and a Virginia Commission for the Arts fellowship for the project "Notes on the State of Virginia," the precursor to *The Middle of Somewhere*. She lives in southwestern Virginia.